AMERICAN SIGNS

AMERICAN SIGNS

Form and Meaning on Route 66

Lisa Mahar

THE MONACELLI PRESS

First published in the United States of America in 2002 by
The Monacelli Press, Inc.
902 Broadway, New York, New York 10010.

Library of Congress Cataloging-in-Publication Data
Mahar-Keplinger, Lisa, date.
American signs : form and meaning on Route 66 / Lisa Mahar.
p. cm.
Includes bibliographical references.
ISBN 1-58093-119-7
1. Signs and signboards—United States—Pictorial works. 2. Vernacular
architecture—United States—Pictorial works. 3. Motels—United States—
History. 4. United States Highway 66—History. 5. Roads—Social aspects—
United States. I. Title.
HF5843.M355 2002
388.1'0973—dc21 2002026332

Printed and bound in Italy

Designed by Lisa Mahar and Ashley Sargent

Cover and spine photography by Lisa Mahar

Acknowledgments

American Signs is the result of eight years of work, from my first trip on Route 66 through the long process of assembling my research into a book. There were many phases of development over the years, and a variety of people contributed in different ways and at different times. Some helped me in broad, fundamental ways and others with very specific issues; some provided emotional support and others intellectual guidance.

Four people in particular dedicated substantial amounts of time and thought to this project. Not only did these people help determine the book's final form, their involvement has led to friendships that I hope will continue long after its publication. No one has worked longer on this project than Ashley Sargent, who helped me on the book's design for two years. Her infallible eye and thoughtful approach gave this book a graphic sophistication and clarity that otherwise would not have existed.

I am also grateful to my two editors. David Brown has, over a year and a half, poked and prodded at my prose, transforming it into a coherent, contemplative text. Additionally, David continually shared his vast knowledge and understanding of material culture in ways that have greatly enriched this book. Andrea Monfried, my editor at The Monacelli Press, took the book near the end and provided insightful, constructive criticism that helped to refine the content even further.

Lori Andreozzi assisted me in the initial stages of the project, poring over decades of *Signs of the Times* and *Tourist Court Journal* magazines. Our serendipitous meeting at a microfiche machine in the main reading room of the New York Public Library marked a turning point for the book.

The Internet played a vital role in helping me find the people who know the most about Route 66 and its motels. In particular, eBay was a great resource; its sellers provided me with an endless and ever-changing source of vintage postcards, which not only helped date the signs but also provided the most reliable documentation of changes in particular motel signs over the years.

My two on-line friends, Douglas Towne and Laurel Kane, helped in countless ways, but mostly by inspiring me and providing me with timely, much needed encouragement. Laurel generously shared her extensive collection of Route 66 postcards, as well as her wisdom and passion for roadside culture, and Doug cheered me on while educating me with his insightful observations on the American highway.

I am grateful to The Monacelli Press, especially Gianfranco Monacelli, who followed my project from the beginning, and Steve Sears, who ensured that the book was produced with care.

I would also like to thank Julia Joern, Shelley Martin, Diane Ghirardo, Philip Kim, Ramon Tapales, Julie Feiten, the Young Electric Sign Company, and the faculty at the College of Architecture and Urban Studies at Virginia Tech in Blacksburg, Virginia for their help, interest, and support.

This project would not have been possible without the understanding and support of my office, especially my husband and business partner, Morris Adjmi. This book often took me away from my responsibilities at work, and Morris always and without hesitation stepped in to cover for me. He also encouraged, comforted, coddled, consoled, and helped me, depending on what I needed most at the time.

Last but not least, I must acknowledge my debt to Paul Klee, whose work inspired me to make this book; to Olivio Ferrari and Ron Daniel, who taught me what I needed to know to create it; and to Henry Glassie, whose contributions to the field of material culture guided me throughout its production.

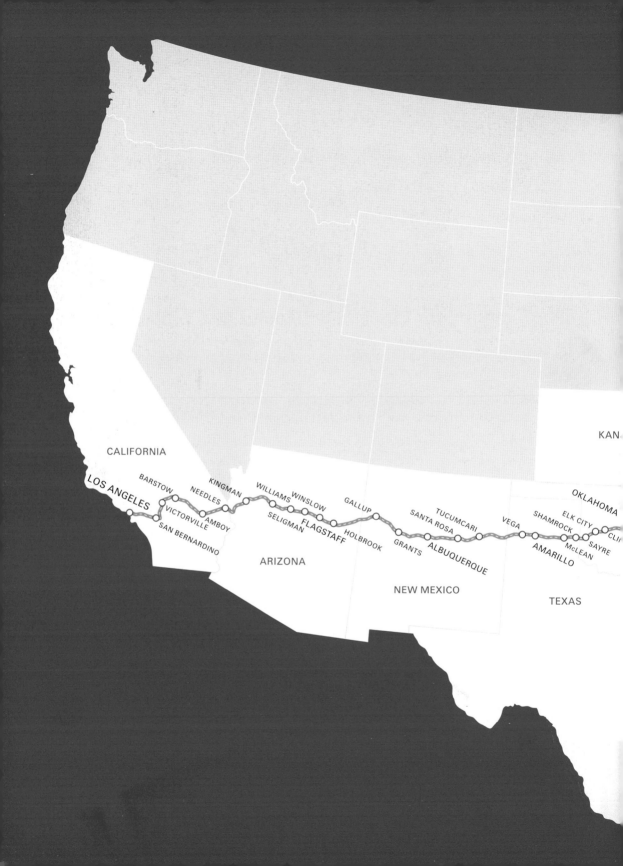

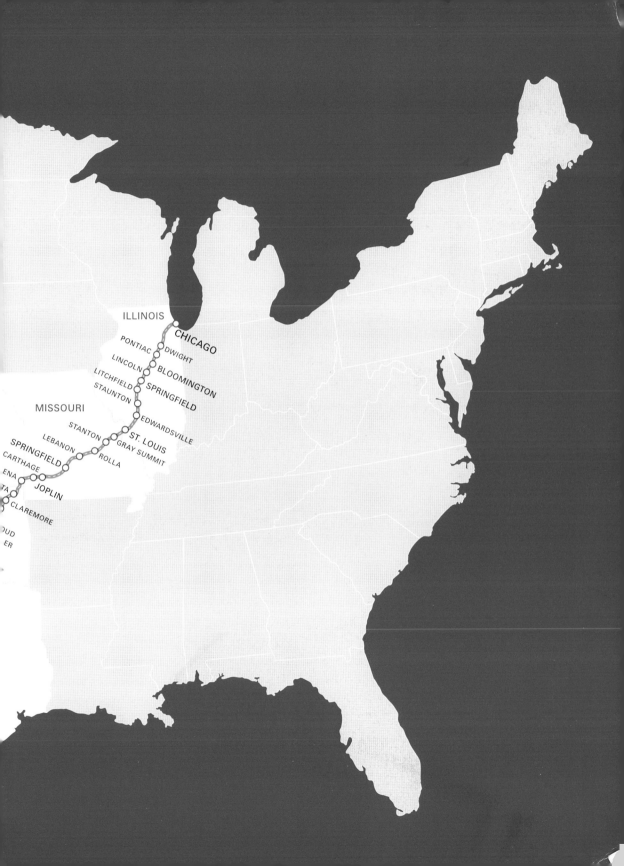

Introduction

This is a book about the motel signs built on Route 66 between 1938 and the 1970s, from the year the highway was fully paved to the era when it was bypassed by the new interstates. It is an analysis of the complex processes by which these signs were created, from conception to placement along the highway. And it is an examination of how and why motel signs have changed over time, and what those changes tell us about the people who made and used them. Careful attention to signs made during these years, which encompass five distinct eras of signmaking, provides insight into changes not only in the signs themselves but also in patterns of transportation, work, and leisure and in regional and national traditions and economies.

Signs orient people in unfamiliar landscapes, functioning not only as physical markers but as cultural, political, and economic ones as well. The signs and other common objects that fill the landscape along Route 66 are concrete reminders both of the ideas once held by their creators and of the cultural climate in which they were built. Motel signs also convey, in three-dimensional form, strongly held beliefs and desires; this is where their beauty lies. "The beauty that we see in the vernacular," observed John Brinckerhoff Jackson in *Discovering the Vernacular Landscape*, "is the image of our common humanity: hard work, stubborn hope, and…love." Formal analysis can uncover this humanity. The carefully executed and well-proportioned hand-painted letters found on an early 1940s sign, for example, transmit the signmaker's pride and knowledge of his craft. The prefabricated plastic letters the signmaker chose during the 1960s reflect his struggle to remain profitable even as his relevance was in question. (Until the mid-1960s, the signmakers along Route 66 were almost exclusively men.)

The ways signmakers approached the generation of form are of paramount importance. Signmakers were, for the most part, vernacular designers—common people making common things—and their design processes mirrored those of

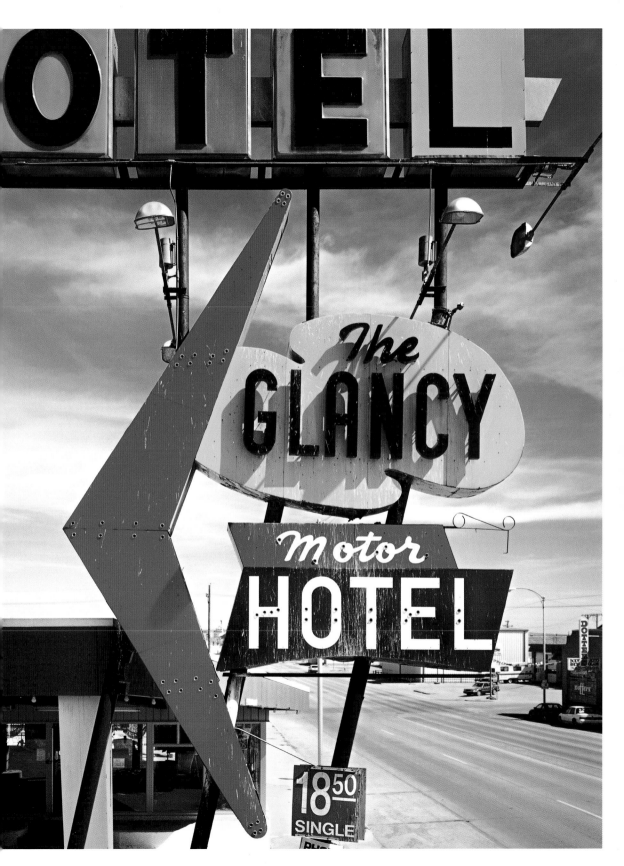

other everyday American designers, such as the builders of barns, simple houses, tools, and other necessary objects. Like many vernacular designers, most signmakers created with the guiding hand of tradition; they incorporated well-known and well-worn patterns of form, material, shape, and symbol to ensure that their signs had meaning and relevance to the people who used them.

Why Signs?

Most simply, signs address basic commercial needs: identifying the name and type of business, marking the location, and attracting customers. But signs also fulfill a more important need: making the unknown familiar. Like nineteenth-century road markers, which provided direction and peace of mind for travelers attempting to orient themselves in the wilderness, commercial signs identify important necessities such as gas, food, and lodging for travelers passing through the roadside sprawl of buildings, directional signs, and parking lots that is, to some extent, the wilderness of the twentieth and twenty-first centuries.

Between the 1940s and the 1970s, signmakers explored different ways to project an image of familiarity to a changing clientele. In the early 1940s, incorporating owners' names on signs made them easily recognizable to local customers. In the 1960s and 1970s, it was repetition, a technique mastered by motel chains, that fostered these associations. The need for such familiarity is pervasive in American culture. In *Common Landscape of America, 1580–1845*, John Stilgoe explored the reasons why Americans were so drawn to traditional constructions. Nineteenth-century Americans, he wrote, "distrusted uniqueness. It mocked the proven American forms and suggested that what was good enough for the typical American was not good enough for its builder."

Signs are interesting not only because they make the unfamiliar familiar but also because they are an essential part of a larger, very sophisticated context that includes other signs, nearby buildings, streets, and even whole towns. They are also influenced by, and sometimes the product of, many different disciplines, from advertising, industrial, and graphic design to architecture and urban planning. As objects, signs are more complex than most. They are three-dimensional and therefore spatial, but they contain two-dimensional symbolic components, including words and illustrations. And signs rely on patterns of form, material, proportion, ornamentation, and symbol to convey meaning to their users. A simple rectilinear sign box painted black and white and without ornament might represent frugality; a star might symbolize quality; and a trendy ornamental detail might create the impression of up-to-dateness. Each of a sign's elements, alone and together, has the potential to convey complex, abstract ideas to those who use them.

A History of Signs and Motels

The American sign has its roots in Europe, in the hanging signboards that marked shops, taverns, and inns from the late seventeenth century on. This signmaking tradition was easily adapted to the New World, where it experienced a gradual buildup of variation over time as folk painters and craftsmen incorporated their own imagery and personal styles. The modern American sign began to emerge in the mid- to late nineteenth century, a time when people were enjoying increased mobility. These signs were designed first and foremost as functional objects. Symbols and illustrations were limited. Unlike eighteenth-century signs, which relied on illustrations to provide information to a mostly illiterate public, late-nineteenth-century signs used words to convey their message. Formally, these signs reflected an economical approach: they were generally rectilinear and symmetrical, painted in a limited palette of colors—often black and white—and they featured basic content such as the name and function of the business, which was rendered in simple, boxy letters. Except for geometric borders or an occasional trendy element, especially in edging details, there were few if any design flourishes.

Signs of the late nineteenth century displayed many of the formal characteristics and underlying patterns of composition that informed the design of other vernacular objects of the period. From the very beginnings of American settlement, vernacular builders had used bilateral, tripartite symmetry as the main formal guide for their structures. "Long before the Virginia farmer started turning the New World's wilderness into material culture," wrote Henry Glassie in *Folk Housing in Middle Virginia*, "[this pattern] had been used in the structuring of artifacts of all sorts. He knew it from furniture and gravestones" as well as houses and barns. Signs were conceived within this shared cultural framework, adapted to the methods and traditions specific to the signmaker's craft.

Signs made during the first decades of the twentieth century continued earlier formal trends: simple, rectilinear compositions suspended outside a business, usually in a downtown business district. The advent of the automobile changed this pattern. Downtowns became congested, encouraging businesses to locate on highway strips. Freed from the spatial confines of Main Street, signs were soon standing on their own, not attached to a building. These roadside signs usually had consistent formal traits regardless of the business they promoted, be it restaurant, grocery, or hardware store.

Motels, however, were different from other businesses because they relied almost entirely on their signs to attract out-of-town customers. The motel industry was born in the mid-1920s with the rise of "tourist camps" catering to auto

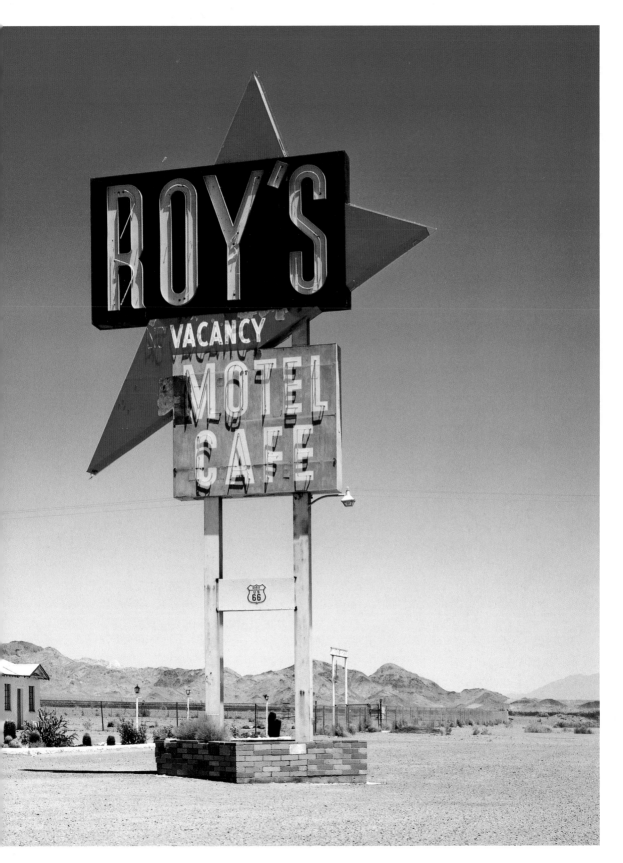

travelers. These camps were established near towns and on popular travel routes; basic amenities such as electricity and central bathrooms and kitchens were provided for a small fee. Private accommodations, however, were not widely available; patrons slept in cars or tents, not buildings. In the 1930s, entrepreneurs began upgrading their facilities to include individual cabins that provided privacy and additional comfort. By the early 1940s, motels like these were appearing along Route 66 and throughout the country. This tremendous growth was due in large part to events of the preceding twenty years: the Great Depression, the rapid expansion of the highway system, and the increased availability of neon. These events also helped to determine signmakers' approaches to conceiving, composing, and producing motel signs for years to come.

Americans continued to drive during the depression, but budget-minded consumers passed up traditional, formal downtown hotels for the savings offered by the new "motor courts" or "auto camps"—complexes of cottages around a common courtyard. (Per room prices were often half of those charged by hotels.) Although business declined slightly during 1932 and 1933, it rebounded the following year and continued to grow through the early 1940s. Motel owners, generally husband-and-wife teams, were nimble and efficient and quickly adapted to customers' changing demands. They incorporated kitchenettes into their cabins, for example, reducing travelers' food expenses. They also provided convenient roomside parking, making bellhops (and tipping) unnecessary. Motor courts were straightforward and approachable, and all of their details conveyed a sense of economy and simplicity.

The Federal Aid Road Act of 1921 brought about a rapid expansion of the national highway system, including the development of Route 66. The highway was given its numerical designation in 1925, and by 1938 the entire road, which ran from Chicago to Los Angeles, was paved. The impact of the highway system on the motel industry was enormous. Older hotels had been built downtown to serve customers arriving by train, but they lacked adequate parking. New motels began to spring up on highway strips, along with other businesses eager to serve travelers. The growth was particularly noticeable on Route 66 because, unlike many of the other new highways, its path did not follow older, extant trails where businesses were already established. Route 66 defined a new territory that tourists and entrepreneurs were eager to explore and shape.

The cultural impact of the new highways was surprising in some ways. When the car replaced the train as the preferred mode of travel, notes Warren Belasco in *Americans on the Road*, it created a symbolic focus not on the future, as might be expected, but on the past. Unlike train travel, cars allowed Americans to recapture the privacy and independence of the stagecoach days,

when an individual could determine when, where, and with whom he or she wished to travel. Trains had curtailed not only the American desire for independence—because of rigid schedules and routes—but also development outside the urban areas they served. The stagecoach analogy was not lost on motel owners and signmakers, who incorporated colonial and Western symbolism into their signs and architecture.

Another event that affected the motel industry, especially as it related to the design of motel signs, was the increased availability of neon. Although it was first used on a sign in Paris in 1921, neon did not become affordable or widely available in the United States until the early 1930s. Along with the new highway system, neon helped provide safe nighttime travel, in effect extending the distance a driver could travel by extending driving hours. Signmakers were quick to incorporate neon into their signs; nevertheless, the new technology did not immediately cause a fundamental shift in how signs were conceived: it was initially used simply as a more efficient method of illuminating borders and letters. Still, its formal contribution was significant. The technology provided a new way of dispersing light; the transformation from light as a point in space to light as a line in space created the possibility for more fluid compositions.

Tradition

An understanding of historical and cultural developments can provide insight into why signs appear the way they do; the corollary is also true. Signs, like other man-made artifacts, represent a concrete, physical manifestation of an idea held in the mind of the maker. In this sense, signs can reveal the beliefs and values of the men who made them. Innovations or mutations to existing patterns of sign composition generally represent other, larger changes—economic, political, or social—occurring within the culture. For example, a particular sign's configuration or ornamentation might convey a heightened connection to nature, a proclivity toward frugality, or racial fear and mistrust. In order to measure and understand these changes, however, it is important to begin from a period of relative stability. Establishing what is traditional is a prerequisite for trying to understand changes occurring over time.

A tradition is something that is handed down or transmitted from the past to the present. Traditions provide chronological and cultural continuity. Without them, it would be difficult to read or understand the constructed landscape. And tradition and the vernacular go hand in hand—most vernacular objects are traditional. Because such objects are ordinary and common, their designers address the needs and expectations of the community rather than their own. Thus vernacular objects—motel signs, churches, or grain elevators—are excel-

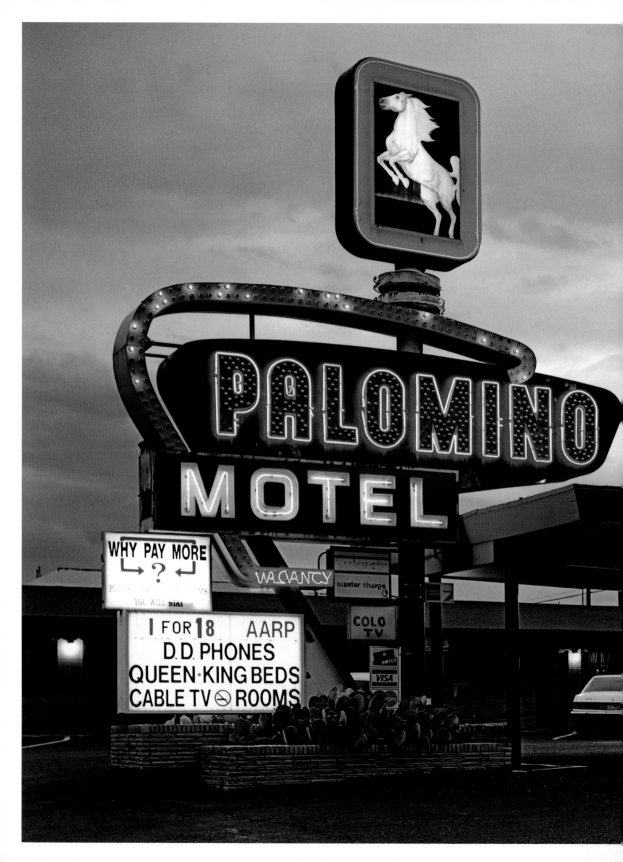

lent indicators of widely held cultural beliefs. In contrast, professionally designed objects are often more representative of the idiosyncrasies and personal taste of their makers. Additionally, the design process is inherently different for a vernacular designer than for a professional designer. "In order to understand the folk design method," Thomas Hubka writes in his essay "Just Folks Designing," "one must understand how…forms are generated within a system of thought dominated by tradition. By working within the tradition the folk designer explores a much narrower design field than a [professional] designer, but he is no less creative."

Signmakers who build traditionally do not replicate previous examples; rather, they reenact familiar patterns within well-defined boundaries. In this way, traditions are extremely flexible: they offer the possibility for a multitude of responses. The basic geometric building block of a traditional sign, for instance, is the square. But while one signmaker might build a sign box that is one square high and two squares wide, another might make one that is one square high and three squares wide. (The signmakers might also make small additions to or subtractions from their basic rectangle, though they would stop short of altering the overall shape.) Although the two signs have different shapes, both are based on a traditional pattern. A new sign can be constructed that is unlike any existing sign but that still contains the particular patterns of other signs. It is this pattern that becomes tradition, not the actual reenactment.

The transmission of knowledge from past to present creates a cultural foundation that connects one generation to the next. It also helps bind individuals to their communities by establishing commonly held beliefs and values. Business owners in a particular town may exhibit a preference for vertically oriented signs over horizontal ones. By choosing to build in a preferred manner, the signmaker in effect agrees to adhere to rules already deemed acceptable by the community. This is a primary reason why a signmaker chose to build traditionally: it reinforced his bond with the community while also ensuring that his sign was understood by its members. Economics also provided an enticing reason: signmakers who did not build traditionally ran the risk of receiving less business; potential clients might perceive them as outsiders.

The signmaking tradition—like other vernacular design traditions—guides rather than prescribes. Signs do change over time, and some incorporate new, innovative elements. But the presence of something new does not mean that the sign ceases to be traditional. All traditions evolve, though the change must be gradual, with slow adoptions of successful innovations. As long as essential patterns are unchanged, a tradition remains intact. It is always important to question whether new elements on a sign are superficial decoration; small, beneficial innovations; or departures from the essential characteristics of the tradition.

The outside influences most likely to alter a tradition are the ones that address a problem that many signmakers are attempting to solve. One of the most enduring issues facing twentieth-century signmakers was how to make their signs appear new and up-to-date but not unfamiliar. Sometimes sign–makers found solutions by adjusting or improving on standard techniques or forms, but often they looked toward external sources and styles—Art Deco and Streamline, for example—which were assimilated and reintroduced on signs as superficially applied ornament, often visible in sign-box edging details or lettering styles. Occasionally, outside styles did alter the fundamental appearance of a sign, as Abstract Expressionism, with its asymmetrical, irregular forms, did during the 1950s. But because of the movement's emphasis on personal expression and the complete abandonment of traditional form, it had little longevity. Tradition rarely accommodates such drastic shifts in method.

Traditions can continue uninterrupted for long periods of time, fade in popularity and later resurge, die out, or remain active in small pockets. Occasionally a fashion or trend becomes a tradition, but more often it is indicative only of its time, with little applicability to the past or future. For various political, economic, and social reasons, some periods tend to be more sympathetic to the past and others to the future. During more conservative periods, signmakers tended to look toward the past for inspiration and were therefore more likely to maintain their traditions. The reverse is also true: during more progressive periods, signmakers imagined the future, abandoning the safety that tradition provided.

Traditions are flexible, but only to a point. Inventiveness that originates from an individual's familiarity with the tools, processes, and materials of his or her discipline can add to a tradition as it changes it, while more superficial innovations soon disappear. When plastic became widely available during the early 1960s, for example, signmakers began to use prefabricated letters instead of hand-painted ones because they were economical and easy to apply and the letter forms were extremely precise. Plastic letters allowed signmakers to create perfect geometric forms, a feat that was difficult to achieve by hand. So this evolution of material, form, and technique fit into signmakers' traditions. On the other hand, if the essential patterns that define signmaking traditions are rejected—such as during the early 1950s, when rectilinear forms were abandoned for asymmetrical ones purely for the sake of being different—the delicate balance between allowable innovation and long-term community acceptance is eroded. Usually such innovations persist for very short periods, as trends or fads, and then traditional methods return to favor.

Signmakers who questioned the pertinence of past traditions, such as the traditions of the 1950s, attempted to create and use new symbols that were personally rather than communally expressive. "The most recent form of origi-

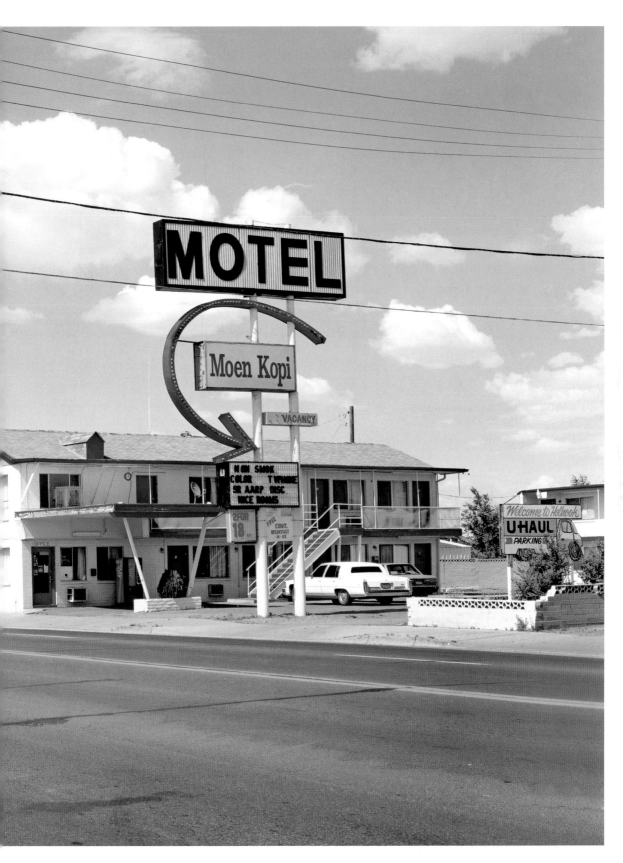

nality," writes sociologist Edward Shils in *Tradition*, "seeks not originality of achievement but originality of being." Signmakers had been among the most traditional of designers, so when their clients began requesting unique symbols and patterns on their signs during the 1950s, they acquiesced, but with increasing anxiety. Without a foundation, they were at a loss for ideas for motel owners who wanted signs that stood apart from the competition and the past. An article in the trade journal *Signs of the Times* offered suggestions for generating designs; it suggested a signmaker "fold a piece of white paper and then put a little ink or paint near the crease and fold again. Open it and you have a design." Or "crumple a piece of paper and hold it under a light bulb, and the shadow will give you an original shape to trace with a pencil."

Ultimately, few signmakers adopted these methods. Instead, their idea of originality emerged from what tradition was not. Asymmetrical, irregular signs were unique, but exactly opposite traditional symmetrical, regular signs. In this sense, signs were still defined by tradition. Yet the formal and conceptual shift was abrupt. By focusing solely on creating original compositions, signmakers severed their historical ties, which left them feeling isolated and with little connection to anything except the moment. As Shils has observed, people without an image of their ancestry "lose the sense of being members of a collectivity which transcends themselves and which transcends their contemporaries." Without this historical and cultural continuity, there was no incentive for signmakers to create signs that lasted for any significant period.

How This Book Works

Just as new signs were created by recombining existing elements and arranging them into new compositions, the form and content of this book are informed by its predecessors in the field of material culture studies. First and foremost, the book attempts to continue—somewhat loosely—the structuralist tradition of formal analysis as promulgated by Claude Lévi-Strauss and applied by many material culturists, but especially Henry Glassie in his book *Folk Housing in Middle Virginia*. I was particularly interested in Glassie's focus on the process of creation rather than on the classification of types. By analyzing the artifactual grammar—the rules that determine how an object's separate elements are held together—rather than merely comparing one similar object to another, Glassie pinpointed precisely how and why objects changed over time. I have adopted aspects of his methodology in this study.

Another inspiration was Paul Klee's *Pedagogical Sketchbook*. Klee wrote this small book for his students at the Bauhaus, and I found both its analytic rigor and its visual method important. In it, Klee combined the science of rigor-

ous analytic method with a faith in the power of ordinary objects to reveal larger truths. Composed primarily of diagrams and with a minimum of text, Klee set out to discover "the inner essence and form-giving cause" behind common things, both constructed and natural, such as arrows, chessboards, pendulums, plants, and circulatory systems. His analytical method—examining seemingly insignificant common things to attain insight into larger universal orders—seemed applicable to a wide variety of objects, including signs.

Like *Pedagogical Sketchbook*, this book relies on graphic elements—photographs, illustrations, and diagrams—in addition to text. Most studies of three-dimensional form do not include adequate visual documentation, and rarely are graphic elements like diagrams used as primary analytical tools. Books about form that rely primarily on text make it difficult for the reader to visualize the subject, and photographic surveys often lack thoughtful analysis. Although this book is visually based, my intention was to move beyond the outward appearance of signs to an in-depth examination of the patterns that guided their production in order to better understand their development and meaning.

Photographs and diagrams work in consistent ways throughout the book. Photographs show the relationship between the subject and its context, and diagrams help isolate specific information from a larger, complex whole. The graphic layout structures the content and provides a sequence and hierarchy to the elements. The black-and-white reproductions allow for a more direct focus on aspects such as form and style; color images, especially large groups of them, often provide too much visual information.

The book is divided into five chapters, each of which represents a period with consistent patterns for making signs. Although the chapters are ordered chronologically, there is some overlap between them, since different patterns often occurred concurrently. This natural pattern emerged from the material itself. New chapters begin when a change in the intellectual and cultural processes of conceiving, composing, making, and placing signs occurs. Innovations are discussed when they become popular, not when they are first introduced.

Each chapter is structured according to two parallel themes. First, they are organized according to the signmaking process: how signs are conceived, what elements are used, how the elements are composed, and how signs relate to their contexts. Second, each chapter moves from an analysis of the most basic sign components—materials, form, structure, typography, naming conventions, color, and symbolism—to its most complex arrangement—a three-dimensional composition in space—and the place of that object in its larger context.

I evaluated signs collectively and over time in order to discover how the signmaking process changed. By comparing each sign to those that came

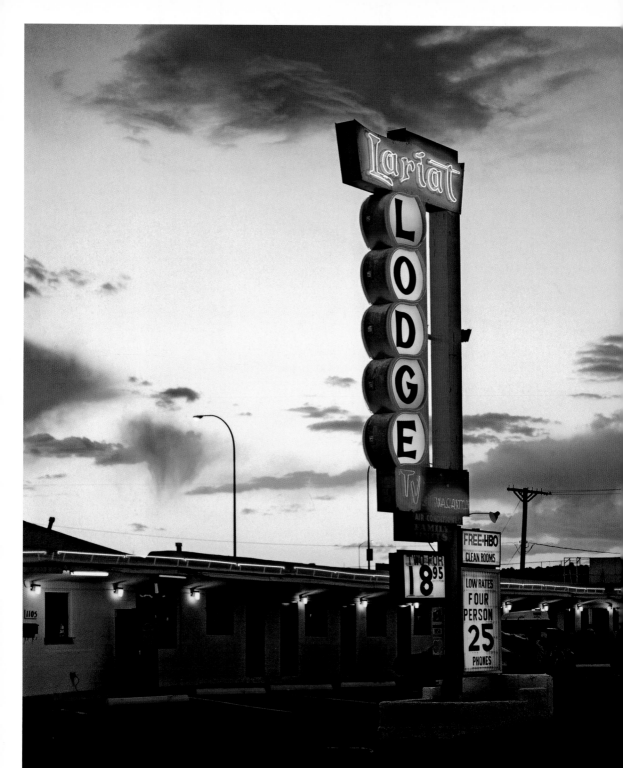

before and after it, it was possible to see how a signmaker's work related to tradition—whether it maintained traditional patterns by repeating them; enriched traditional patterns by introducing innovations that addressed specific problems; or ignored traditional patterns by creating a unique composition. The first circumstance leads to habitual repetition; the second, to lasting and positive change; and the third, to novelty. The comparison of one sign to another revealed conceptual and formal patterns that, when consistent, defined a chapter.

I gathered material for this book in several ways. I photographed as many of the existing motel signs on Route 66 as I could—close to five hundred of them. There were many more new signs standing than old, however, so I began collecting vintage advertising postcards of the motels. Such postcards were extremely popular during the 1940s, 1950s, and 1960s and, with the assistance of collectors, dealers, and eBay, were relatively easy to find. The postcards did more than document early signs; they also showed changes in individual motel signs over time, since new postcards were often printed when improvements to a motel complex were made. I also relied heavily on the industry's monthly trade journals, *Signs of the Times* and *Tourist Court Journal*, to understand trends and signmakers' intentions and to help date the signs I photographed. I approached several sign shops on Route 66 that had been in business between 1938 and 1968, but almost none had documented or archived their work. I also approached motel owners, but except for a few already documented examples, little knowledge about motels' histories has passed on to current owners.

Conclusion

Although signmakers occasionally managed to break away from traditional models, they consistently measured their work in relation to established and accepted rules of form generation. Even in the late 1960s, as new materials, technologies, and business models threatened the validity of traditional design methods and forms, signmakers continued to reintroduce many of the patterns that their predecessors had followed since the late nineteenth century. Throughout most of 1940s and 1950s, transmission by example was of great importance; the men who designed and built signs learned mostly from one another, in part by reading industry journals but chiefly by duplicating and improving on one another's signs. Many attended high school—some attended trade schools—but most learned through an apprenticeship during which technical skills and ideas about form were passed on from one generation to the next. The more experience a signmaker had, the more likely it was that his sign was well crafted, but a proclivity toward simple, symmetrical signs had little,

if any, relationship to technical ability—cultural factors more often determined the particular arrangement of a sign's elements.

A careful examination of signs reveals many things about designers, about tradition, and about the culture in which the signs were produced. But like most studies of material culture, the intent of this book is not to point to clear conclusions about the practice and tradition of designing signs. Rather, it is an attempt to discover the many ways in which collectively held beliefs determine and shape the common objects of everyday life.

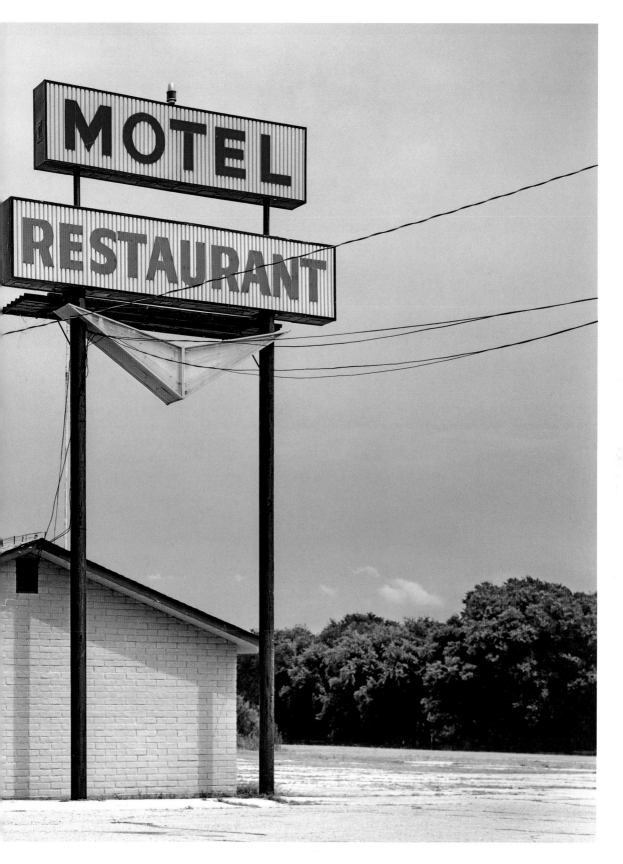

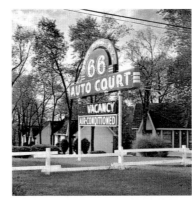
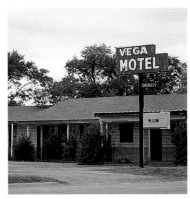
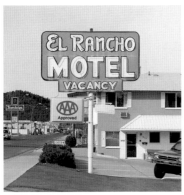
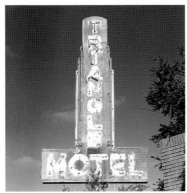

1

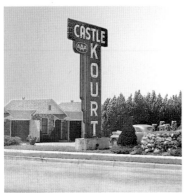
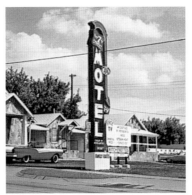
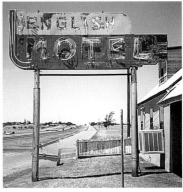

Symmetry, Geometry, Rigor: 1938–1947

Route 66 received its numerical designation in 1926, but it remained unpassable in many places until 1938, when it was fully paved. The completion of the highway resulted in an explosion of new businesses, including motels, which needed signs to identify them. Better engineered automobiles allowed Americans to drive for longer distances and at night, which meant that these signs needed to be illuminated. Although electrified signs existed as early as the 1890s, it was the ready availability of neon during the early 1930s that inspired a new generation of signmakers.

While few people today know who designs commercial signs, during the 1930s and 1940s signmakers were well-known members of the towns they lived and worked in. They took great pride in their products, crafting them from durable materials and designing them with community as well as consumer appeal. As a journalist from the trade journal *Signs of the Times* observed, when a "sign leaves your shop, it is still joined to it by an intangible bond. The sign is a never resting ambassador, showing the lasting beauty and dependability of your work."

Signs of this era were fundamentally traditional—formally consistent with their predecessors and well integrated into the physical and cultural landscape. And while the period was defined by new technologies such as neon, in terms of design signmakers tended to follow nineteenth-century traditions, relying most often on the simple, rigorous geometry of the square.

Signmakers did not, however, blindly follow past precedent. Though they obeyed the traditional formal guidelines of their craft, they also displayed enormous creativity when building new signs. So while there were clear patterns in how they conceived and built signs, no two were exactly alike. "The signs from various shops take on their own individual personalities," wrote signmaker Phil Hammond. "The alphabets, color schemes, designs and methods of prefabrication are all an expression of the men who designed and built them."

Although the motel industry emerged from the Great Depression largely unscathed—customers abandoned pricey hotels for inexpensive alternatives—the hardships of the time were severe and enduring for most Americans. Motel owners and signmakers built economically not only because tradition dictated it but also because the times demanded it. Customers spent conservatively and expected the motels they frequented to convey frugality. The materials restrictions brought on by World War II reinforced this tendency: during 1942 and 1943, signmakers were forced to repair or update older signs rather than replace them.

Concept

Signmakers working during the first half of the 1940s drew their inspiration for new signs from traditional forms and common knowledge. This knowledge, which consisted of local customs, such as the use of specific colors or typestyles, as well as national traditions, such as the use of geometric forms arranged symmetrically, functioned as form-generating guidelines that, in effect, predetermined the manner in which signmakers conceived, composed, and produced their signs. As a result, signs were outwardly varied but fundamentally consistent. Occasionally, unique elements such as rounded or stepped edges were added, but only for decorative effect; rarely did they violate the spirit of the traditional aspects of the sign.

1.1 > INFLUENCES/SOURCES

Signmakers gathered inspiration from several places when creating a new composition. First, they looked to their own and local competitors' existing work; signs close to each other often displayed similar formal characteristics. Other makers' designs were never replicated exactly, however; individual signmakers often had preferences for certain color combinations and lettering styles.

Second, signmakers looked at structures in their communities in order to create signs that were formally compatible with the buildings they were next to or near. In general, the traditional patterns that dictated how signs were designed, such as symmetry and the use of the square as a geometric building block, were the same ones that determined the appearance of houses, churches, and other vernacular structures.

Third, signmakers studied local features such as the physical aspects of the site, local landmarks, and indigenous plants and animals, particularly for naming inspiration. Motel names such as "Twin Oaks" and "Sage Brush" were inspired by natural examples.

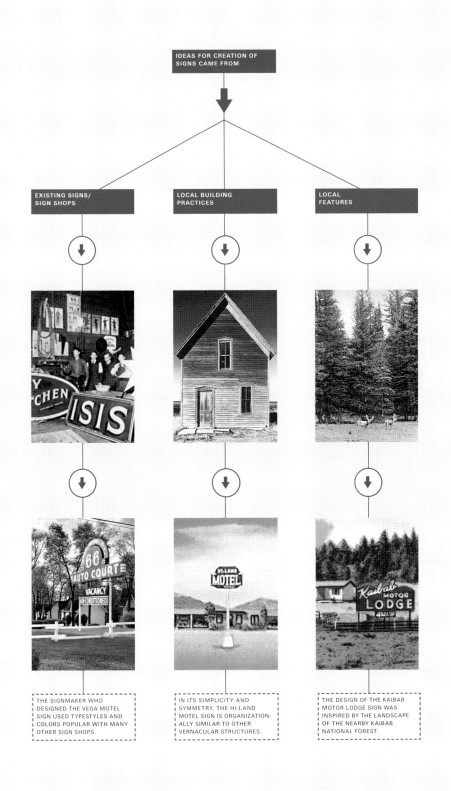

IDEAS FOR CREATION OF SIGNS CAME FROM

EXISTING SIGNS/ SIGN SHOPS

LOCAL BUILDING PRACTICES

LOCAL FEATURES

THE SIGNMAKER WHO DESIGNED THE VEGA MOTEL SIGN USED TYPESTYLES AND COLORS POPULAR WITH MANY OTHER SIGN SHOPS.

IN ITS SIMPLICITY AND SYMMETRY, THE HI-LAND MOTEL SIGN IS ORGANIZATION-ALLY SIMILAR TO OTHER VERNACULAR STRUCTURES.

THE DESIGN OF THE KAIBAB MOTOR LODGE SIGN WAS INSPIRED BY THE LANDSCAPE OF THE NEARBY KAIBAB NATIONAL FOREST.

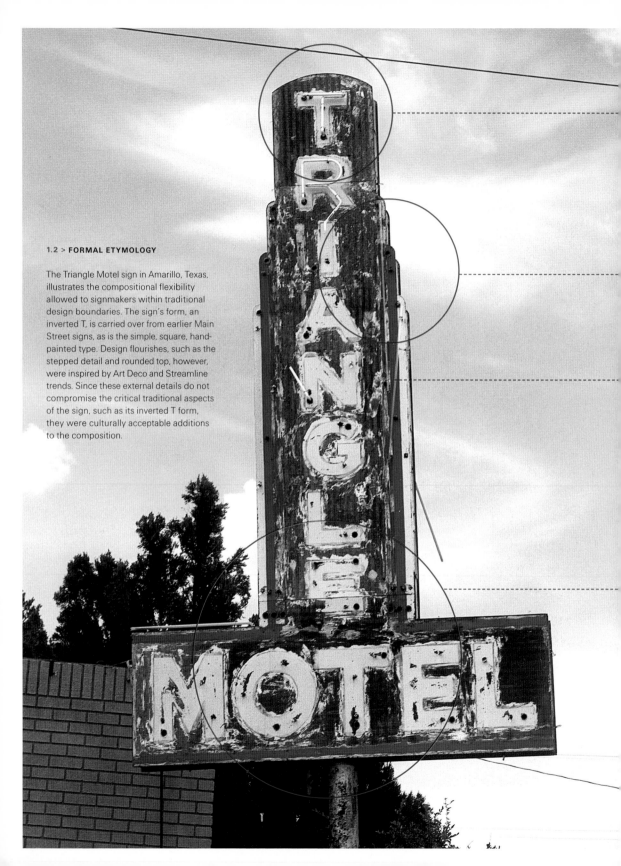

1.2 > FORMAL ETYMOLOGY

The Triangle Motel sign in Amarillo, Texas, illustrates the compositional flexibility allowed to signmakers within traditional design boundaries. The sign's form, an inverted T, is carried over from earlier Main Street signs, as is the simple, square, hand-painted type. Design flourishes, such as the stepped detail and rounded top, however, were inspired by Art Deco and Streamline trends. Since these external details do not compromise the critical traditional aspects of the sign, such as its inverted T form, they were culturally acceptable additions to the composition.

Signmakers at times incorporated stylistic details that were external to local traditions, but only when those elements addressed specific problems, such as making a sign appear technologically progressive. It was also imperative that external styles were incorporated without denying the basic rules of form generation. At the Triangle Motel, the curved sign top, a Streamline flourish, was added because it made the sign appear modern. But this did not violate the sign's underlying geometry, so it appeared modern in a culturally acceptable way.

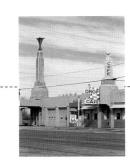

The geometric flourishes near the top of the sign are typical of the stepping detail common to Art Deco objects of the period. (The buildings shown here are located on Route 66 in Shamrock, Texas.) Like the Streamline details, they were used to make the sign appear more up-to-date. The geometric precision of Art Deco was entirely consistent with the signmaker's desire to create a geometric composition and, as a result, was extremely popular.

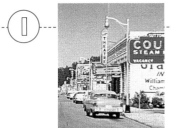

Because of space limitations, Main Street businesses, such as these in Williams, Arizona, often used thin vertical signs attached to the facade or an armature on the roof. The change in context from downtown to highway had little effect on the way signs were conceived and built. The Triangle Motel's modified T form, for example, is carried over from Main Street precedents.

The letters on the Triangle Motel sign are simple and geometric, much like the sign's other components. They are sans serif, squarish in proportion, and consistent with type treatments on traditional pre–World War II signs. Square letters made it easy to display type vertically or horizontally.

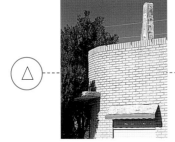

Local identifiers such as indigenous plants and unique landscape features were often used in defining the identity of a motel. In this example, the name of the motel, Triangle, reflects the unusual form of its site: the diagonal intersection of two streets on the outskirts of Amarillo. The motel itself reflects this shape in its plan.

Components

Signmakers rarely strayed from the materials and forms they were already accustomed to using, which usually reflected local customs and building practices. Signs were composed from basic geometric components made of simple materials. The underlying geometry of the square informed all aspects of a sign's composition, determining everything from the shape and size of its box to the form of its letters.

**DEWEY GRAIN ELEVATOR,
ROSLYN, NORTH DAKOTA: PLAN**

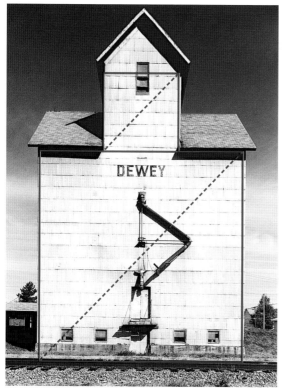

1.3 > MATERIALS

Sign boxes were constructed of galvanized steel. Although materials were less important than local traditions in deciding a sign's overall form, the proportions of commercially available steel were still important in the design process. Before about 1940, the dimensions of the steel sheets used in the construction of signs were determined by the yardstick, then the standard tool for measurement. Steel sheets were divisible by a yard in both length and width and could be split into four separate squares.

By the early to mid-1940s, the six-inch steel rule replaced the yardstick as the measurement tool of choice as new steel sheets divisible into six-inch increments were introduced. Even so, the four-square proportion remained; this practice continued to impose a geometric rigor on signs' overall form not because the material dictated it but because signmaking tradition did.

The use of the square as a compositional organizer was a large-scale cultural tradition that helped determine the form of other American constructions, regardless of region or material. It structured both the plans and elevations of wood buildings from the period, including barns, grain elevators, and other functional structures.

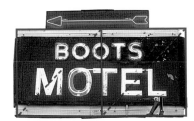

BOOTS MOTEL SIGN, CARTHAGE, MISSOURI:
AN EXAMPLE OF THE 1:2 "SUITCASE" SIGN BOX

36" X 144" STANDARD GALVANIZED-STEEL CONFIGURATION, DIVISIBLE BY A YARD, PRE-1940

30" X 120" STANDARD GALVANIZED-STEEL CONFIGURATION, NOT DIVISIBLE BY A YARD, POST-1940

24" X 96" STANDARD GALVANIZED-STEEL CONFIGURATION, NOT DIVISIBLE BY A YARD, POST-1940

Although signs from the early and mid-1940s consistently adhered to strict principles of geometric ordering, their designs were varied. Most sign boxes from this period were either rectangular or a variation of the traditional T form, and almost all were developed from the basic square building block. The most common configurations of sign boxes were T forms, rectangles of 1:2 proportion, and variations on these layouts, all of which were considered standard as early as the first decade of the twentieth century.

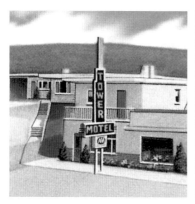

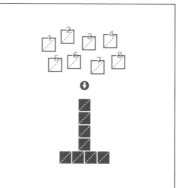

Although the square was a rigid compositional guide, it allowed the signmaker considerable leeway in developing new variations on tried and true configurations, such as the inverted T form in the Tower Motel sign in Santa Rosa, New Mexico, which was more stable than a freestanding T form. Innovations also came from the incorporation of stylistic influences such as the Streamline trend, seen here in the rounded detail on the sign box. Even with such borrowed elements, the use of the square building block ensured that the sign would maintain a traditional appearance.

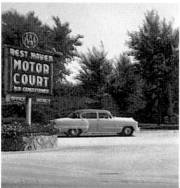

The Rest Haven Motor Court sign in Springfield, Missouri, is an unusual example of a perfectly square sign. Even though the square dictated the form of most sign boxes, it was rarely used in its pure form.

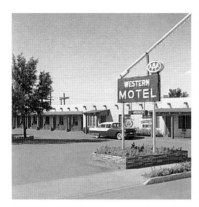

The Western Motel sign in Holbrook, Arizona, is an example of a 1:2 rectangular "suitcase" sign box—a form common since the turn of the twentieth century. The two different type treatments differentiate the name from the function.

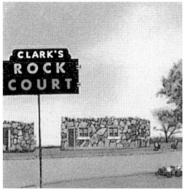

The Clark's Rock Court sign in Lebanon, Missouri, is a variation on the 1:2 "suitcase" sign box. Here an additional horizontal panel projecting from the top of the main box serves as a location for part of the business name.

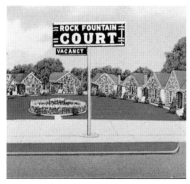

Slightly elongated, the 1:3 sign box at the Rock Fountain Court in Springfield, Missouri, allows for a longer business name. Additional elements such as the "vacancy" sign are treated as separate components.

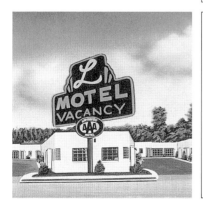

The L Motel sign in Flagstaff, Arizona, is a 1:3 sign box with an additional square on top. Moving the name up provided additional space in the lower rectangle, where both name and function traditionally fit, to include "vacancy." The AAA designation was a separate element.

Although the square-based, modified T forms and rectilinear "suitcase" sign boxes were the most common forms for signs from the late 1930s through the late 1940s, there were also examples generated from another geometrically pure form: the circle. The shape would probably have enjoyed greater popularity if not for the difficulty of hand-cutting it out of metal; in addition, the circle worked well only when the words, numbers, or illustrations placed within it were short and symmetrical. At the turn of the twentieth century, the circular shapes placed at the top of vertical signs generally contained a star, but most 1940s signmakers used the space in a more functional way: to identify the business. Like the square, the circle was rarely used alone. Instead, it was usually treated as an addition to a traditional square-based sign box.

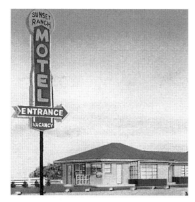

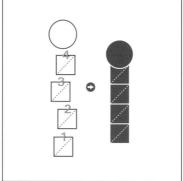

The Sunset Ranch Motel sign in St. Louis, Missouri, is a variation on the inverted T form, with the arrow serving as the horizontal part of the T. The circle may not have been the best choice for this particular configuration, since business names were difficult to integrate into the shape's limited area. The smaller name also caused a shift in the traditional hierarchy of the sign's content, placing a much greater emphasis on the function, "motel," than on the name, "Sunset Ranch."

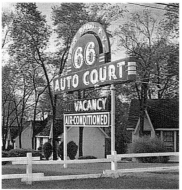

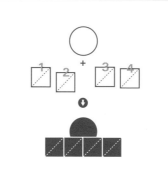

The 66 Auto Court sign in St. Louis, Missouri, dates from the early 1940s, as evidenced by the rounded, Streamline corners and the use of "auto court" rather than "motel." The name, "66," is appropriately short and symmetrical and fits easily within the circular form.

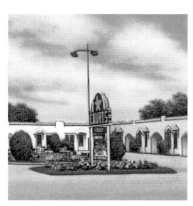

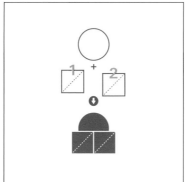

The substitution of a symbol for the written word for the business name in this sign for the Star Courts Motel in Elk City, Oklahoma, is unusual. But as in other successful iterations of the circular sign, the symmetry, brevity, and uniformity of the star shape made it easy to incorporate into the form.

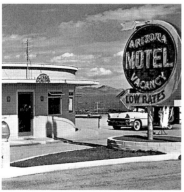

The Arizona Motel in Kingman, Arizona, is a rare example of a pure circular sign box. In addition to the difficulty in producing this form, it resulted in a waste of material and an inefficient use of space for placing copy. Most motel sign content—name and function—required a wider rather than a taller configuration. The circle necessitated the insertion of additional content for the sign to appear fully utilized. The circular form mimics the curved elements of the adjacent building.

The square provided the geometric
foundation for most sign configurations
during this period.

The circle was a secondary geometric component and was used primarily as a form to place the motel name on.

It was more important for a sign to appear geometrically pure than it was for it to actually be so. Signs' hand-painted letters and forms were made to seem perfectly square even though often they were not. Even in much earlier examples, such as nineteenth-century inn signs, the importance of projecting an image of replicability and precision was apparent. In one recent study of eighteenth- and nineteenth-century tavern and inn signs from Connecticut, less than two percent of the examples had traces of freehand drawing. The others displayed evidence of "various reproductive aids, either templates or mechanical devices such as pantographs." Despite the fact that neon's flexibility allowed for script and more stylized type treatments, letters during the 1930s and 1940s were usually sans serif, all capitals, and square, and strokes were of uniform dimension.

The transition from light bulbs (points of light) to neon (lines of light) occurred during the late 1920s and early 1930s and had a tremendous impact on how letters were perceived at night. Like many new technologies, however, neon did not immediately change how type was conceived and executed. "Creative exploration with the luminous tube for the first several years of its popularity was limited to illumination qualities," wrote a reporter for *Signs of the Times*. "Sign shape was not noticeably altered." Although neon tubing allowed for a fluidity of form that would simplify the execution of script, signmakers continued to use sans serif block type because tradition dictated it. It was not until the late 1940s, when there was a distinct shift in how signs were conceived, that neon was finally used to its full technological and aesthetic capacity.

It was important for signmakers to be up-to-date in terms of materials and building techniques. Customers expected to encounter the newest technologies and were wary of motels that looked old. It was even more important, however, for signmakers to maintain the geometric ideal of the pure square, and they rejected the formal freedom neon provided to do so. The letters used on the OK Motel sign are typical of the period and consistent with earlier examples: they are uppercase, with a regular and square proportion, and sans serif, with uniform stroke widths. As with the construction of sign boxes, it was not important for all of the building blocks to be of the same dimension as long as they were square.

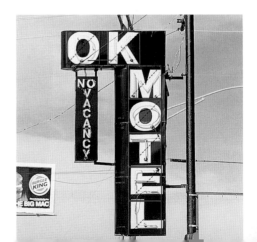

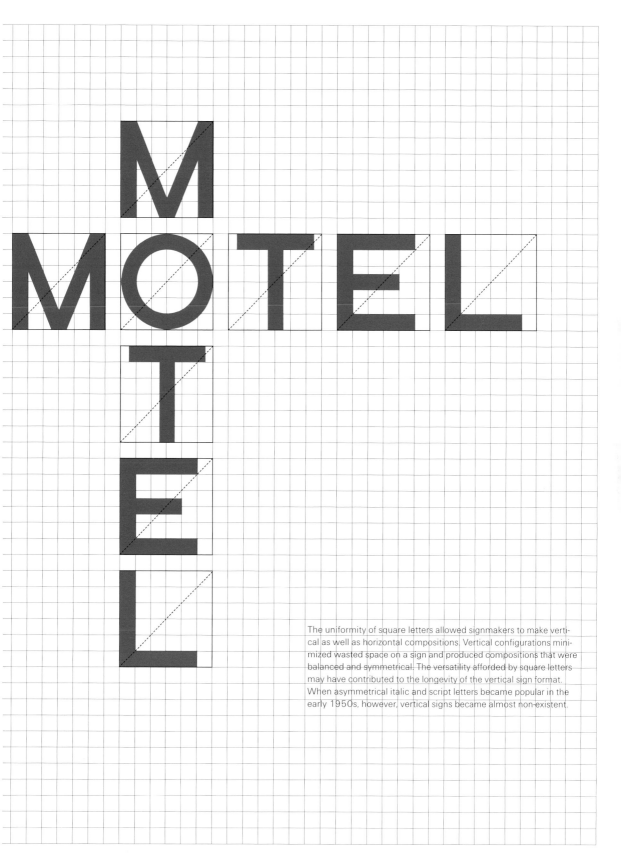

The uniformity of square letters allowed signmakers to make vertical as well as horizontal compositions. Vertical configurations minimized wasted space on a sign and produced compositions that were balanced and symmetrical. The versatility afforded by square letters may have contributed to the longevity of the vertical sign format. When asymmetrical italic and script letters became popular in the early 1950s, however, vertical signs became almost non-existent.

DAY

M

Behind a sign's neon tubing, letters were painted in light colors and sometimes outlined in a bright or darker color to emphasize their form and geometry. During the day, the crisp painted outlines of the letter forms were clearly visible against the contrasting background, usually a light color against a dark one. Neon tubes, although transparent, added dimensionality to a sign, especially in strong sunlight when shadows were cast by the tubes.

NIGHT

Neon was used primarily to outline letters and occasionally to define the outer edge of a sign box. It radically affected the perception of the letters by softening the geometric rigidity of the letter forms. Neon also altered the perception of a sign box at night: by emphasizing the letters, the overall form of the sign was visually diminished.

Owners' Names

SMITH BROS. MOTEL
COOK'S COURT
JIM DOUGHERTY'S COURT
FINN'S MOTEL
LEONARD'S MODERN MOTEL
DUKE'S CABINS
BAILEY'S MOTEL
ED'S CAMP
CLARK'S TOURIST CAMP
OTTO'S MOTEL COURT
WHITT'S MOTEL

Town Names

VEGA MOTEL
EL RENO MOTEL
AMARILLO MOTEL
KINGMAN MOTEL
HOLBROOK MOTEL

Local Features

TWIN OAKS COURT
FOREST MOTEL
ROCK VIEW COURT
CANYON LODGE
KAIBAB MOTOR LODGE

Motel names of the 1940s tended to fall into one of three categories: names of owners, town names, and unique local features. Using the owner's name conveyed his or her position within the community. "The electric sign should advertise the name of the business," advised signmaker Paul Fritsch. By choosing their own name to identify their businesses, motel owners conveyed both personal responsibility and pride in the services they sold. The use of first and last names suggested a familiarity with one's neighbors.

Also common were names based on the motel's location, either towns or prominent elements found on or around the motel site, such as specific flora or geographic features. "In naming a court," urged a writer for the *Tourist Court Journal* in 1945, "try to incorporate the name of the city in which it is located if at all possible." Specimen trees and the site's terrain also inspired many motel names during this period. All three types of names supported the motel's somewhat contradictory status as both a unique, one-of-a-kind business and a familiar, comforting place to stop for the night.

Early motels of the 1920s were referred to as "camps," reflecting the fact that customers slept in tents rather than rooms. As owners began building permanent structures in the mid- to late 1930s, the nomenclature shifted to "cabins" and also to the quaint "cottages," as the Colonial Revival took hold. When that style fell out of favor during the early 1940s there was a shift toward more modern terminology. "Court" became the most popular term, reflecting the U-shaped organization of many motel complexes, though this was eventually eclipsed in the late 1940s by the more generic "motel" (motor + hotel).

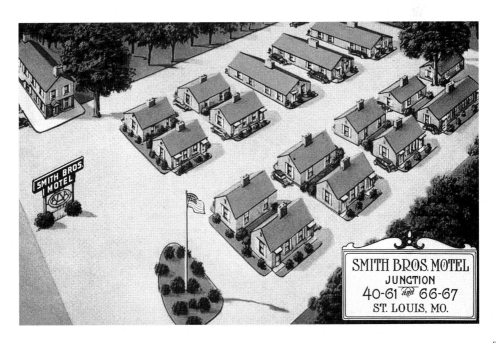

Color choices rarely reflected a sign's content, since motel names, generally identifying people or places, did not suggest any particular color. Instead, neutral and subdued colors were used to ensure that signs would blend in with their natural and man-made landscapes. Black and muted variations of blue, green, and red were commonly used for backgrounds, while white and cream were the most popular colors for type. The use of light-colored letters ensured that neon light would adequately reflect off the sign's surface at night. Conversely, dark-colored backgrounds helped to reduce reflection and light spread.

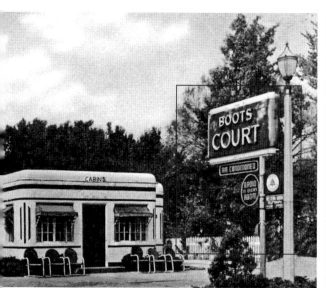

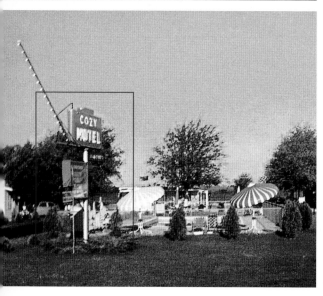
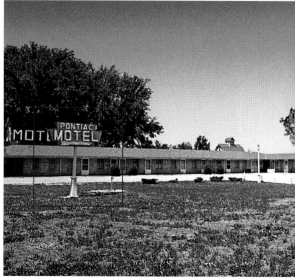

Because the sign industry's trade journals were published in black and white until the early 1960s, signmakers had a particularly well-developed language for color. Published photographs of signs were often accompanied with detailed descriptions of color use. During the early to mid-1940s, color names consistently described natural things—animal, vegetable, or mineral in a pure state—such as "fawn," "lemon," or "slate." Although many of the natural things referred to were not found locally, color names did convey a connection between the signmaker and the natural environments he placed his signs in.

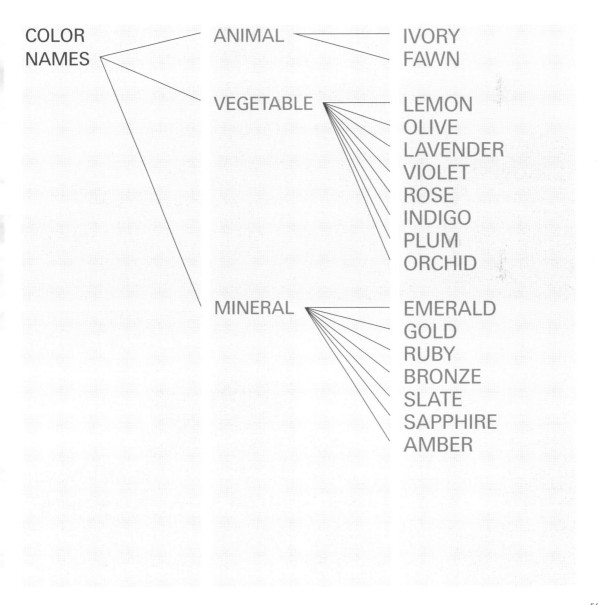

COLOR
NAMES

ANIMAL
 IVORY
 FAWN

VEGETABLE
 LEMON
 OLIVE
 LAVENDER
 VIOLET
 ROSE
 INDIGO
 PLUM
 ORCHID

MINERAL
 EMERALD
 GOLD
 RUBY
 BRONZE
 SLATE
 SAPPHIRE
 AMBER

Although the period from 1938 to 1947 is defined primarily by its adherence to local customs and practices, a number of external trends infiltrated the signmaking tradition. Each of these styles—the Colonial Revival, Art Deco, Streamline, and the International Style—provided answers to problems signmakers were already attempting to solve, such as how to make a sign feel up-to-date or geometrically rigorous.

Stylistic trends were often more alluded to than wholly incorporated. Most often the added elements affected the appearance of the sign's borders, but occasionally signmakers went so far as to add illustrations or script. In the 1930s and early 1940s, symbols of colonial America, such as images of stagecoaches and lanterns and the use of colonial names, began to appear on motel signs. This trend in symbolism was a direct result of the boom in automobile travel. Cars allowed Americans to determine where they wanted to go, when they wanted to leave, and with whom they wanted to travel. As Warren Belasco notes in his book *Americans on the Road*, driving a car was a rejection of the restrictions of trains and, by extension, modern America in favor of the freedom of the open road, a freedom that harked back to the American Revolution.

❶ Colonial Revival

The Colonial Revival movement became popular at the end of the nineteenth century and enjoyed several waves of fashion through the 1950s and beyond. Colonial symbols—pediments and columns—were applied to architecture as well. Colonial imagery, especially the use of stagecoach illustrations on signs, emphasized the new freedom afforded by the automobile.

❷ Streamline

Although the Streamline style has some similarities to Art Deco, especially in its machinelike qualities, it can be differentiated by the rounded contours that were initially designed to minimize resistance to air or liquid. The style was originally applied to planes, trains, and automobiles, but by the 1930s and 1940s it was being used for all types of consumer products, from toasters and chairs to signs.

❸ Art Deco

The Art Deco movement originated in Europe during the mid-1920s and was integrated into the American vernacular during the 1930s and 1940s. The style's distinguishing characteristics include simple, clean shapes and ornament that is geometric or stylized. Although Art Deco objects were rarely mass-produced, they reflected an admiration for the inherent qualities of machine-made objects, such as symmetry, planarity, and the unvaried repetition of elements.

❹ International Style

The International Style was developed by European architects during the 1920s and 1930s and gained popularity in the United States soon after. International Style architecture was rectilinear, geometric, and stripped of all decoration. The style had its origins in American vernacular forms such as grain elevators, factories, and other mass-produced objects, and for this reason, signmakers felt comfortable integrating its language into their signs.

COLONIAL SYMBOLS REFERRED BACK TO THE "STAGECOACH" DAYS, WHEN TRAVELERS COULD JOURNEY WHEN, WHERE, AND WITH WHOM THEY WISHED.

COLONIAL REVIVAL
REPRESENTED:
PRIVACY
INDEPENDENCE

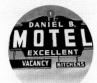

COLONIAL NAMES AND TRADITIONAL DESIGN DETAILS HELPED TO CREATE A CONSISTENT AND UNIFIED COLONIAL THEME.

SIGNMAKERS USED STREAMLINE DETAILS TO MAKE THEIR SIGNS LOOK MODERN.

STREAMLINE
REPRESENTED:
REPETITION
SIMPLICITY
UP-TO-DATENESS

ROUNDED CORNERS WERE APPLIED TO SIGNS TO MAKE THEM APPEAR TECHNICALLY PROGRESSIVE THROUGH AN ASSOCIATION WITH MACHINELIKE FORMS.

THE INCORPORATION OF ART DECO DETAILS ALSO MADE SIGNS APPEAR UP-TO-DATE, SINCE THEY ALLUDED TO MACHINE-MADE FORMS AND CURRENT DESIGN TRENDS.

ART DECO
REPRESENTED:
GEOMETRY
REPETITION
UP-TO-DATENESS

STEPPED EDGES WERE READILY ACCEPTED INTO THE SIGNMAKER'S VOCABULARY SINCE THEY HIGHLIGHTED AND AUGMENTED THE GEOMETRIC QUALITIES OF A SIGN.

INTERNATIONAL STYLE FORMS WERE ADOPTED BECAUSE THEY WERE SIMILAR TO AMERICAN VERNACULAR FORMS—GEOMETRIC, RECTILINEAR, AND STRIPPED OF ORNAMENTATION.

INTERNATIONAL STYLE
REPRESENTED:
REPETITION
SIMPLICITY
UP-TO-DATENESS

INTERNATIONAL STYLE FORMS PROVIDED A SOLUTION TO A TRADITIONAL PROBLEM: HOW TO CREATE A SIGN THAT WAS REPETITIVE, GEOMETRIC, AND TECHNO-LOGICALLY PROGRESSIVE.

Composition

During the 1940s, the rules that bound the individual components into a sign were, like the components themselves, rigid and consistent. The most individual component of the sign, the business name, took precedence over the function. Compositions were usually symmetrical—as they had been since before the turn of the century—and content was kept to a minimum, in part to ensure the sign's longevity.

1.10 > CONTENT HIERARCHY

The name of the business was of primary importance regardless of the shape of the sign, and it was consistently placed above the function. This arrangement stressed the unique aspects of the business rather than identifying its function.

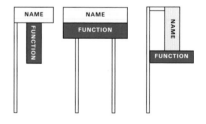

Owners counted on the longevity of both their businesses and their signs, which in turn determined the content included on them. By identifying only the name of the business and its function, motel signs remained useful as long as the owner did not sell the business. Temporary or secondary information, such as pricing, specials, or affiliations, was placed on separate signs that could be easily replaced or updated. These smaller signs were usually attached to a nearby supporting structure, as seen at the Kingman Motel in Kingman, Arizona. If they were attached to the main sign, they were visually treated as separate from the geometry of the sign box.

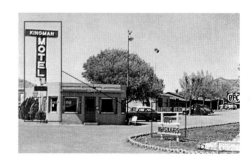

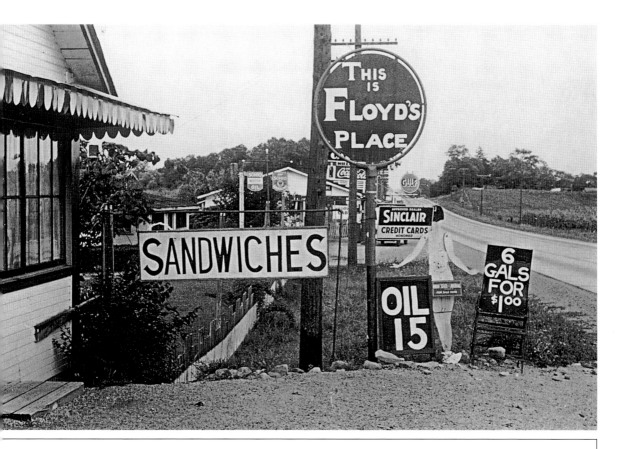

Floyd's familiarity with his clientele is implicit in his decision to forgo any indication of his type of business on the main sign. Although not a motel, this example underscores the importance of placing variable content—price, specials, and the like—on less permanent signs.

PERMANENT SPACE

FLEXIBLE SPACE

FLEXIBLE SPACE

FLEXIBLE SPACE

FLEXIBLE SPACE

SIGNS WERE DIRECT, SIMPLY ORGANIZED, AND EASY TO READ

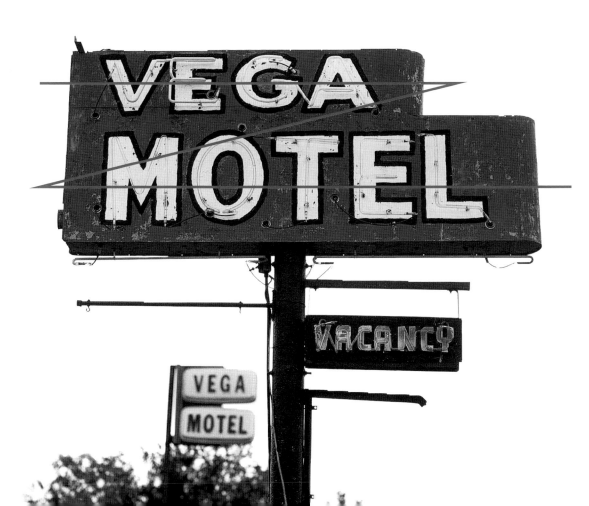

1.10 > CONTENT HIERARCHY

The use of simple forms, uniform lettering, and minimal content arranged symmetrically resulted in signs that were easy to read and understand. Content was organized so that the eye could absorb it quickly and economically, as shown in these diagrams, redrawn from the trade journal *Signs of the Times*.

Signs displayed the same traditional patterns of symmetry as those found in vernacular structures of the period. The square was the form generator for the different elements of a sign; symmetry was the glue that bound those elements together. All aspects of a sign's composition, including its shape and type treatment, emphasized a rigid adherence to geometry, regularity, and symmetry.

HI-LAND MOTEL, FLAGSTAFF, ARIZONA

HOUSE

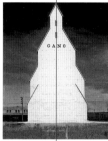

GRAIN ELEVATOR

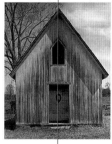

MEETING HOUSE

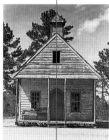

CHURCH

The proclivity for symmetrical compositions was so ingrained that, in this general store, signs were placed symmetrically even though it meant unnecessary duplication. It was more important that the building and signs presented a symmetrical image than that they served the purely functional need of conveying information.

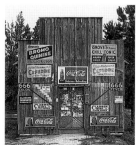

Context

During the 1940s, signs were seamlessly integrated into their cultural and physical contexts. "If I have to erect a sign," noted signmaker E. Emmerson, "I take the greatest care to see that it does not affect the [area], because if there is any trouble about it, my customer will come back to me and I shall have to remove it or argue out my case." As a result, motel complexes respected the environments they were inserted into; their signs reflected this through color and naming conventions. Signs were also consistent, formally and conceptually, with other structures of the era. Physically, signs remained in scale with the architecture they represented.

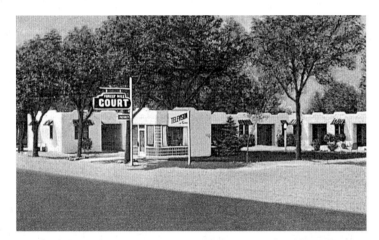

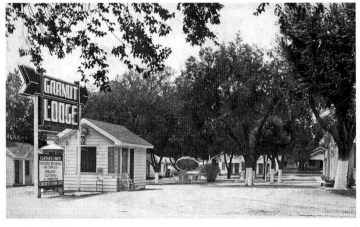

1.12 > NATURAL CONTEXT

Advertising postcards from the 1930s and 1940s convey the importance owners placed on integrating their motel into its natural context. Trees, shrubs, and scenic vistas were featured prominently (often over signs) in the hope of attracting more customers. The *Tourist Court Journal* even suggested that signmakers place their signs with "a tree [and] several bushes planted in front of [or around it] to add to its appearance."

Abundant vegetation provided what customers desired most: a sense of privacy and seclusion from other guests. Individual cabins were nestled among the trees and away from the road, but public structures such as gas stations and offices were located in clearings in direct view of passing motorists.

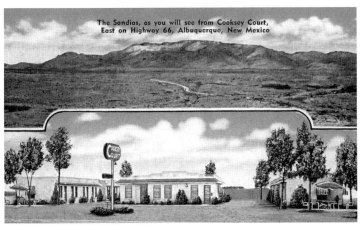

The Sandias, as you will see from Cooksey Court,
East on Highway 66, Albuquerque, New Mexico

The relationship between the motel and the surrounding landscape was also highlighted by illustrations of the views seen from the rooms. Generally, these vistas were of pure, natural landscapes, with little evidence of human intervention.

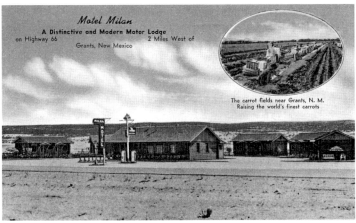

Motel Milan
A Distinctive and Modern Motor Lodge
on Highway 66 2 Miles West of
Grants, New Mexico

The carrot fields near Grants, N. M.
Raising the world's finest carrots

It was also common for 1940s postcards to include illustrations of local landmarks, such as this nearby carrot field. Although not visible from the motel, the reference connected the motel with the larger context of the town and its agricultural heritage.

1.13 > ARCHITECTURAL/STREET CONTEXT

Highway signs from the 1940s followed the formal precedent set on traditional Main Streets. In downtown areas, such as this mid-1940s view of Tucumcari, New Mexico, signs were attached directly to the buildings they identified—a simple convention that dated back to the first shop signs.

As motels sprang up along the open strips outside of busy downtown areas, new building configurations were introduced. Although there was plenty of space to install a sign away from the main building and nearer to the highway, most early motels continued the tradition of attaching their signs directly to the main building. Many motel complexes also followed Main Street patterns by maintaining a physical wall close to the highway, even though their interior courtyards were spacious and open, as seen at the El Jardin Lodge in Albuquerque, New Mexico.

While early motel complexes created a wall to the street, later examples, such as the Beacon Motel in El Reno, Oklahoma, were more open and located back from the road. Most often the main office building was placed at the front and center of an open U configuration, which allowed motorists to see the entire motel from the highway. As the motel's street presence opened up, it also became more common to place the sign on its own, away from the motel and near the street.

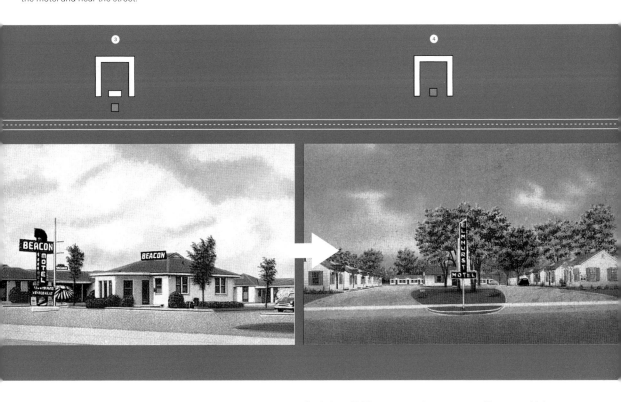

By the late 1940s, most motels were arranged in an open U shape, and the view of the motel complex from the highway was unobstructed. The office was located on the right or left end of the U instead of in the middle, which gave the motel sign more visual prominence. As the space around the sign increased, signmakers began to favor horizontal sign boxes over vertical ones.

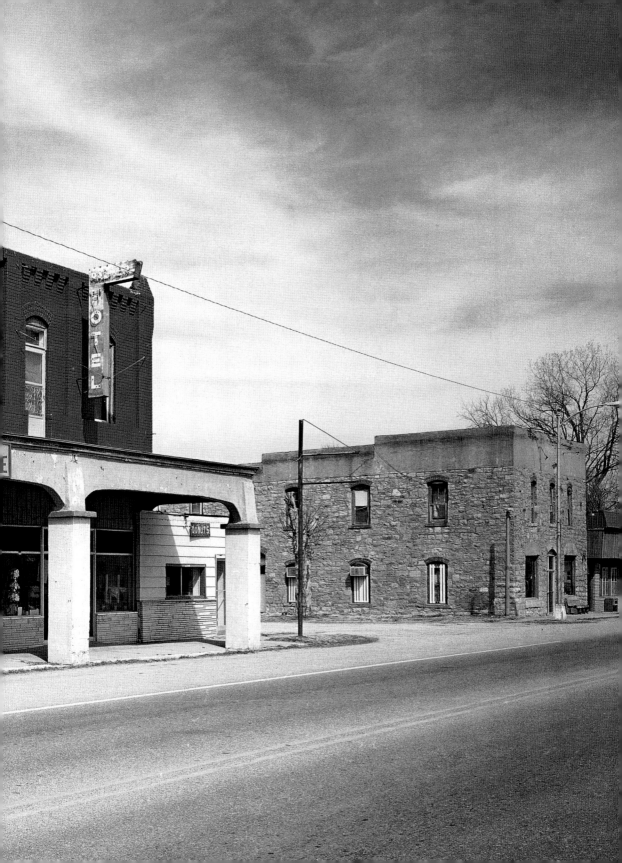

Just as the placement of highway motel signs followed the precedents of traditional Main Streets, so too did the form. The T and inverted T forms were common configurations for both Main Street signs and highway signs throughout the 1940s. By the mid-1940s, signmakers began to respond to the structural challenges of freestanding, vertically oriented signs. Early attempts placed the vertical element closer to one side or the other of the horizontal element in an L arrangement, to allow for easy attachment to a pole. This was abandoned as signmakers realized that stacking the two vertical elements horizontally would produce a form that was both structurally sound and spatially efficient.

EARLY 1940S

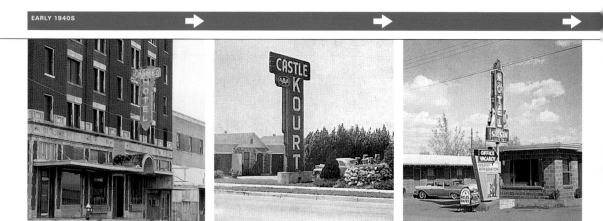

A hanging traditional vertical T form sign on a Main Street.

A freestanding traditional vertical T form sign on a highway strip.

An inverted vertical T form sign on a highway strip.

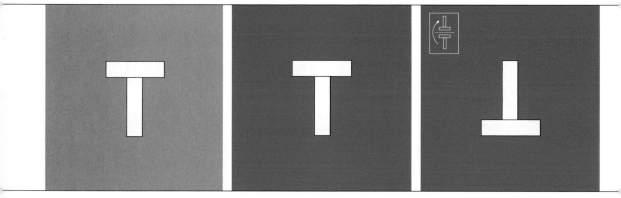

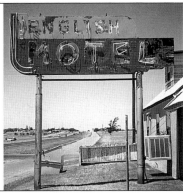

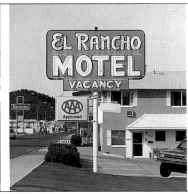

A freestanding L form sign.

A collapsed L form sign. The different paint colors help to differentiate the two shapes.

A horizontal suitcase sign. The unified, symmetrical 1:2 rectangle reads as one unit.

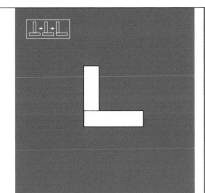

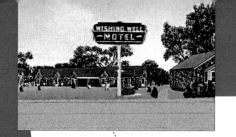

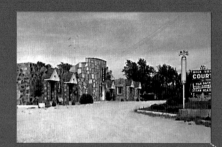

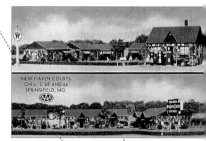

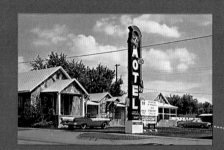

SPRING

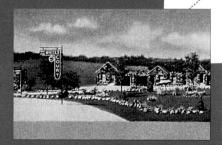

JOPLIN

CARTHAGE

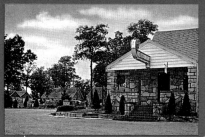

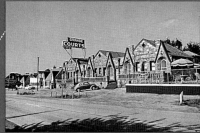

ST. LOUIS

STANTON

'ILLE

ROLLA

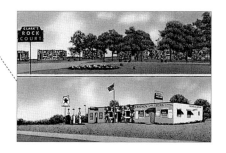

1.15 > REGIONAL CONTEXT

Both signs and motel buildings maintained a close connection with their regional contexts. In Missouri, for example, the use of regionally themed names and traditional sign forms—especially the inverted T and the 1:2 "suitcase" sign box—combined with the use of locally mined stone for the construction of motel rooms, gave motels across the state a formal consistency. The rocky landscape provided a rich source of building materials; from Carthage to Rolla, builders used the same materials and construction techniques, creating a three-hundred-mile stretch of rock-faced motels and motor courts.

Conclusion

The signs that were produced during the first boom of motel construction, from about 1938 through about 1947, were remarkably consistent, both with each other and with older signmaking traditions. This continuity with the past came more from the desire to implement workable solutions to continuing formal problems than from any nostalgic tendency on the part of signmakers. The comfort of using familiar forms occasionally resulted in configurations that outlived their function, such as the T and inverted T, which were rooted in the tight real-estate demands of downtowns. In general, though, it was a period grounded firmly in the present. New ideas were integrated into the signmaking tradition when they served a functional or aesthetic purpose, such as how to create geometrically rigorous forms, or were consistent with the tradition's inherent values of symmetry, economy, simplicity, and repetition.

Innovative sign compositions were arrived at not through the introduction of new forms but through the modification of existing ones. The constraints provided by traditional compositional guidelines were extremely flexible and allowed for many unique variations. The square remained the basic building block for all compositions, rescaled and/or repositioned to create any number of mutations. By the end of this period, however, the 1:2 rectangular sign box emerged as the configuration with the most lasting impact.

As the motel industry continued to expand and the car became a necessity rather than merely a form of entertainment, customers arrived from farther and farther away. In general, they were not familiar with local customs and traditions and instead brought with them generalized expectations of regional identity. As a result, there was soon a shift away from local identifiers, such as owners' names, toward more thematic regional identifiers.

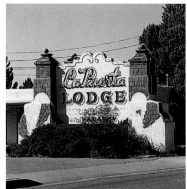

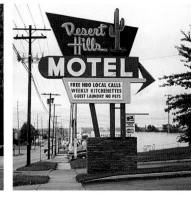

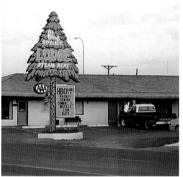

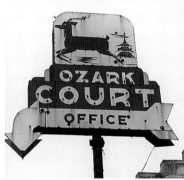

2

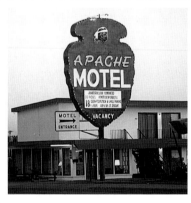

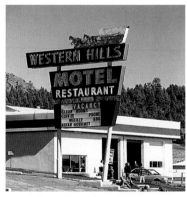

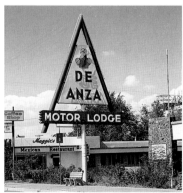

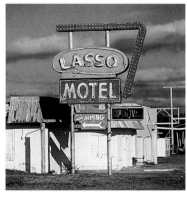

Theming and Regional Symbolism: 1945–1960

The United States underwent fundamental economic and cultural changes during the 1930s and 1940s, as it experienced the Great Depression, World War II, and by the end of this period, a great economic boom. In *The Theming of America*, sociologist Mark Gottdiener argues that this postwar boom led to several cultural shifts, including a shift from a culture of sales, where the relationship between producer, distributor, and consumer was simple and direct, to one of marketing, where demand is spurred by carefully constructed and directed messages and symbols. This change was seen most prominently in national advertising, but it also affected almost every sphere of consumer culture. The traditional motel signs of the late 1930s and early 1940s illustrate the idea of direct sales: an unadorned 1:2 sign box reading "Clark's Motel" offered nothing more than a place to sleep, owned by a person named Clark. These signs did have some symbolic content: progressivism was conveyed through machinelike forms, for example, and the simple geometry promoted an image of functional efficiency and cleanliness.

After World War II these subtle symbols no longer provided a sufficient means of differentiating one business from the next. Motel owners and signmakers responded by boldly theming their buildings and signs. Long-distance travelers might not connect with traditional local identifiers, such as proprietors' names, so they were replaced with broader regional symbols, or themes, that would seem more familiar. "If there are Indians around, or if it is in the Spanish section, or in the wild and wooly West," wrote a reporter for *Tourist Court Journal*, "the guests expect the motif to be in keeping with the locale and with that for which the state is noted. Don't disappoint them. Make their dreams come true."

Although owners and signmakers incorporated a variety of regional themes on their signs, Western ones were especially common on Route 66. The Wild West had been an important part of popular culture since the late nineteenth century, but it had particular relevance to this era. Feelings of patriotism were at an all-time high following the end of World War II, and Western imagery symbolized American freedom. Americans moving out of cities and into the new suburbs were, in essence, taming a new frontier, much as their ancestors had a century earlier. Western themes were also enticing to both adults and children, which made them appropriate for motels catering to families on vacation.

Although this emphasis on regional cultures—other popular themes were Native Americans and the Spanish of the Southwest—might have led to signs that helped create a sense of place, the symbols were often portrayed inaccurately, especially as they related to indigenous flora and Native American culture. This was probably due to a combination of owners' or signmakers' unfamiliarity with the symbols and a purposeful generalization for the sake of tourists ignorant of the cultural subtleties.

Concept

Regional symbols were popular all along Route 66, but it was in the West that theming reached its full potential. Travelers to the western United States expected to see the symbols of the region, which they were familiar with from advertising, movies, films, television shows, and novels. Motel owners provided them in great quantity. Native American cultures were often represented by tepee-shaped motels, Mexican cultures by Spanish motel names, and the West itself by symbols such as cowboys, native flora, and other easily recognizable elements of the landscape.

2.1 > INFLUENCES/SOURCES

Inspiration for motel and sign themes came from a variety of sources. Television, as it became more affordable and available, was an increasingly influential force in determining cultural trends. This new presence in popular culture amplified existing interests, such as the Wild West. Western themes had permeated popular culture since the early 1900s, but they reached new heights during this era. By 1955, more than 30 million American families had televisions in their homes, and many were tuned to Western-themed shows such as *Cisco Kid*, *The Adventures of Wild Bill Hickock*, *Death Valley Days*, *The Lone Ranger*, *The Roy Rogers Show*, and *Gunsmoke*.

Advertisers took advantage of the exposure that television offered, and by 1957, the average American was watching some 420 commercials a week. Ad agencies found Western imagery an appropriate choice for advertising a variety of products. The "Western cowboy" incarnation of the Marlboro Man, for example, was created by Leo Burnett in 1954 to add a more patriotic and masculine edge to the cigarettes.

Signmakers were certainly aware of this cultural trend and used it to their advantage. Western themes were popular throughout the western portion of Route 66, where signmakers embellished their signs with regional symbols, such as local plants, animals, or Native American tribes, and national ones, such as the cowboy.

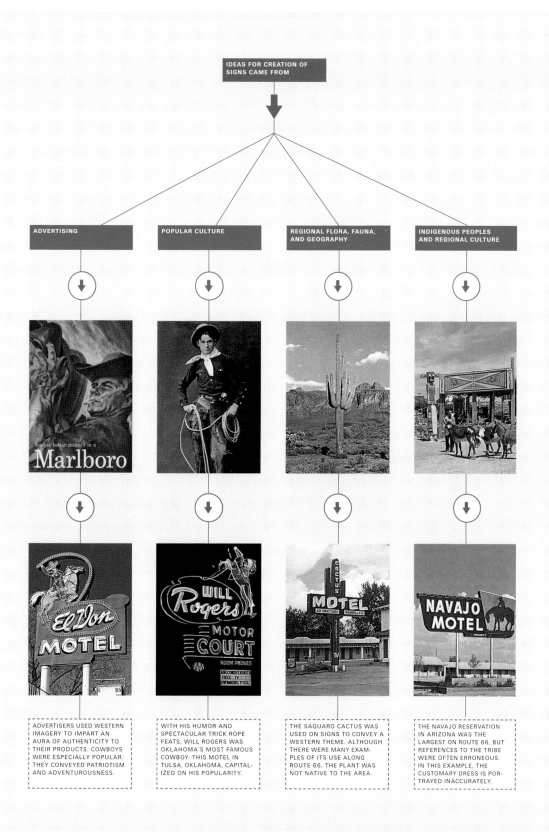

IDEAS FOR CREATION OF SIGNS CAME FROM

ADVERTISING

ADVERTISERS USED WESTERN IMAGERY TO IMPART AN AURA OF AUTHENTICITY TO THEIR PRODUCTS. COWBOYS WERE ESPECIALLY POPULAR: THEY CONVEYED PATRIOTISM AND ADVENTUROUSNESS.

POPULAR CULTURE

WITH HIS HUMOR AND SPECTACULAR TRICK ROPE FEATS, WILL ROGERS WAS OKLAHOMA'S MOST FAMOUS COWBOY. THIS MOTEL IN TULSA, OKLAHOMA, CAPITALIZED ON HIS POPULARITY.

REGIONAL FLORA, FAUNA, AND GEOGRAPHY

THE SAGUARO CACTUS WAS USED ON SIGNS TO CONVEY A WESTERN THEME. ALTHOUGH THERE WERE MANY EXAMPLES OF ITS USE ALONG ROUTE 66, THE PLANT WAS NOT NATIVE TO THE AREA.

INDIGENOUS PEOPLES AND REGIONAL CULTURE

THE NAVAJO RESERVATION IN ARIZONA WAS THE LARGEST ON ROUTE 66, BUT REFERENCES TO THE TRIBE WERE OFTEN ERRONEOUS. IN THIS EXAMPLE, THE CUSTOMARY DRESS IS PORTRAYED INACCURATELY.

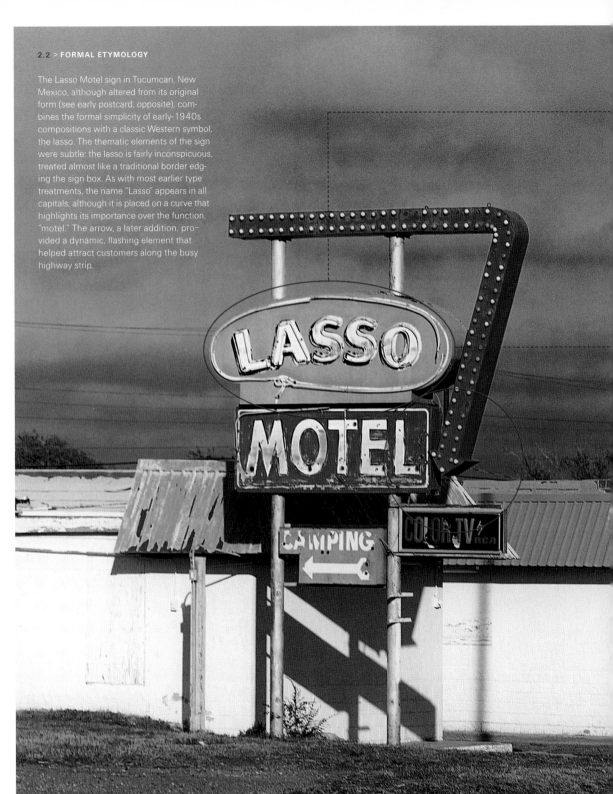

The Lasso Motel sign in Tucumcari, New Mexico, although altered from its original form (see early postcard, opposite), combines the formal simplicity of early-1940s compositions with a classic Western symbol, the lasso. The thematic elements of the sign were subtle: the lasso is fairly inconspicuous, treated almost like a traditional border edging the sign box. As with most earlier type treatments, the name "Lasso" appears in all capitals, although it is placed on a curve that highlights its importance over the function, "motel." The arrow, a later addition, provided a dynamic, flashing element that helped attract customers along the busy highway strip.

The West has been a favorite subject of popular culture since the late nineteenth century, when dime novels sensationalized the frontier. At the turn of the century, Buffalo Bill Cody toured his Wild West show around the country, and a few years later the first Western film was made. By the early 1940s, the Hollywood Western had become a hugely popular genre; a decade later, television featured three different Western series: *The Lone Ranger, Gunsmoke,* and *The Roy Rogers Show.*

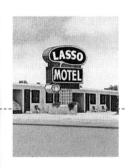

This mid-1940s postcard of the Lasso Motel reveals that the sign was originally painted black and white and lacked the arrow. It was later repainted, probably in the early to mid-1950s, in a bolder red and green combination. The supporting structure of the sign was also modified. It was originally constructed of glass blocks, an Art Deco material, but these were replaced with a more traditional and less obtrusive pole structure. The motel buildings reveal an interesting mixture of International Style machinelike forms and hacienda-esque details.

As developments in abstract art began to infiltrate American culture in the early to mid-1950s, signmakers responded by individualizing regionally themed signs with asymmetry and bold colors. Although these formal adjustments made a sign appear more progressive, they also caused a conceptual disconnect between a sign and its immediate context. As at the Lasso Motel, this sign in Tulsa, Oklahoma, was made asymmetrical through the use of an arrow and other irregular forms. The bright, contrasting colors used here, red and green, evidence the increasing importance of making a sign stand out from its competition.

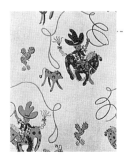

Western themes were also found on all types of consumer products, from clothing to toys to home accessories. This textile pattern was designed by Marjorie Young between between 1951 and 1952.

Components

Form, color, type, and naming conventions all worked toward conveying a theme, though to different degrees at different times. The themed signs of the mid-1940s were conservative, constrained variations on traditional forms. As the regional theming trend expanded and competition increased, signs became more formally dynamic. Even as the shapes became more innovative, however, signs were built from traditional materials and hand-painted until the late 1950s, when plastics became more widely available and affordable.

2.3 > MATERIALS AND FORM

At first, signmakers integrated cultural symbols—cowboy boots, tepees, and cacti—with little adjustment to the traditional methods of form generation. Illustrations were placed on top of traditional rectilinear signs because the "suitcase" sign box made it impossible to integrate an irregular illustration. Over time, signmakers began to stray from the rigid geometries dictated by tradition.

Themed signs of the 1940s were generally consistent with the other 1:2 rectangular signs of the era. The sign box was sometimes enlarged to accommodate an illustration that augmented the thematic content.

By the late 1940s, figurative illustrations were enlarged and placed on top of the main sign, but they were no longer enclosed in a rectangular box. Illustrations continued to maintain their symmetrical, regular appearance.

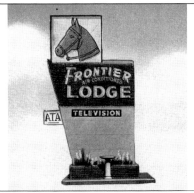

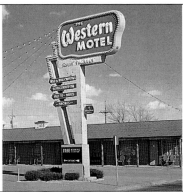

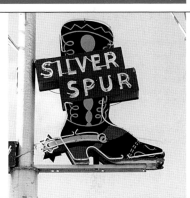

This early-1950s sign illustrates the era's transition from symmetrical to asymmetrical forms. The image of the horse is contained in a traditional, but off-center, square. The dark area of the sign is also consistent with a traditional 1:2 sign box; its left edge is angled, however, and its solid base is non-traditional.

At the height of abstract art's popularity between 1951 and 1954, illustrations became more abstract and the rectangular sign box virtually disappeared. Dynamic, asymmetrical forms were introduced to grab the attention of passing motorists.

Figurative elements regained their popularity briefly during the mid-1950s as color television renewed America's interest in images. Sign forms from this period were often determined entirely by a themed, figurative element, in this case a cowboy boot.

Early themed signs, such as this one at the
De Anza Motor Lodge in Albuquerque, New
Mexico, often adopted the pole-based struc-
ture common during the early 1940s. As
themed elements comprised more and more
of a sign's overall identity, all elements of the
sign, including its structure, were utilized.

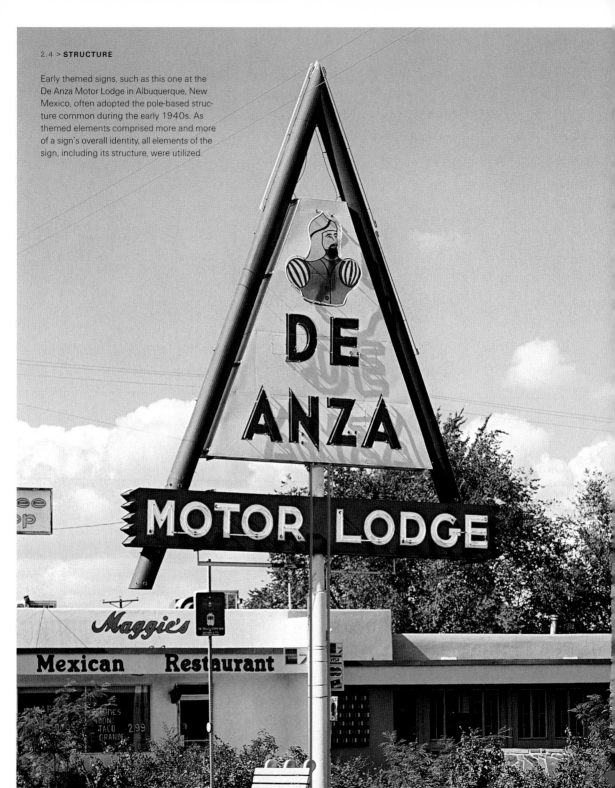

By the early 1950s, signmakers began to realize the value of the sign's structure in conveying thematic content. "In the majority of custom sign installations," wrote signmaker Paul Fritsch, "the poles and signs are ill suited to each other. It is possible to shape the pole so that it becomes a form of identification along with the sign." Motels named after trees, such as the Blue Spruce Lodge in Gallup, New Mexico, found it particularly easy to incorporate the pole into their themed message.

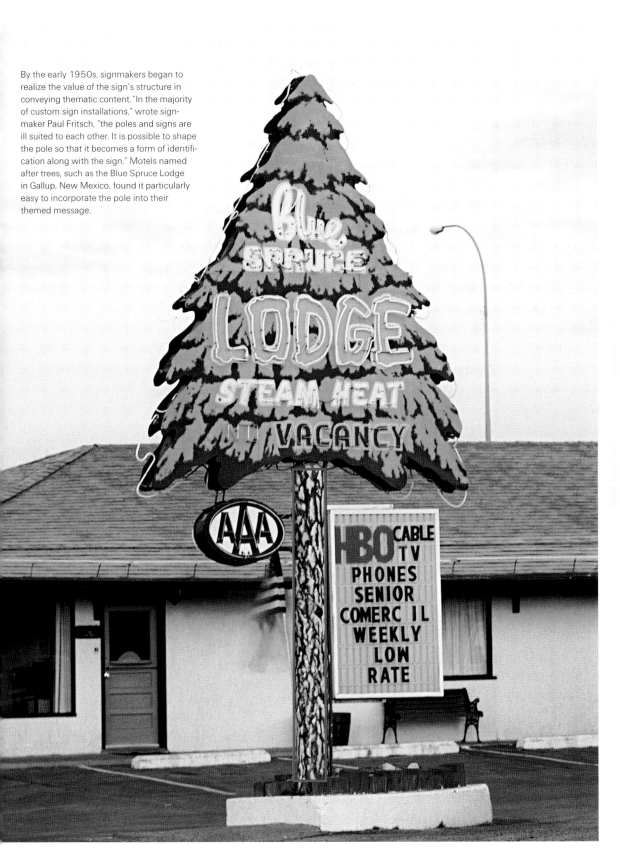

Like the other components of signs from this period, type styles were extremely varied. While type consistently worked toward conveying a particular theme, it did so more subtly or more obviously depending on when the sign was made. In the late 1940s, early themed signs followed the type treatments of prewar signs: square, sans serif, all capitals. By the early 1950s, however, type became more expressionistic in an effort to emphasize the name and theme. Script was especially popular and was often set on a curve or angle to make it more noticeable. By the mid-1950s type began to return to simpler, less stylized forms, although it still retained the ability to promote a specific theme. Stylized type treatments were almost always reserved for the name of the business; the function, "motel," remained simple and generic.

| MID-1940S | EARLY 1950S | LATE 1950S |

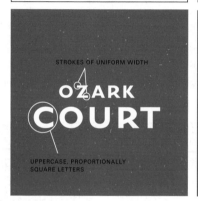

STROKES OF UNIFORM WIDTH

UPPERCASE, PROPORTIONALLY SQUARE LETTERS

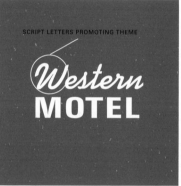

SCRIPT LETTERS PROMOTING THEME

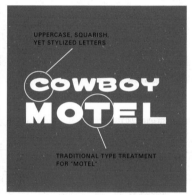

UPPERCASE, SQUARISH, YET STYLIZED LETTERS

TRADITIONAL TYPE TREATMENT FOR "MOTEL"

This mid-1940s sign in Stanton, Missouri, expresses its theme with the name and a single illustration. The sans serif letters are uniform and square, consistent with type treatments from the late 1930s and early 1940s.

The script type at this Oklahoma City motel provides a bold contrast to the more traditional sans serif word "motel," accentuating the Western theme.

These letters from a mid- to late 1950s sign in Amarillo, Texas, reflect a move away from decorative script to simpler but still stylized typefaces.

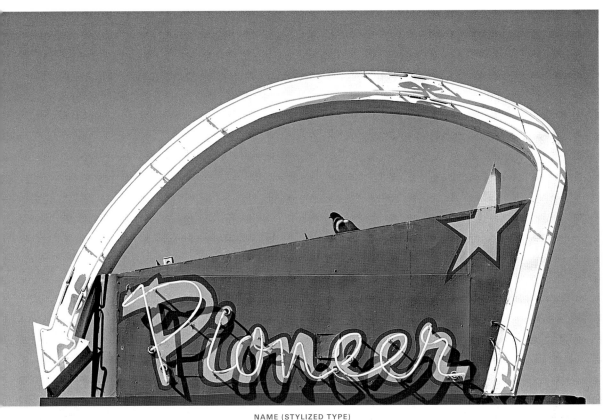

NAME (STYLIZED TYPE)
FUNCTION (GENERIC TYPE)

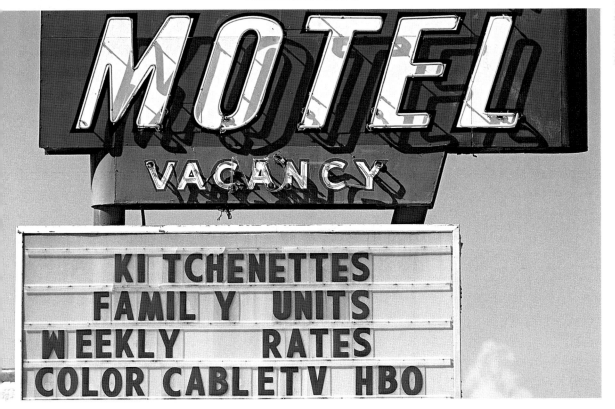

Theming dictated all aspects of a sign's appearance and content, and motel names were no exception. Indigenous peoples, distinctive natural topography, and native flora were the most popular categories for names. Mid-1940s names generally reflected the regional culture more accurately than 1950s examples, which were more likely to repeat stereotypes portrayed in the media.

SPANISH/MEXICAN	NATIVE AMERICAN
EL CORONADO	APACHE
LA SIERRA	WIGWAM
GRANDE	ARROWHEAD
LA PUERTA	ZUNI
LA PLAZA	WAL-A-PAI
LOS ALAMITOS	SUPAI
LA SIESTA	NAVAJO
SPANISH COURTS	TEWA
CASA LINDA	ACOMA
LA HACIENDA	ZIA
LA LOMA	CHIEF
EL VADO	KIVA
DE ANZA	BOW & ARROW
EL CAPITAN	THUNDERBIRD
PALO DURO	TOCOM-KARI
LA SIERRA	GERONIMO

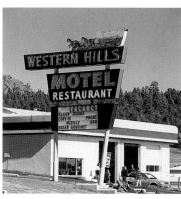 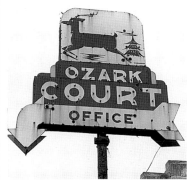 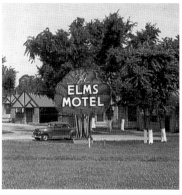

WESTERN	GEOGRAPHIC	FLORA
WESTERN HILLS	OZARK	ELMS
ROUND-UP	ALPINE	CIBOLA
COWBOY	DESERT HILLS	SAGE BRUSH
WESTERN	LA MESA	PIÑON
GHOST RANCH	SANDIA	CACTUS
SILVER SPUR	LA LOMA	YUCCA
COVERED WAGON	CANYON	PINE TREE
RODEO	HIGH DESERT	TWIN OAKS
LASSO	DESERT SANDS	BLUE SPRUCE
LARIAT	MOHAVE	ORANGE BLOSSOM
FRONTIER	HILL TOP	
THE SPUR	LAKE SHORE	
BONANZA	KAIBAB	
CORRAL		
PALOMINO		
WILL ROGERS		

When a sign contained an illustration, colors were used to amplify its thematic content and make the illustration appear more representational, as at the Blue Swallow Motel in Tucumcari, New Mexico. The trend toward the use of realistically applied colors mirrored the growing popularity of color television. As signmaker C. E. Meyer admonished in 1958, "Remember how desperately newspapers are trying to add color, how television is trying to bring color sets into every home, and you will appreciate the wonderful advantage you have in the use of color." In this example, the top of the sign is painted a pale blue and the bottom a darker blue, to conceptually support the business name. Signmakers mixed their own paints and used many different colors to achieve a naturalistic effect.

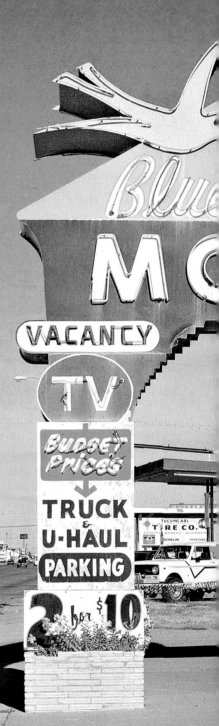

1. PALE BLUE
2. LIGHT BLUE
3. WHITE
4. DARK BLUE
5. WHITE
6. FOREST GREEN

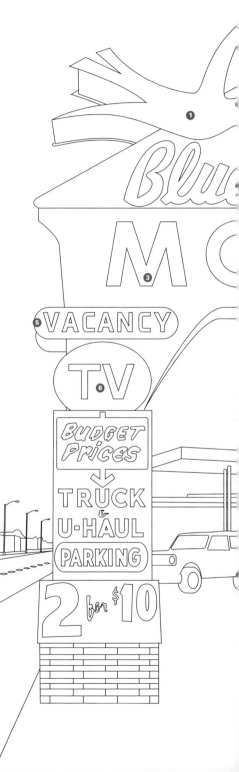

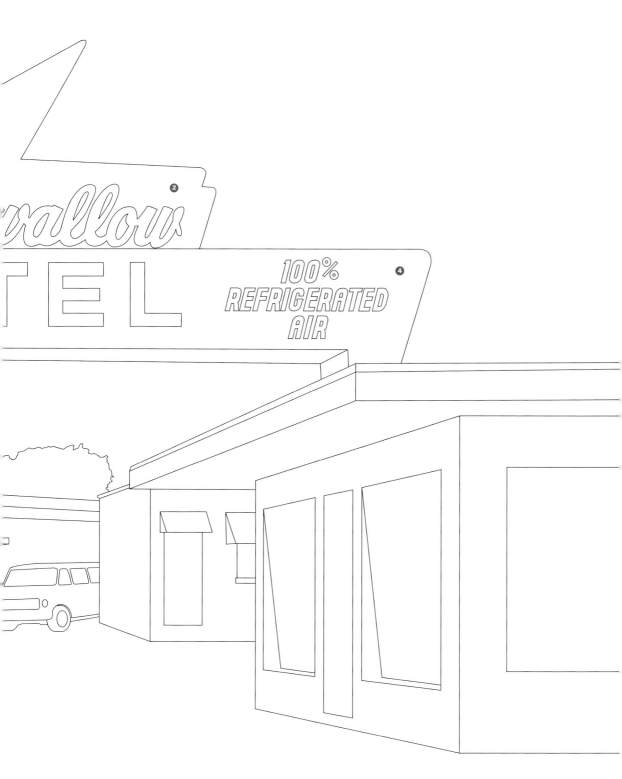

When the trend toward theming began, a motel's symbolism—conveyed through illustration, name, and sometimes architecture—usually referred to unique aspects of local culture, such as the Piñon Lodge in Albuquerque, which took its name from a local shrub. By the early 1950s, however, names became more generic. A less culturally specific name made a sign more accessible to out-of-towners and could be used in more than one region.

Illustrations were almost always literal representations rather than abstractions. Cowboys, Indians, and other regional icons conveyed a sense of adventure to tourists—but within the confines of familiar, established themes. Figurative elements provided an aesthetic departure from the stripped-down, geometric signs of the 1940s and therefore projected a contemporary image. The use of historical symbols, however, insured that, conceptually, the signs remained traditional.

The popularity of figurative imagery was also spurred on by the proliferation of advertising images and the increased availability of television. Clients were learning "the value of picturing their products in television, newspaper, and magazine advertising," commented a staff reporter for *Signs of the Times* in 1955, "and [now] they're demanding pictorials more and more in their signs." Throughout the culture, written methods of conveying information were eschewed for more accessible visuals.

❶ Spanish/Mexican

Spanish/Mexican themes were easy to create by including Spanish words in the business name. Owners and signmakers did not always find it necessary for the words to convey something ethnic. The Casa Linda ("Beautiful House") Motel, for example, has a simple, generic name, while the El Coronado Motel is specific to the region's history. When such specific cultural symbols were used, they usually alluded to famous historical figures.

❷ Native American

Indian themes were ubiquitous. Signs with elaborately illustrated feathered headdresses, tepees, and bows and arrows generated consumer excitement and showcased a signmaker's painting skills. This iconic imagery, however, had more in common with Midwestern Indian tribal customs than with those of the Southwest, where attire was simpler and more subdued.

❸ Western

The most ubiquitous Western symbol was a cowboy on a bucking horse with a lasso; it was found on motels signs in every southwestern state along Route 66. Cowboys not only said "Western," they were also ideal symbols of adventure and freedom, the same qualities tourists expected to experience while on vacation. Cacti, wagon wheels, and other symbols of frontier life were also common.

❹ Geographic

Local features such as the terrain, mountain ranges, and other identifying geographic elements were commonly used to theme signs through the early 1950s. By the middle of the decade, however, references to local features were being replaced with more general, regional ones. Themes that were applicable to several states, such as "southwestern" or "desert," for example, would be more accessible to a wider audience.

❺ Flora

Native plants were difficult to illustrate and, even when well-executed, formally nondescript. Additionally, many plants—such as the piñon—were unfamiliar to out-of-towners and therefore not very compelling. Later examples used more recognizable plants, such as the saguaro cactus.

SPANISH/MEXICAN
MID-1940S SIGNS USED IDENTIFIERS THAT RELATED TO A SPECIFIC AREA. "CORONADO" WAS APPROPRIATE FOR THIS MOTEL IN ALBUQUERQUE—CORONADO TRAVELED THROUGH THE AREA IN THE SIXTEENTH CENTURY.

NATIVE AMERICAN
THE TOCOM-KARI MOTEL IN TUCUMCARI, NEW MEXICO, WAS NAMED AFTER A LOCAL FOLKTALE'S TWO PROTAGONISTS; KARI KILLED HIMSELF AFTER HIS GIRLFRIEND, TOCUM, WAS MURDERED BY A RIVAL.

WESTERN
THE WILL ROGERS MOTOR COURT IN TULSA, OKLAHOMA, EXPLOITS THE COWBOY THEME WHILE CELEBRATING ONE PERSON, AN OKLAHOMA NATIVE.

GEOGRAPHIC
THIS MOTEL'S NAME, SANDIA, REFERS TO A MOUNTAIN ON THE OUTSKIRTS OF ALBUQUERQUE, WHERE THE BUSINESS IS LOCATED.

FLORA
THE PIÑON LODGE IN ALBUQUERQUE REFERS TO A SHRUB INDIGENOUS TO THE AREA.

LOCAL SYMBOLS

REGIONAL SYMBOLS

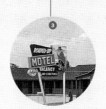

SPANISH/MEXICAN
ALTHOUGH THE USE OF SPANISH NAMES OR WORDS IMMEDIATELY THEMED A MOTEL AS EITHER SPANISH OR MEXICAN, LATER EXAMPLES USED MORE GENERIC TERMINOLOGY. HERE LA PUERTA ("THE DOOR") PROVIDES A THEME THAT WOULD WORK ANYWHERE IN THE SOUTHWEST.

NATIVE AMERICAN
THE CHIEF MOTEL IN HOLBROOK, ARIZONA, USES A GENERIC NATIVE AMERICAN THEME THAT APPEALS TO A BROAD AUDIENCE.

WESTERN
THE ROUND-UP MOTEL IN CLAREMORE, OKLAHOMA, USES A GENERIC COWBOY TO CONVEY A STEREOTYPICAL WESTERN THEME.

GEOGRAPHIC
THE HEART-SHAPED BOX ON THE HEART OF THE OZARKS MOTEL SIGN IN SPRINGFIELD, MISSOURI, ILLUSTRATES THE TRANSITION TOWARD UNIVERSAL SYMBOLS EVEN ON REGIONALLY THEMED SIGNS.

FLORA
"CACTUS" IS MUCH MORE GENERIC THAN THE SAGUARO THAT ILLUSTRATES IT, WHICH IN ANY CASE IS NOT NATIVE TO GALLUP, NEW MEXICO, THE MOTEL'S LOCATION. BOTH THE NAME AND ILLUSTRATION, HOWEVER, ARE ICONIC WESTERN SYMBOLS.

The cactus and lasso were two of the most popular Western symbols found on Route 66 signs during the late 1940s and early 1950s. While all of the examples shown here are named either "Cactus Motel" or "Western Motel," they are different motels, built at different times. Seen together, these signs reveal the changing ways in which themed messages were conveyed.

❶

❷

❸

MID-1940S

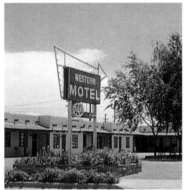

EARLY 1950S

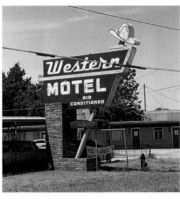

MID/LATE 1950S

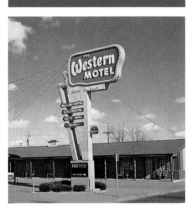

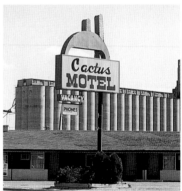

In early examples, the themed message was apparent in terms of the business name only. Color choices were dictated by tradition or the personal preferences of signmakers or motel owners.

By the early 1950s, all aspects of a sign were themed, including the name, any figurative element, and the color treatment. The rectangular sign box was eventually replaced with dynamically arranged irregular shapes.

During the mid- to late 1950s, there was a shift toward more abstract illustrations, as seen here in the stylized cactus, sun, and lasso forms.

① WORD

② WORD +
FIGURATIVE ICON +
COLOR

③ WORD +
ABSTRACTED ICON +
COLOR

One other type of symbol appeared on signs in the 1940s: that of a recommendation service or referral chain. Both vouched for motels in unfamiliar territory, giving reliable information to tourists traveling farther from familiar towns and businesses. They also foreshadowed the emergence of franchises, which began to take hold in the early 1950s as tourist travel expanded to more than just one season.

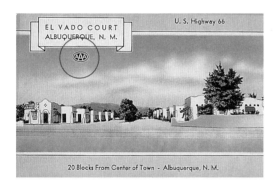

Recommendation services such as the American Automobile Association existed primarily for traveling customers, not motels. If a motel was approved by the AAA, it meant that it met customers' standards. Although the group was established in 1902, AAA logos did not begin to appear on motel signs in large numbers until the 1940s. Early examples rarely placed the AAA symbol directly on their main sign; it was rather on a nearby secondary sign or just on the advertising postcard.

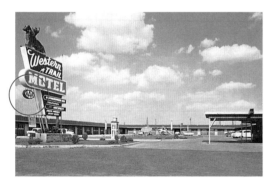

As tourists began to place more reliance on recommendation services, their logos were moved to a more prominent position on the main sign. Generally, the plaque hung below it, either from the pole or from the sign box itself, as shown here.

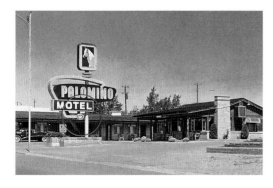

By the late 1940s, the AAA logo had become integrated into the sign itself as a permanent element. It was often placed near the top, as seen here at the Palomino Motel in Tucumcari, New Mexico.

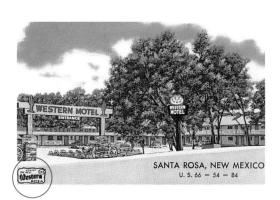

Best Western was another popular referral chain. Founded in 1946, it structured its business on soliciting motels along major western highways, including Route 66. In exchange for membership dues from affiliated motels, Best Western printed and distributed travel guides and bought advertising in national magazines and major newspapers. All motels were inspected annually; some 15 percent were dropped each year for failing to meet the chain's standards.

If there was an existing sign at the motel, the Best Western logo was often placed off to the side on a smaller, adjacent structure. These signs were easy to update and did not visually interfere with the original sign. The Best Western symbol reflected both the business range of the franchise and Western theming trends.

On newer signs, such as this late-1950s sign for the Ranger Motel in Shamrock, Texas, the Best Western logo was placed on a plaque that hung from the sign's structure. The lasso was a permanent part of Best Western's identity until the late 1950s, when Western themes fell out of favor.

Composition

The overall appearance of signs from the 1940s and 1950s varied: earlier examples retained traditional formal attributes such as symmetry and simplicity, while later signs rejected those qualities as the demand for more original compositions emerged. The hierarchy of a sign's content, however, remained almost the same, with the most individual elements—name or illustration—positioned on top.

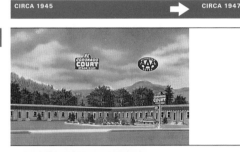

CIRCA 1945 → CIRCA 1947 →

EL CORONADO COURT/MOTEL

TEXAS ANN COURT/MOTEL

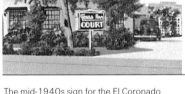

2.9 > SYMMETRY/HIERARCHY

When the trend toward theming began in the mid-1940s, signmakers were using traditional approaches to symmetry and hierarchy: symmetry was rigidly enforced, and the motel name always appeared above the function. By the end of the decade, the arrangement of sign elements was much less controlled, as the trend toward asymmetry and new shapes intensified and more emphasis was placed on the function, "motel."

The mid-1940s sign for the El Coronado Court is typical of the period: symmetrical, with an overall form based on the traditional 1:2 sign box.

Like the El Coronado sign, the Texas Ann sign is formally traditional, although the name is executed in script and a Colonial-style border is added. The motel name appears to be non-contextual (it is located in New Mexico); it probably referred to the owner's name and home state.

As theming became an increasingly important method of attracting customers, a simply rendered illustration of a longhorn steer—a symbol of the cowboy West in general and Texas in particular—was added. Plaques for affiliations and amenities hung from the bottom; like the illustration, they maintained the sign's symmetry.

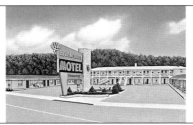
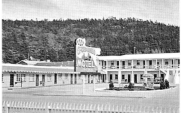

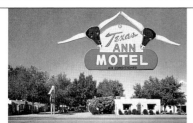

As pressure to create more individualized signs mounted, signmakers began to develop more dramatic compositions. This sign was made more dynamic by placing two identical, detailed illustrations at angles and by incorporating lasso edging and rounded box forms. Symmetry, however, was not abandoned.

Although the name El Coronado still provides some thematic impact in this early-1950s iteration, the non-traditional configuration of the sign, especially its asymmetry, makes it appear more progressive and up-to-date. The AAA logo is given a more prominent position on the sign, reflecting the increasing importance of national affiliation groups.

Figurative illustrations briefly reappeared on signs during the mid- to late 1950s. Signs also began to return to more symmetrical configurations. Without the AAA logo, ragged right edge, and slightly off-center pole placement, this sign would be symmetrical and square.

Context

Although signs made during the late 1940s and the 1950s maintained a relationship with their natural, architectural, and cultural environments, it was often in an idealized or symbolic way that did not reflect the true nature of these contexts. Early examples tended to reflect specific regions more accurately than later ones, which were often overly general and plagued with inconsistencies.

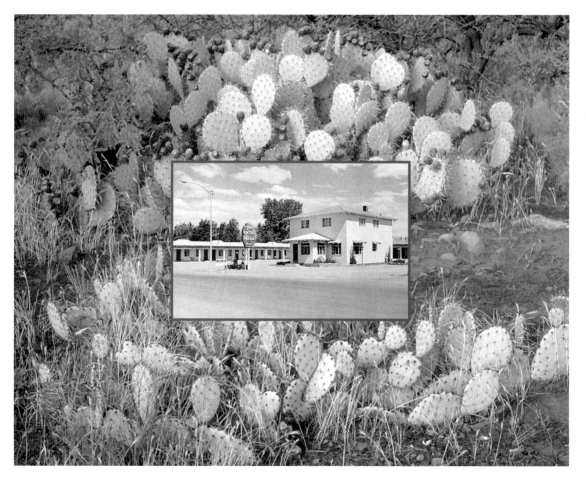

2.10 > NATURAL CONTEXT

Names and illustrations of native flora were often used to provide a Western theme. The sign at the Cactus Motel in Gallup, New Mexico, was built in the late 1940s. Although the name of the motel is generic, the sign is built in the shape of a prickly pear cactus, a species native to the area. The prickly pear was not as distinctive or as easily recognizable as the saguaro cactus and was soon abandoned.

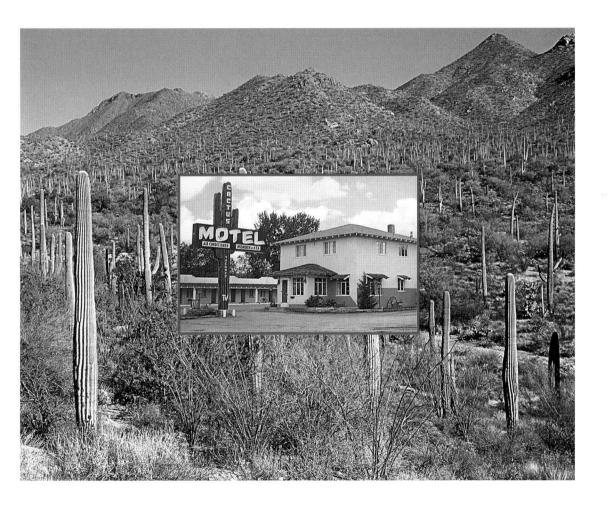

The more general the plant reference, the more likely it was that the motel was located outside of the species' native range. For example, this mid-1950s iteration of the Cactus Motel sign uses an illustration of a saguaro, though the motel is located four hundred miles outside of the plant's native area. As Southwest historian Douglas Towne notes in his article "The Mysteries of the Wandering Cactus Unearthed," motels with more specific names, such as the El Sahuaro Motel, in Tucson, Arizona (a town not on Route 66), are generally located within the plant's native habitat.

GALLUP

ALBUQUEF

ARIZONA

SAGUARO NATIVE RANGE

NEW ME

Motels signs that included a saguaro illustration were relatively common along Route 66, but none were located within the natural range of the species. This illustration, which locates the motels in relation to the plant's native habitat, is based on an illustration in Douglas Towne's "The Mysteries of the Wandering Cactus Unearthed."

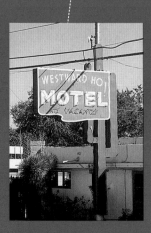

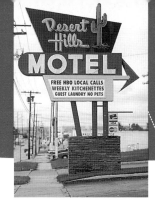

TULSA

CARI

McLEAN

SAYRE

CLINTON

OKLAHOMA

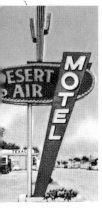

TEXAS

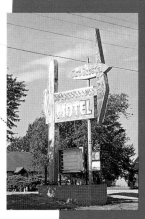

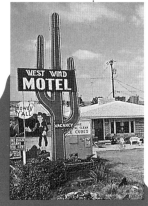

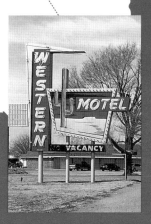

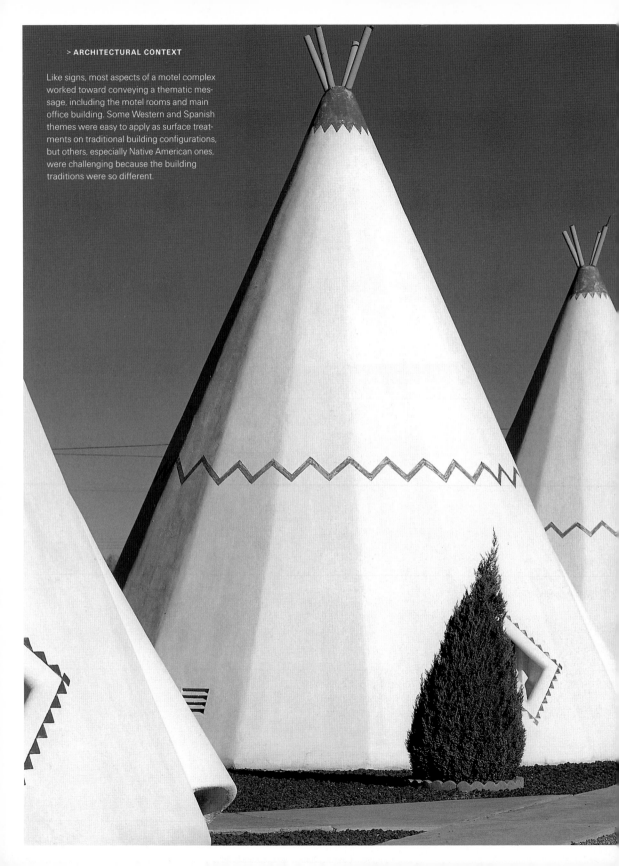

Like signs, most aspects of a motel complex worked toward conveying a thematic message, including the motel rooms and main office building. Some Western and Spanish themes were easy to apply as surface treatments on traditional building configurations, but others, especially Native American ones, were challenging because the building traditions were so different.

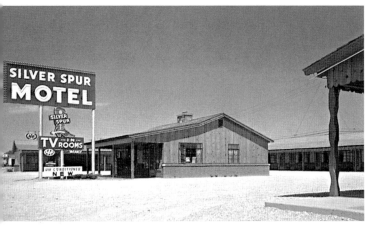

Most motels meant to evoke the Wild West were themed by adding surface treatments such as natural wood and carved columns.

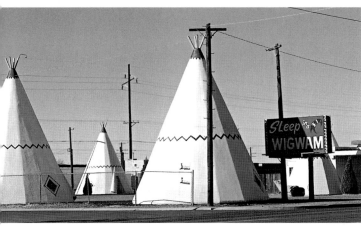

The tepee was one of the more interesting structures adapted for motel rooms, but like many Native American symbols used in signs and architecture, it was inappropriate. The tepee was actually used by Plains Indians, hundreds of miles from this motel in Holbrook, Arizona.

Adobe-style construction for motels was common from the early 1940s through the mid-1950s. The style enjoyed tremendous popularity not only because of its ability to portray a Spanish theme but also due to its stripped down, undifferentiated surfaces, which were economical and easy to build. These simple, streamlined forms conveyed modernity and up-to-dateness as well as regionalism.

Nowhere was the transition from local to regional symbols seen more clearly than along the southwestern portion of Route 66, where Native American–themed signs were plentiful. In northeastern Arizona, home to the western pueblos, the highway borders the Navajo reservation, and many motel signs in the area were themed accordingly.

The Navajos were the largest Native American tribe in North America and were well established in the Four Corners area of Utah, Colorado, New Mexico, and Arizona. This photograph of a Navajo Indian village in Chambers, Arizona, shows a unique type of conical Navajo building, the hogan, and the tribe's customary style of dress—loose pants with a cotton or buckskin shirt.

NAVAJO INDIAN RESERVATION

CHAMBERS

NAVAJO

SELIGMAN

ARIZONA

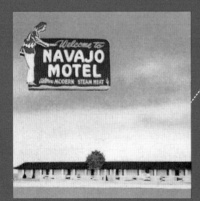

The Navajo Motel in Seligman, Arizona, is close to the reservation. The detailed illustration accurately portrays traditional Navajo clothing.

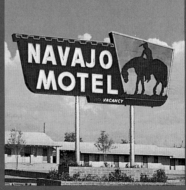

Although this late-1950s motel is appropriately located in Navajo, Arizona, the illustration on its sign is a copy of James Earle Fraser's iconic sculpture *The End of the Trail*. Although this image is symbolic of the tragedies faced by Native Americans, the figure in it is a Plains Indian, not a Navajo.

Most of the eastern pueblos were located between Albuquerque and Taos, New Mexico, and Indian themes were particularly popular in this area. Owners and signmakers borrowed freely from the symbolism and imagery of local tribes to theme their signs and buildings.

O TAOS

TEWA RESERVATION

ALBUQUERQUE

NEW MEXICO

The Taos Pueblo in New Mexico typifies eastern pueblo architecture. The Rio Grande Valley between Taos and Albuquerque was home to a number of Indian villages, including Tiwas, Tewas, and Tanos.

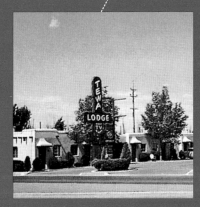

The architecture of the Tewa Lodge in Albuquerque resembles indigenous pueblo architecture. The sign's only thematic element is its name, however, a trait consistent with other early-1940s themed signs.

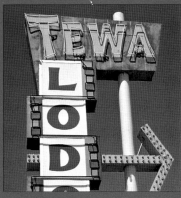

This late-1950s sign for the same motel is similar in appearance to other signs from the period in Albuquerque and nearby Gallup. The sign is stylized, but none of its elements relates to Tewa culture. The small decorative squares bordering the plastic letters, however, seem to have been added in an effort to impart an abstracted Indian theme.

Many of the motel signs in the Southwest combined Indian, Mexican, and Spanish elements, reflecting centuries of cultural cross-pollination and patterns of control. Spaniards, who had come into contact with Native Americans as early as 1540, developed a large Spanish vocabulary for describing Native American culture. In contrast, Native Americans adopted Spanish words primarily to identify things or customs foreign to their own, such as "burro," certain fruits and vegetables, units of measure, and religious terms such as "sin" and "saint."

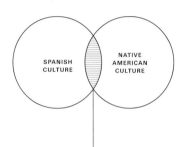

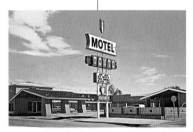 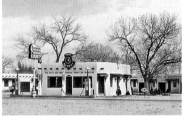 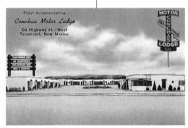

It would be difficult to choose a more derogatory motel name than Tonto (Spanish for "stupid"). Although the word originally referred to a subgroup of Apaches who lived near modern Flagstaff—named the Tontos by Spaniards during the 1700s—this sign was almost certainly meant to capitalize on the well-known character from the radio, film, and television series *The Lone Ranger*.

The Spanish called the stone and adobe Indian villages they found in the Southwest "pueblos," or towns. "Pueblo Bonito" means "pretty town" and was used to give this motor court in Albuquerque a Spanish/Indian theme. Pueblo Bonito was also the name of an Anasazi Indian ruin at the nearby Chaco Canyon.

This motel in Tucumcari, New Mexico, has a Spanish name, "Conchas" (shells), the name of a local lake and also the term for a traditional Native American ornament, the oval pieces of silver jewelry found on decorated leather belts.

The name "El Vado" is Spanish for "the ford" and refers to the motel's location near the Rio Grande.

The El Vado sign in Albuquerque contains both Indian and Spanish elements. The illustration of a Native American in an elaborate headdress, however, is consistent with Plains Indians, not those from the pueblos.

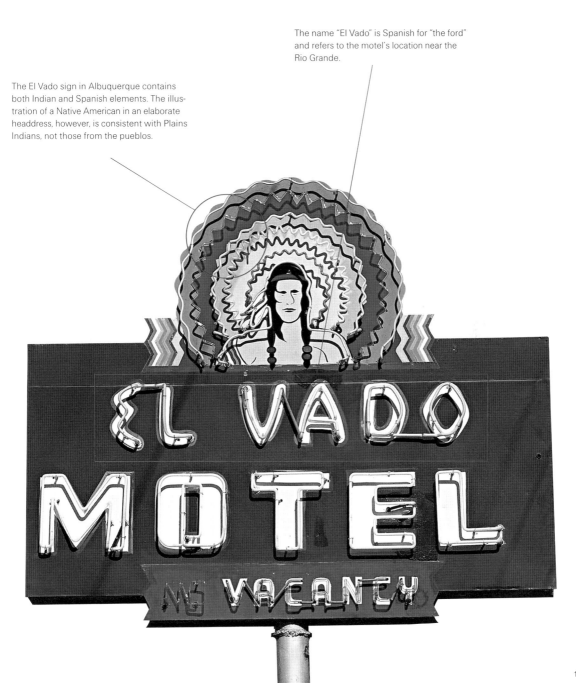

Conclusion

During the late 1940s and the 1950s, many conceptual and formal modifications were made to signs in order to meet the needs of a rapidly expanding cultural context. Themed elements, especially names and illustrations, became increasingly generic to attract a wider audience, and the standardized logos of recommendation groups became a permanent addition to many signs. Both served the purpose of making a motel seem familiar to those from outside the community. The more general a sign's thematic elements became, however, the more likely it was that the traditional relationship between a sign and its immediate context—both natural and cultural—was lost.

As symbols became more generic, the forms used for signs became less traditional. Mid-1940s signs, whose symbols accurately portrayed local customs and features, were arranged symmetrically, in much the same manner as earlier, unthemed examples. By the mid-1950s, as symbols began to lose their contextual authenticity, themed signs were composed of irregular forms arranged asymmetrically in compositions that had more in common with the abstract signs that would come to the fore in the 1950s.

The movement from local symbols to regional ones and then toward their elimination reflected a conceptual shift away from nature and tradition and toward culture and the future. This shift also opened the door for the expansion of chains, which by definition were not part of the local context. With local and regional symbols eliminated, chains were free to use standardized sign designs in any region.

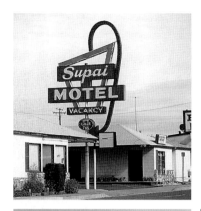

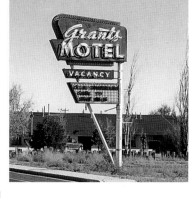

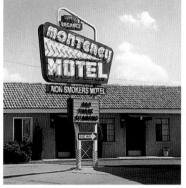

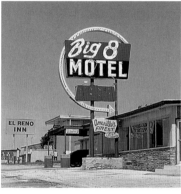

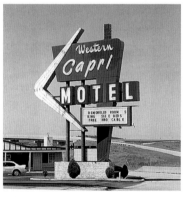

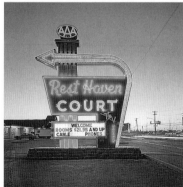

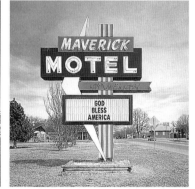

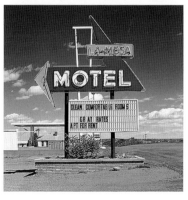

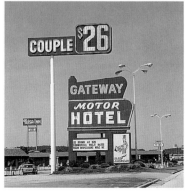

Abstraction and Self-Expression: 1950–1957

The economic boom of the 1950s spawned many new motels along Route 66, creating great pressure for owners to differentiate their businesses from the competition. The era also saw an emerging cultural fascination with personal expression and abstraction, as evidenced by events in the art and design worlds. And the economic and baby booms encouraged a much higher level of consumption in America, fueled by the developing advertising industry. This combination of forces—especially competition and consumer demand for the new—led motel owners to insist on fresh, unique signs that would attract attention. For the first time, signs took on an identity of their own, separate from the landscape, architecture, and local customs that surrounded them.

A 1951 *Signs of the Times* article reminded readers that sign buyers were "demanding something entirely new…only an idea of unusual novelty will sell them." The strict focus on originality forced signmakers to make a deliberate break with the past; rather than rely on the guidance of tradition, they made new signs from scratch. In fact, almost all the signs made during this period rejected signmaking traditions in one way or another. It was customary to make a sign symmetrical and regular, for example, so many new signs were asymmetrical and irregular. Signs of the 1950s also avoided any relationship with their specific context.

The difficulties of working in new ways and without identifiable boundaries were enormous. Signmakers had to study the work produced by other design-related industries, such as advertising, graphic design, architecture, and art. They also had to keep an eye on the rapidly changing tastes of popular culture. Sign shops began to place much more emphasis on design, segregating their staff into creative and production departments.

The rampant commercial growth along Route 66 was also responsible for the growth of motel chains and a gradual shift toward the use of prefabricated, modular components. Ironically, although increased competition made it necessary to present a unique image to the public, it also made it more likely that chains, with their familiar, identical signs and buildings, would succeed. Motels were compelled to pursue two contradictory goals: to create a novel design, and to repeat it over and over to promote and maintain brand recognition.

Concept

Ideas for new signs came from external sources such as science, television, magazines, art, and film—a mix that led to an obsession with originality and newness. Innovation in the 1950s came not from rearranging traditional elements but from creating compositions that were the opposite of traditional: asymmetrical, irregular, abstract, decorative, brightly colored. Personal expression, which traditional design discouraged, also became an important source of inspiration. Signs reflected the idiosyncrasies of their makers rather than the particular needs or expectations of a community. While previous generations of signmakers incorporated symbols and forms that were firmly rooted in the concerns of the present and not-so-distant past, signmakers of this period were fixated on possibilities offered by the future. Symbols of progress were widely used.

3.1 > INFLUENCES/SOURCES

As signmakers concentrated on creating original designs, visual and conceptual cues to the local context were eliminated. References to nature and regional culture were replaced with either abstract forms or symbols that celebrated the achievements of mankind. Technological, scientific, and artistic achievements featured prominently in the symbolism of the period. This external focus helped cause a gradual erosion of the designer's sense of responsibility toward the communities and landscapes his signs were placed in— he no longer found it important to design a sign that fit in. As signmakers looked to other sources for inspiration, the benefit of working within a narrower field of design exploration and of focusing on specific, traditionally defined problems—such as creating a sign from the geometric foundation of a square—was lost.

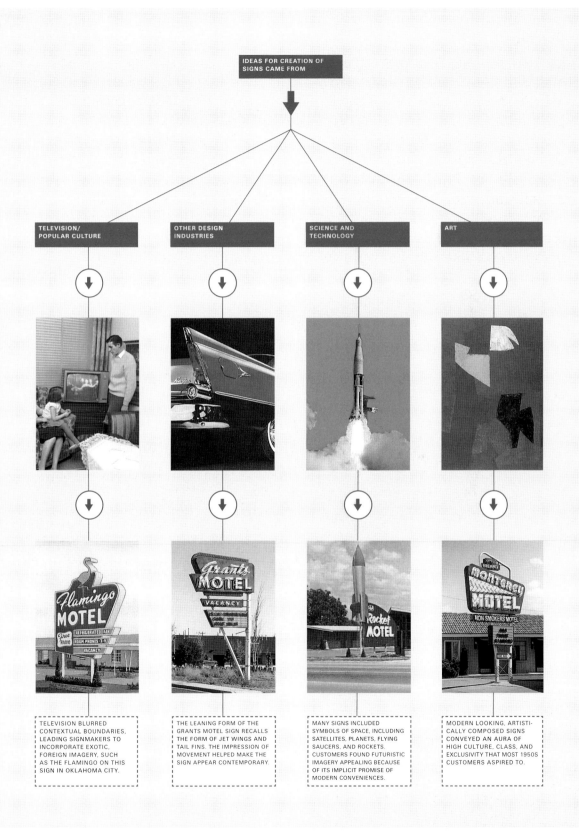

IDEAS FOR CREATION OF SIGNS CAME FROM

TELEVISION/ POPULAR CULTURE

TELEVISION BLURRED CONTEXTUAL BOUNDARIES, LEADING SIGNMAKERS TO INCORPORATE EXOTIC, FOREIGN IMAGERY, SUCH AS THE FLAMINGO ON THIS SIGN IN OKLAHOMA CITY.

OTHER DESIGN INDUSTRIES

THE LEANING FORM OF THE GRANTS MOTEL SIGN RECALLS THE FORM OF JET WINGS AND TAIL FINS. THE IMPRESSION OF MOVEMENT HELPED MAKE THE SIGN APPEAR CONTEMPORARY.

SCIENCE AND TECHNOLOGY

MANY SIGNS INCLUDED SYMBOLS OF SPACE, INCLUDING SATELLITES, PLANETS, FLYING SAUCERS, AND ROCKETS. CUSTOMERS FOUND FUTURISTIC IMAGERY APPEALING BECAUSE OF ITS IMPLICIT PROMISE OF MODERN CONVENIENCES.

ART

MODERN LOOKING, ARTISTICALLY COMPOSED SIGNS CONVEYED AN AURA OF HIGH CULTURE, CLASS, AND EXCLUSIVITY THAT MOST 1950S CUSTOMERS ASPIRED TO.

The Hacienda Holiday Motel sign in Oklahoma City is an example of how far signmakers went to create original compositions for their clients. Fearing that they might lose control over the design process to an emerging class of professional designers, signmakers looked for inspiration in other disciplines, especially art and science.

The use of abstract symbols common in art of the period, such as this detail from Joan Miro's *Woman in Front of the Sun* (1950), made signs appear up-to-date.

Script lettering was used to convey uniqueness and add visual drama to the sign.

Forms and structures were often angled to create more dynamic, and therefore noticeable, compositions, as seen in this late 1950s building.

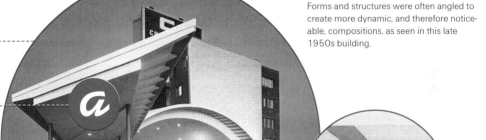

Bold, stylized arrows were common additions to signs during this period. Artists such as Paul Klee also found them enticing.

Abstracted figurative elements were also found in the design world, as seen in this mid-1950s engraved bowl designed by Ingeborg Lundin.

Irregular shapes were non-traditional and therefore appropriate forms for signmakers looking to create original signs. Artists also made use of them, as in this 1959 mobile, "Big Red," by Alexander Calder.

Asymmetrical compositions, as in this plate design by Florence Wainwright, conveyed individuality and uniqueness.

Components

Each element of a sign was meant to project a bold, individual presence. Simple rectilinear forms were abandoned for irregular shapes, and a wide variety of materials and techniques was incorporated for dramatic visual effect and consumer appeal.

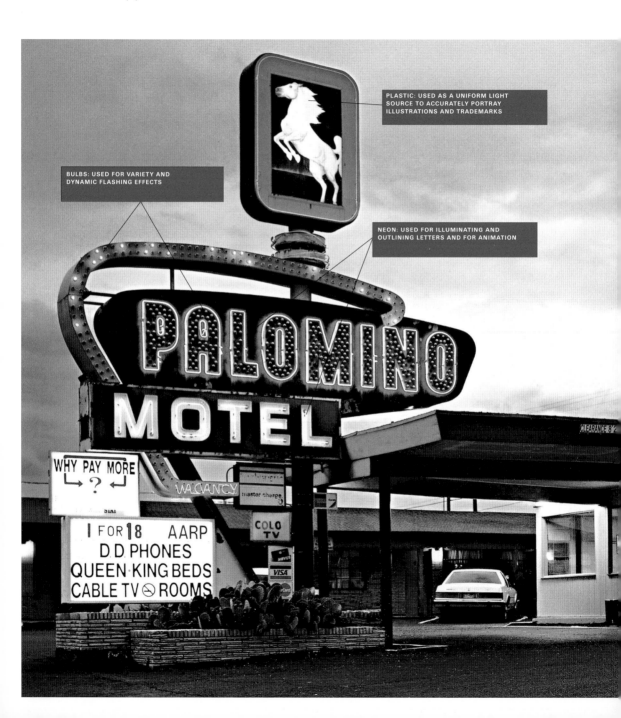

PLASTIC: USED AS A UNIFORM LIGHT SOURCE TO ACCURATELY PORTRAY ILLUSTRATIONS AND TRADEMARKS

BULBS: USED FOR VARIETY AND DYNAMIC FLASHING EFFECTS

NEON: USED FOR ILLUMINATING AND OUTLINING LETTERS AND FOR ANIMATION

3.3 > MATERIALS

As individuality and originality became increasingly important, signmakers began to place more emphasis on material selection. Metal and neon remained the most popular and economical choices, but they were often combined with flashier or more technologically advanced materials.

Bulbs had not been used in signs since the adoption of neon in the early 1930s. They reappeared in the early 1950s, but instead of being used traditionally—to outline letters or borders—they were employed to create dynamic flashing effects.

Although plastic was introduced to the signmaking industry after World War II, it was not commonly applied to whole signs. Until the early 1960s, its use was limited to illustrations or isolated letters or words. The material remained expensive, and its inherent simplicity, especially its flatness and lack of detail, made it somewhat inappropriate for a period that favored glittery, dramatic signs.

Nowhere was the break from tradition seen more dramatically than in a sign's form. Signmakers chose irregular, asymmetrical shapes over traditional ones, whether or not the business the sign identified was new. By the mid-1950s, many signmakers had begun creating their signs as fragmented compositions, a final abandonment of traditional form.

In the mid-1950s, the Wishing Well Motel in Springfield, Missouri, replaced its traditional sign, which was based on a 1:2 rectangular sign box, with an L-shaped composition of four elements. Though the L shape recalls earlier Main Street signs, the shape of the Wishing Well's sign box is irregular, more dramatic, and includes decorative elements. The words "Wishing Well" and "motel" are treated as separate elements through the use of different colors and type styles.

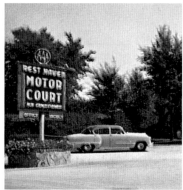

The asymmetrical form, large wrapping arrow, script type, and advertising panels of the Rest Haven Court's mid-1950s sign are characteristic features of motel signs from the period.

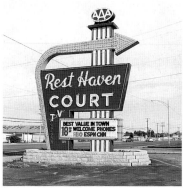

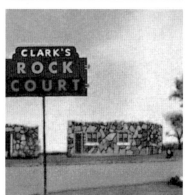

The only elements that remained the same on these two signs from the mid-1940s and the early 1950s were the name (although depersonalized with the removal of "Clark's") and the square, sans serif letters. The newer sign has no formal relationship to its context. The angled structure, palette-shaped sign box, and bright red paint all help to separate it from nearby buildings and natural elements.

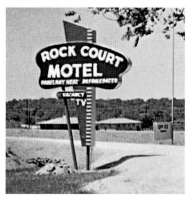

The updated Tower Motel sign in Santa Rosa, New Mexico, formally distances itself from the traditional inverted T form of the mid-1940s sign. Each element on the new sign is perceived as a distinct component: the name "Tower" is spatially segregated from "motel," and the letters are treated as individually articulated elements.

The simple, symmetrical sign for the Skyline Motel in Flagstaff, Arizona, was replaced with a larger and bolder asymmetrical arrangement.

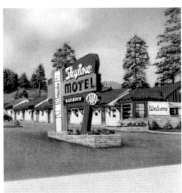

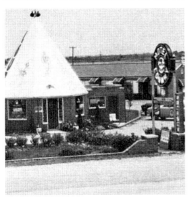

Early signs, like the one for the Conway Motel in El Reno, Oklahoma, were often composed of geometrically pure shapes. In this example, the form also reflected the circular motel office. The late-1950s replacement was designed with only contemporary stylistic trends in mind—it was no longer important to maintain a formal connection to the motel's architecture.

Although motel chains did not gain widespread popularity until the late 1950s, Holiday Inn had begun to expand nationwide much earlier. The most visible aspect of the first major chain's growth was the "great sign," as it was referred to. And like the older signs it took its aesthetic cues from, the Holiday Inn sign garnered recognition that attested to the skill with which independent motel owners and signmakers were able to define their businesses' identity. A sign functioned as the motel's logo; it appeared on stationery, ads, and other materials. While independent motel signs influenced the first Holiday Inn sign, as the chain expanded it was the Holiday Inn sign that began to influence the vernacular.

BEFORE 1952

STAR

The star, a traditional symbol used in vernacular signs, denoted quality of service.

WRAPPING ARROW

Early arrows were generally thin and functioned more as a border than as a primary visual element.

LEANING FORM

By the late 1940s, a "slant" form was used to add visual interest and to attract the attention of passing motorists.

COLOR

NAME

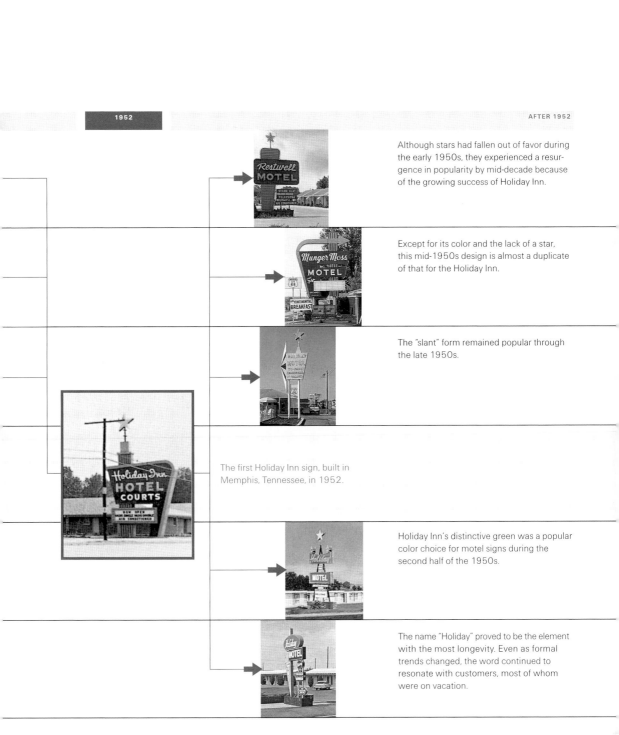

Although stars had fallen out of favor during the early 1950s, they experienced a resurgence in popularity by mid-decade because of the growing success of Holiday Inn.

Except for its color and the lack of a star, this mid-1950s design is almost a duplicate of that for the Holiday Inn.

The "slant" form remained popular through the late 1950s.

The first Holiday Inn sign, built in Memphis, Tennessee, in 1952.

Holiday Inn's distinctive green was a popular color choice for motel signs during the second half of the 1950s.

The name "Holiday" proved to be the element with the most longevity. Even as formal trends changed, the word continued to resonate with customers, most of whom were on vacation.

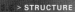

As compositions became more complex, structure became an increasingly important element of the sign. Structure was used either as an abstract framework for organizing the sign's varied elements or as a conceptual and visual connection to a motel's architecture. Only rarely was it used as an overtly thematic component of the sign, as it had been during the late 1940s and early 1950s.

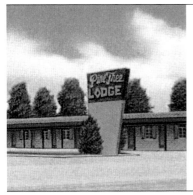

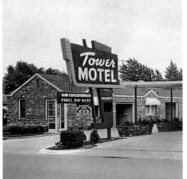

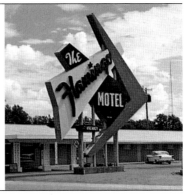

Early attempts to make structure an important aesthetic component were focused on creating a solid, relatively permanent visual barrier that contrasted with the natural context and related to the man-made one. This early-1950s structure for the Pine Tree Lodge in Gallup, New Mexico, was massive and therefore more noticeable. It was built from the same materials as the motel building, thus creating a visual connection between the sign and the architecture.

The sign box for the Tower Motel sign in Oklahoma City conveyed the visual weight of earlier, architectural structures like the Pine Tree Lodge's, but the structure consisted of easy-to-install metal poles. Unlike traditional pole structures, however, their placement was determined as much by aesthetic reasons as by functional ones. The gradual return to pole-based structures also made it possible to build taller signs—those constructed from architectural building materials had to remain relatively small.

Poles made it easy to arrange separate, irregular components such as those on the Flamingo Motel sign in Elk City, Oklahoma. They were readily available and did not require specialized labor, as did architectural materials like brick.

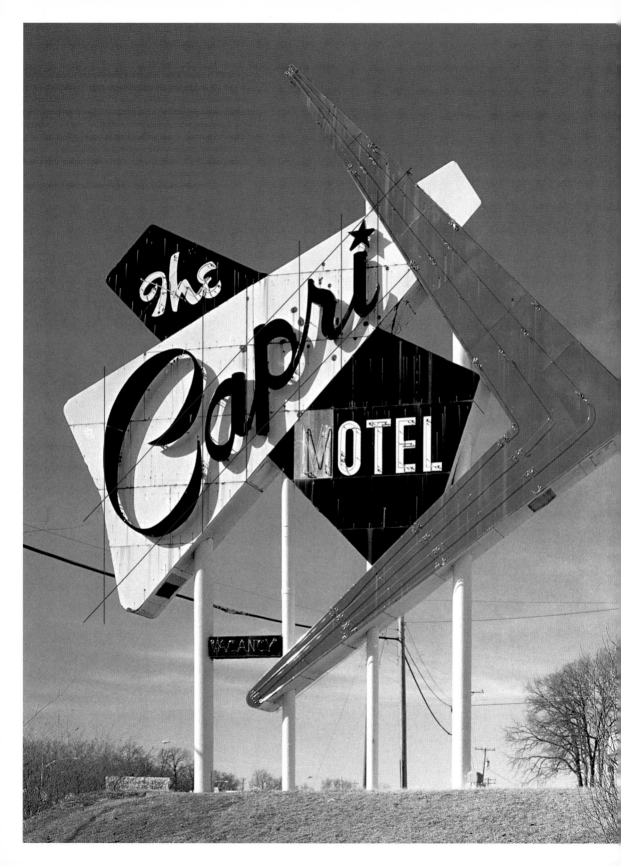

Signmakers reconsidered almost all aspects of a sign's design during the early 1950s, including the way in which type was used. The simple, sans serif style traditionally used to identify motel names was abandoned for more expressive, stylized or script type that conveyed a personal touch. "'Make it look like handwriting,' was the usual request heard from a client indicating a desire for script," wrote signmaker Bob Fitzgerald. Text was often set on a diagonal or curve to create even more energetic compositions that helped to highlight a sign's most individualized identifier, its name. The type treatment used for "motel," however, consistently remained sans serif. This was one of the only elements that remained traditional throughout the period.

Man/Nature Interaction

GARDENWAY MOTEL
PARK PLAZA MOTEL
FOREST MANOR MOTEL
LAKEVIEW MOTEL
GREEN ACRES MOTEL
CAVE PARK MOTEL
PARK LANE MOTEL
EVERGREEN GABLES MOTEL
TOWN AND COUNTRY MOTOR HOTEL
PARKVIEW MOTEL
GATEWAY MOTOR HOTEL
RAILFENCE MOTEL

Man-Made Constructions

SATELLITE MOTEL
ROCKET MOTEL
HIWAY HOUSE MOTEL
BYPASS MOTEL

Many pre-1950s motels had names inspired by the natural environment—the Forest Motel in Amarillo, Texas, for example—which reflected their symbiotic relationship with the surrounding area. As the economy boomed in the 1950s, advances in the technology, chemical, and building industries, among others, redefined America's relationship with nature. New "wonder drugs," faster cars, jets, superhighways, and the nascent space program were all evidence of mankind's power to control and shape the natural world.

When new motel names included a reference to nature, they reflected this control. Names such as "Park Plaza" or "Railfence" conveyed—subtly and not so subtly—the trend toward defining nature through man's impact on it. As the decade progressed, references to nature became less common. Instead, motel names paid homage to technological achievements—most commonly space travel ("Satellite Motel") and the new suburban landscape ("Hiway House Motel"). Keeping with the theme of progress, "motor hotel" became a popular alternative to "motel." The reintroduction of "motor"—which had been subsumed into "motel" in the early 1940s—emphasized both the technological advances of automobiles and America's ever-increasing love of car travel.

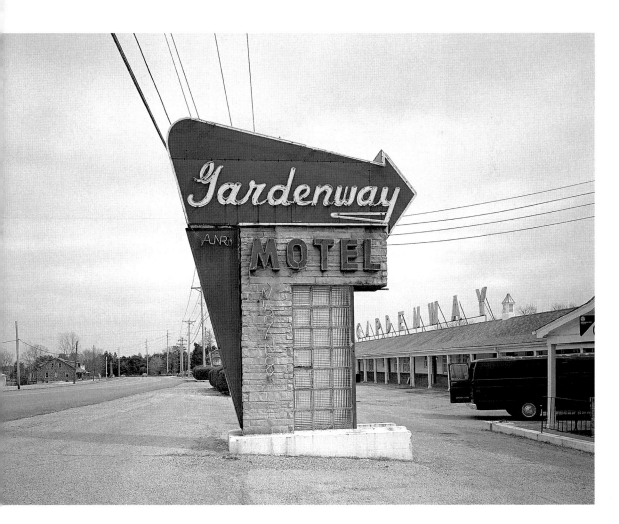

The motel chains that began to emerge in the 1950s followed some of the same naming trends that independents did. Holiday Inn, the most successful of the 1950s chains, adopted a name with no connection to local geography, environment, or culture. A locally specific name would have been inappropriate for a business with widely diverse locations—from the beginning, Kemmons Wilson, the company's founder, envisioned a chain with hundreds of locations. The signmaker chose the name when he watched the 1942 film *Holiday Inn* while working on the design, and Wilson approved. The word "holiday" was fitting since it was devoid of local context, and the signmaker's use of a movie title was in keeping with the era's trend toward external inspiration.

Although the basic design of the Holiday Inn sign remained consistent for many years, the function part of the chain's name changed. The chain debuted as the Holiday Inn Hotel Courts; this was followed by Holiday Inn Hotel and Holiday Inn Motel. Eventually the chain's brand identity was strong enough that the function was dropped altogether; in 1957 the chain became simply Holiday Inn.

| 1952 | → | 1955 | → | 1957 |

The first Holiday Inn was built in 1952 in Memphis, Tennessee. Although the business name already contained both the name, "Holiday," and the function, "inn," the sign also included both "hotel," to imply that it was upscale, and "courts," to connect it with competing independent motels.

In the mid-1950s, Holiday Inn replaced "hotel" with the more modern "motel." Increasingly, hotels were perceived as being expensive and overly formal, and this change in nomenclature emphasized that Holiday Inn's pricing was competitive with other independent motels.

By 1957, the Holiday Inn chain began to expand across the United States. Its widespread recognition made the clarification provided by "motel" unnecessary, and it was permanently dropped.

Signs of the 1950s contained many more colors than earlier examples, primarily because of their marketing potential. The colors used for signs were named in much the same way as motels: they were inspired by nature but reflected human intervention in it. While 1940s color names such as "plum" suggested natural things useful or valuable to people but not altered by them, the colors of the mid-1950s were often named after natural substances in modified states. For example, "grass" is natural, as is "rose," but both exist primarily in the cultivated form: that of a well-manicured lawn or a hybridized shrub. Likewise, "butter," "cream," and "brick" are all things made by people from simple, natural ingredients. Other colors used during this era, such as sand, aqua, and "holiday turquoise," were used to project an image of exoticism and leisure.

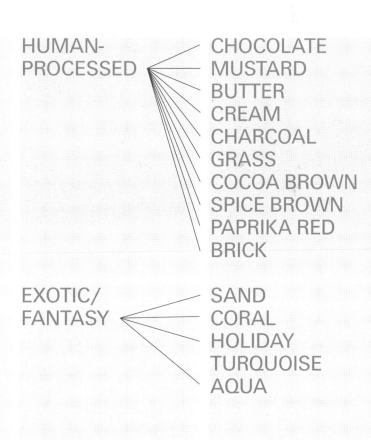

COLOR
NAMES

HUMAN-
PROCESSED

CHOCOLATE
MUSTARD
BUTTER
CREAM
CHARCOAL
GRASS
COCOA BROWN
SPICE BROWN
PAPRIKA RED
BRICK

EXOTIC/
FANTASY

SAND
CORAL
HOLIDAY
TURQUOISE
AQUA

Symbolism, used in conjunction with specific forms, helped signmakers to amplify desirable attributes such as being up-to-date or culturally themed. Signs could be made to appear progressive, by adding trendy, stylized details, or regressive, by including historical symbols. While representational symbols, such as plants and animals, were popular in the late 1940s, the 1950s saw a return to abstracted symbols. This helped to emphasize a sign's modernity and individuality. "The trend," wrote a reporter for *Signs of the Times*, "seems to be that clients not only will accept symbols as part of the advertising message, but seem to be insisting on them."

The ultimate goal of using symbols to make a sign appear progressive was the same during the mid-1940s and the early 1950s, but there were fundamental differences. The earlier decade's symbols, such as Art Deco flourishes, were used because they amplified a sign's up-to-dateness without breaking the traditional rules of symmetry and geometric rigidity. Some of the symbols used during the 1950s, such as arrows and stars, had their origins in earlier signs but were used for the opposite reason: they made a sign appear less traditional through their abstracted, exaggerated forms and asymmetrical arrangements.

❶ Angled Forms

During the early 1950s, the design of cars, houses, furniture, art, and signs was influenced by the overwhelming popularity of angled forms. They added a heightened sense of originality and modernity to the objects they influenced, and for signs, they had the added benefit of making it possible to project a sign toward oncoming traffic, thereby making it more noticeable to passing motorists.

❸ Abstracted Symbols

Abstraction was a sophisticated conceptual exercise previously explored primarily in modern art. In the early 1950s, signmakers began to incorporate abstracted symbols in their signs in an effort to elevate them aesthetically. From references in trade journals, it seems likely that their ideas came primarily from the works of well-known Abstract Expressionist painters such as Jackson Pollock.

❷ Irregular Shapes

Irregular shapes represented, on some level, a rejection of previous, more geometric sign shapes. This shift away from anything old-fashioned was repeated countless times throughout American culture, as consumers' pent-up demand for newness encouraged designers to invent new forms.

❹ Asymmetry

Asymmetric form and shape were also, though to a lesser degree, an outward expression of the pressure signmakers' felt to innovate in any way they could. Moving away from the tried and true forms of symmetrical signs was an important element in creating new, original designs.

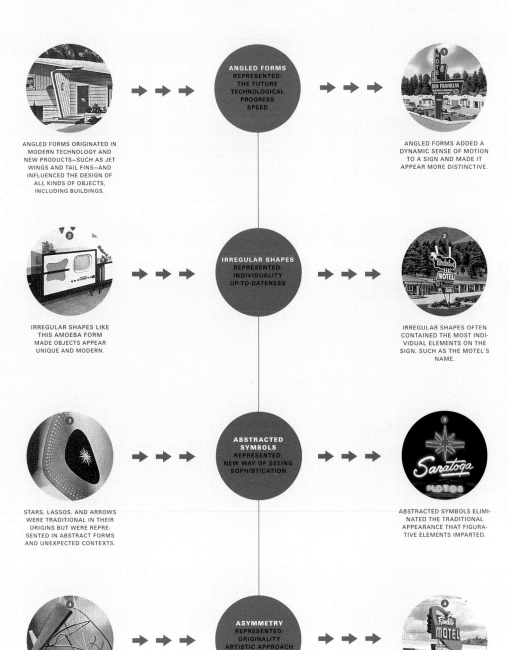

ANGLED FORMS
REPRESENTED:
THE FUTURE
TECHNOLOGICAL
PROGRESS
SPEED

ANGLED FORMS ORIGINATED IN MODERN TECHNOLOGY AND NEW PRODUCTS—SUCH AS JET WINGS AND TAIL FINS—AND INFLUENCED THE DESIGN OF ALL KINDS OF OBJECTS, INCLUDING BUILDINGS.

ANGLED FORMS ADDED A DYNAMIC SENSE OF MOTION TO A SIGN AND MADE IT APPEAR MORE DISTINCTIVE.

IRREGULAR SHAPES
REPRESENTED:
INDIVIDUALITY
UP-TO-DATENESS

IRREGULAR SHAPES LIKE THIS AMOEBA FORM MADE OBJECTS APPEAR UNIQUE AND MODERN.

IRREGULAR SHAPES OFTEN CONTAINED THE MOST INDI-VIDUAL ELEMENTS ON THE SIGN, SUCH AS THE MOTEL'S NAME.

ABSTRACTED
SYMBOLS
REPRESENTED:
NEW WAY OF SEEING
SOPHISTICATION

STARS, LASSOS, AND ARROWS WERE TRADITIONAL IN THEIR ORIGINS BUT WERE REPRE-SENTED IN ABSTRACT FORMS AND UNEXPECTED CONTEXTS.

ABSTRACTED SYMBOLS ELIMI-NATED THE TRADITIONAL APPEARANCE THAT FIGURA-TIVE ELEMENTS IMPARTED.

ASYMMETRY
REPRESENTED:
ORIGINALITY
ARTISTIC APPROACH

ASYMMETRICAL DESIGN, LIKE IRREGULAR SHAPES, WAS A SYMBOL OF NEW, PROGRESSIVE DESIGN.

ASYMMETRY WAS UNEXPECTED AND, LIKE ANGLED FORMS, HELPED TO CREATE DYNAMIC COMPOSITIONS THAT HAD MORE IN COMMON WITH CONTEMPORARY ART THAN WITH OTHER SIGNS.

Large arrows were popular additions to signs, since they served both as expressive components that enticed and directed customers and as decorative elements that could distract from a sign's flaws. "Any time a designer runs into trouble with some structural problem," wrote signmaker Lucian Howze, "that customer may find that he is getting an arrow on his sign, even though he didn't know before that he needed it."

As highways became increasingly congested and difficult to navigate, motels and other roadside businesses began to place their buildings farther back from the road to accommodate increased traffic and parking. With buildings hidden from immediate view, signs became even more important in attracting customers; large arrows helped to make a unique statement while pointing the way.

❶ Early-1950s arrows had tails of uniform width and often included a rudder at the opposite end of the point. They either bordered the main sign box or were physically integrated into the sign.

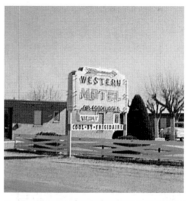

❷ Mid-1950s arrows were expressive, dynamic, and forceful. Arrowheads were large, and tails were wide or of varying width for visual impact.

❸ By the late 1950s, tails were dropped altogether. This was part of an overall trend toward a simplification of all sign elements.

The lasso first appeared in the late 1940s on Western-themed signs. It gained popularity in the 1950s, though by then it was rarely a literal lasso. It appeared as an artist's palette in some signs but more often as an amoeba form, without a concrete meaning. Because the shape appeared to be unlike a traditional sign box—though in many cases it was just an altered rectangle—signmakers used it to communicate originality and uniqueness. The amoeba form was also a widely used symbol of modern design, appearing on consumer goods, textiles, furniture, and printed pieces.

① Earlier signs used lassos as explicit symbols, either juxtaposed with a cowboy and horse as seen in this example in Flagstaff, Arizona, or in combination with the word "lasso."

② Later examples were more abstract than earlier ones. Lassos were usually distinct elements and were rarely combined with other Western-themed illustrations such as cowboys. The name, however, usually conveyed a Western theme.

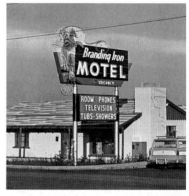

③ Late-1950s lassos were completely abstract; the signs that contained them had no references to Western themes. Their irregular, expressionistic shapes were what appealed to signmakers.

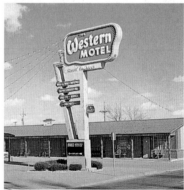

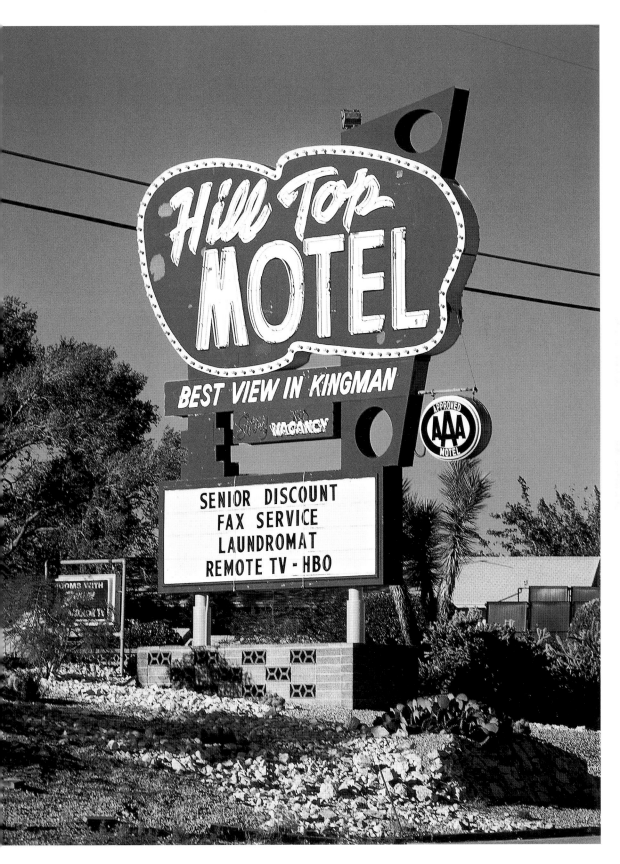

3.9 > SYMBOLISM: STARS

The star is one of the most enduring symbols used on motel signs. Until the late 1940s, it symbolized quality of service and was rendered simply, with little design detail. By the late 1940s, the shift toward regional themes resulted in the star's reinterpretation as a Native American, Spanish, Mexican, or Western symbol. Stars resurfaced in the 1950s as a favored decorative element, but like the arrow, the form was altered to reflect new meanings. The trade journals called them either "asterisks," a name originated by the designers who created them from standardized alphabets, or "sputniks," after the new phenomenon of space travel. Asterisks were always two-dimensional, consistent with their origin on the printed page. Sputniks were three-dimensional, like the satellites they referred to. These new names and forms were progressive, a quality traditionally constructed stars did not convey.

Composition

Until the 1950s, the integrity of the basic sign box was rarely altered. Signmakers used decorative elements—Art Deco steps, smaller panels, figurative shapes—but these were additions to the box, not departures from it. When signmakers began to make signs that were deliberately non-traditional, the most obvious and dramatic candidate for change was the composition. Signs became fragmented, irregular, and composed of loosely overlaid forms, dynamic arrangements of asymmetric shapes that represented a dramatic shift from older compositions.

3.10 > ASYMMETRY

A 1951 *Signs of the Times* article described the two most common ways sign compositions were generated during this period. In the first method, "a rectangle is drawn and then the perimeter of the rectangle is taken from or added to until a design is arrived at." The Rolla Rancho Motel in Rolla, Missouri, is an example of this type.

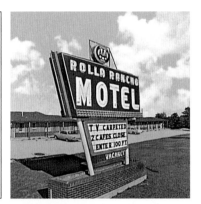

In the second technique, two or three different shapes are "played with in thumbnail sketches and brought together in various combinations until an unusual effect or suitable arrangement presents itself." The asymmetrical combination of forms on the Holbrook Motel sign in Holbrook, Arizona, is representative of this method.

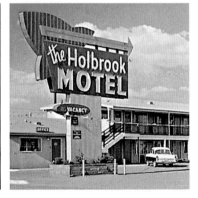

Signmakers arranged their compositions asymmetrically because it was considered innovative to do so. "Slant signs" were the most common type of asymmetrical sign. They were designed to lean precariously in one direction—generally but not always away from the motel and toward the highway, to better attract passing motorists.

Signs became progressively more asymmetrical and fragmented. Early-1950s signs were often one irregular shape; later examples contained several individual forms that were distinctly separate from each other. By the end of the decade, almost every element of a sign was separate, as designers pursued ever more unconventional compositions and as new, modular components became widely available.

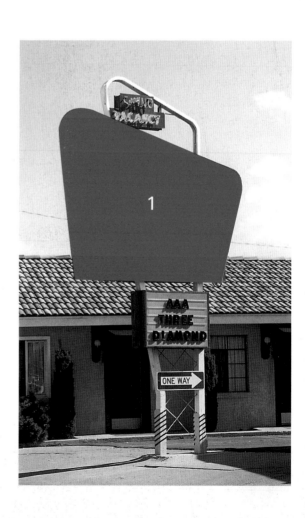

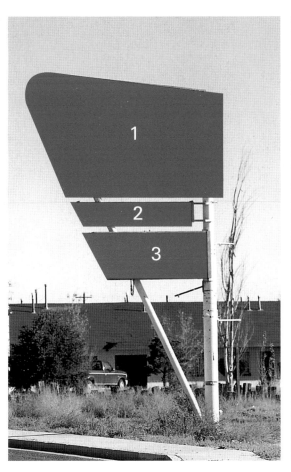

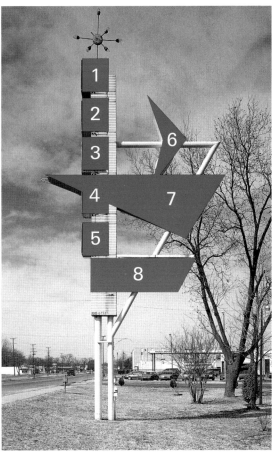

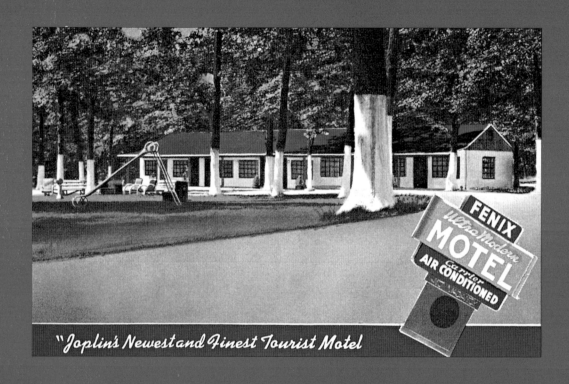

"Joplin's Newest and Finest Tourist Motel

The appeal of asymmetry was so pervasive that some motel owners who
had not yet updated their signs produced postcards that mimicked the effect.

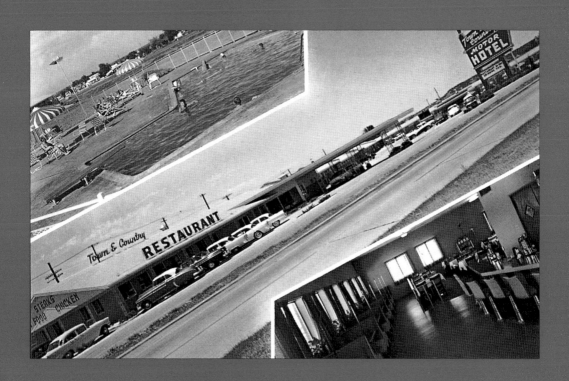

Context

As they had in the late 1940s, signs continued to maintain their separation from their natural surroundings, both physically and symbolically. However, connections between a sign and other man-made constructions, such as the highway or the building it identified, were often intensified. Designs ignored local and regional traditions and cultures in favor of more individual, expressive compositions that were formally distinct from historical examples.

3.11 > NATURAL CONTEXT

The idea of human control over nature, which was seen in business and color names of the period, also found expression in the landscaping of motel grounds. During the 1940s, native plants found on motel property were usually preserved and made part of the motel's identity. In the 1950s, by contrast, existing vegetation was cleared away and replaced with non-native or exotic plants composed in neat arrangements and confined within man-made containers at the base of the sign and close to surrounding buildings.

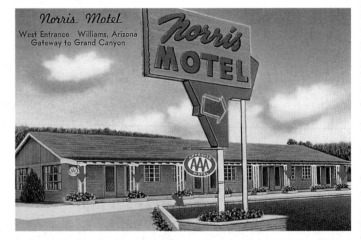

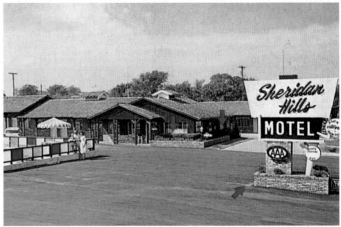

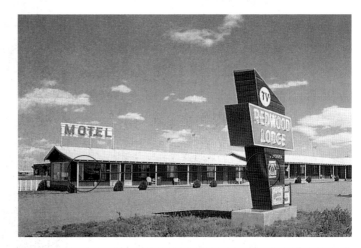

3.12 > ARCHITECTURAL CONTEXT

Signs built during the 1950s often conveyed an amplified formal connection to the buildings they identified. This connection was achieved primarily through the use of identical materials on both sign and building. These materials were generally architectural, such as brick or wood, not those traditionally used for signs. By incorporating such materials, signmakers revealed their insecurity about their diminishing role in the signmaking process as that of the architect was expanding. It also seems likely that, as signmakers turned away from nature as a source of inspiration, they focused instead on strengthening the relationship between their signs and buildings, roads, and other constructions.

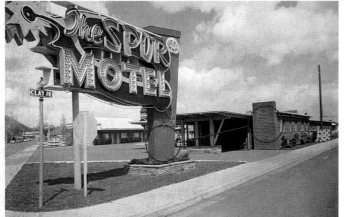

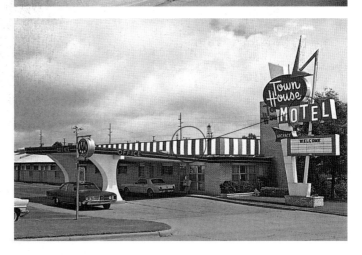

Before creating a sign, signmakers often surveyed traffic patterns and competition in the area. Arrows were applied to signs to help direct traffic to the business and for visual impact. The key element of sign design in the 1950s, however, was differentiation along the increasingly crowded highway strip. A *Signs of the Times* article described a good designer as one who "studies the area in which the sign is to be placed, so that it will be in contrast to the others." This was a significant departure from the methods of 1940s signmakers, who studied the surrounding landscape in order to harmonize with it.

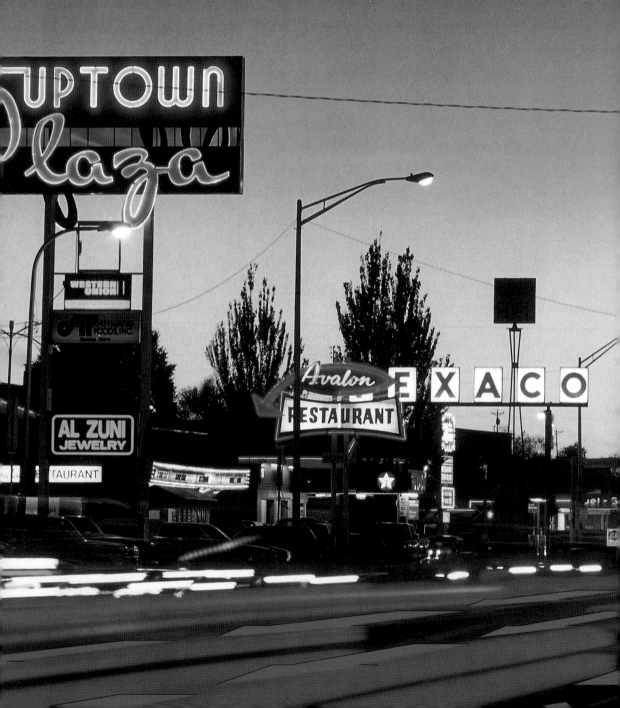

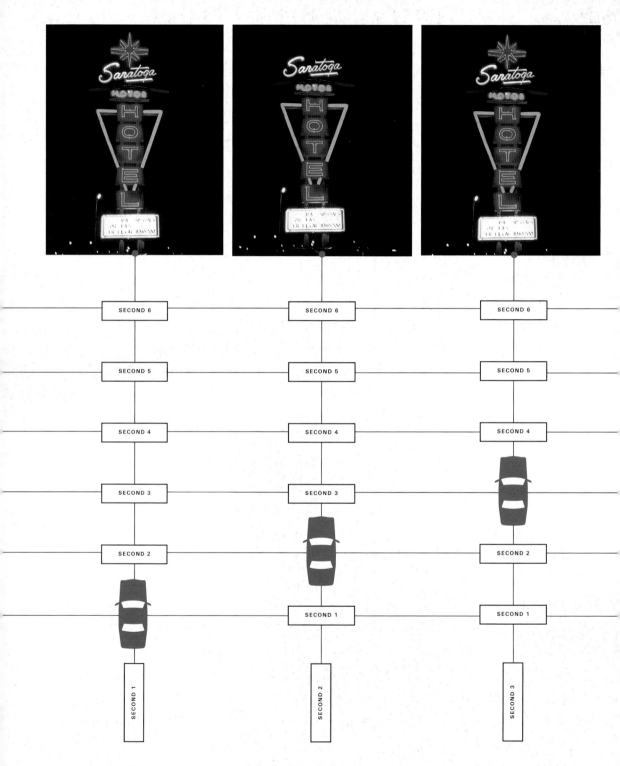

Signs were designed to be an integral part of the three-dimensional landscape. Taking into consideration both cars and competition, signmakers combined all available light technologies—bulbs, neon, and fluorescents—with animation and flashing effects. Sign animations were precisely timed so motorists could absorb the complete message in a strictly limited period of time.

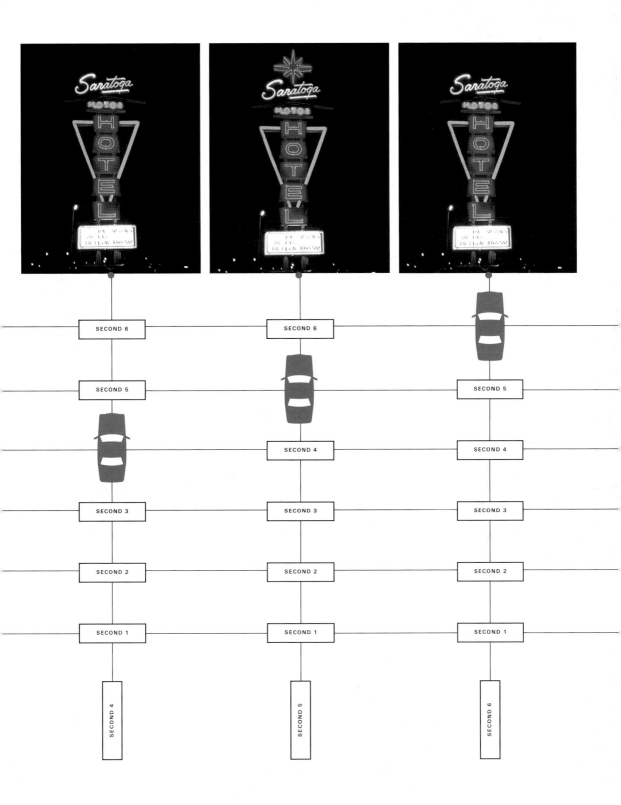

As signmakers focused on the conceptual possibilities offered by the future, local and regional context became less important. "Forward looking signmen," suggested signmaker Lucian Howze, "must expand their sales from a local operation into a statewide or multi-state business. Improved roads and better cars and trucks aid in expanding the territories." Regional symbols became increasingly rare, and those that did appear during this era were usually inappropriate—flamingos in Oklahoma, for example. These did not so much capitalize on tourists' unfamiliarity with a region, as did themed signs of the late 1940s and 1950s, as they reflected the belief that man could create an ideal environment anywhere.

Most of the signs that placed a premium on self-expression and originality could have been installed in any city or town. (In fact, chain signs like Holiday Inn's were already being designed without a chosen site in mind.) They could exist anywhere precisely because they were appropriate nowhere—their symbols and forms lacked conceptual ties to any particular location. This movement away from context as a source of inspiration opened the door for chains, which were developing consistent brand identities that could be repeated in any location. By the late 1950s, the country was primed for the rapid expansion of national chains and franchises.

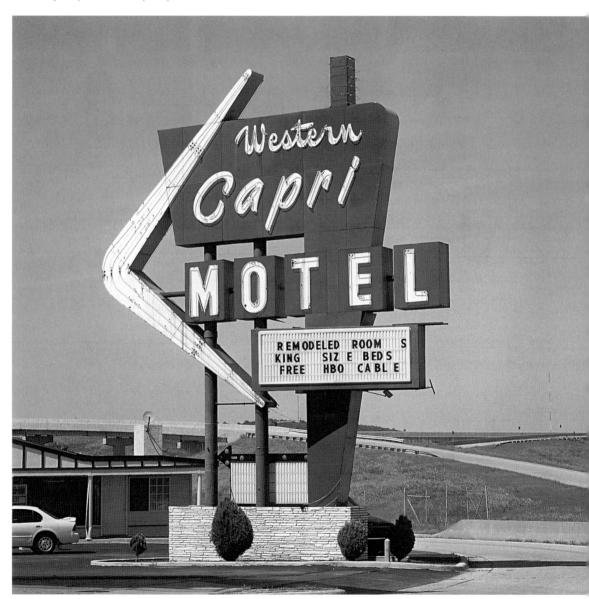

MANUFACTURED FANTASY ENVIRONMENTS

NEWLY DISCOVERED OR "CONQUERED" ENVIRONMENTS

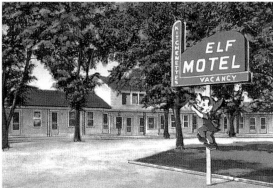

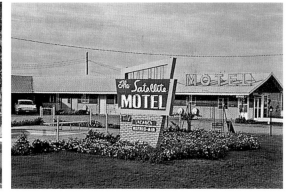

Motel signs often included references to foreign things—like elves or exotic plants and animals—that would never be found naturally in the area where the motel was located. Unusual themes were generally included for one of two reasons: to transport the customer to a fantasy world of relaxation and comfort, or to create the impression of originality and uniqueness.

As space travel became an inevitable reality during the late 1950s and early 1960s, signmakers began to incorporate the symbols that represented this new "conquered" context. Rockets, satellites, and sputniks glorified technological progress as well as man's ability to overcome the forces of nature.

Conclusion

At the demand of their clients, signmakers in the 1950s rejected traditional methods of composition to create signs that were unique and original. Inspiration came not from nature, local culture, or the signmaking tradition but from developments in art, popular culture, and science and also from a firm belief in the promise of the future. The cultural focus on technological achievements encouraged confidence in man's ability to control and improve the environment. Signs exemplified this tendency in every way, from a widespread use of symbols such as "sputniks" as ornamentation to the containment of a motel's landscaping in geometric planters.

New directions in design and art, especially the development of Abstract Expressionism, also influenced the way signs were conceived. Many of the qualities of Abstract Expressionism could be found in the new signs: they depicted forms not drawn from nature, they placed an emphasis on personal emotional expression rather than communal expression, and they abandoned conventional compositional structures.

The emergence of a new professional design industry in the United States, and the influence of artists and designers who had fled Nazi-dominated Europe, were also responsible for a shift away from traditional methods of composition. New ways of working, foreign to both the signmaking tradition and American culture, were introduced and integrated into the signmaker's repertoire. The new availability of television also helped to blur cultural boundaries.

By the end of the 1950s the explosion of new forms was subsiding. Modular signmaking technologies became increasingly popular, which made the creation of new signs easier yet encouraged standardization. This would lead to a return to simple, easy-to-build forms and would also pave the way for existing motel chains to become more standardized.

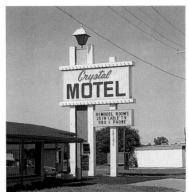
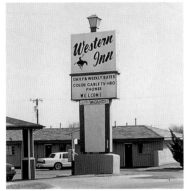
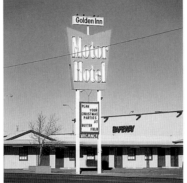

4

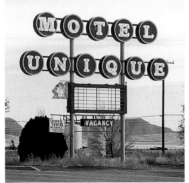
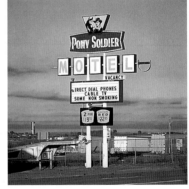
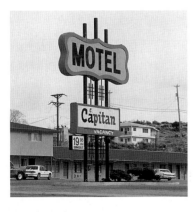
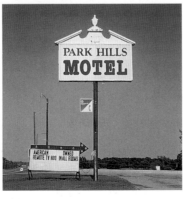

Specialization, Modularity, Segregation: 1957–1965

The late 1950s and early 1960s was a defining period for the sign industry. For the first time, signmakers no longer guided the complete process of conceiving, building, and installing signs. The most important reason for this loss of control was the increased affordability of plastic, which stimulated the production of more regularly shaped, "modular" components. These prefabricated plastic elements were one factor in the explosive growth of motel chains; the lightweight, identical signs they used were inexpensive and easy to transport and install. The national nature of the chains also required the development of brand identities that could be applied to all corporate materials, not just signs. This trend toward national branding, which was repeated throughout corporate America, accelerated the rise of a new group of professional designers, including industrial and graphic designers, architects, and art directors, who were hired, instead of signmakers, to provide complete design and branding services.

It was not only the chains that turned to "professionals" for design services. Independent motel owners continued to demand original designs; to get them they occasionally hired professional designers directly, especially the architects who were already designing their motels, or encouraged signmakers to find outside creative talent. By the late 1950s, many sign businesses were hiring freelance art directors to do design work. This assault on signmakers' creative abilities—by both clients and professional designers—continued throughout the early 1960s. Eventually, signmakers accepted the idea that others were better equipped to provide design direction. Even though the motel industry expanded at a blistering pace, the role, and the ego, of the signmaker began to wither.

Route 66 enjoyed explosive growth during these years, benefitting from the era's incredible prosperity. Yet this affluence also highlighted the disparity between the haves and have-nots, both economically and racially. Many in a position to protect their wealth and social standing, such as business owners, became more conservative. Some motel owners and signmakers included symbols on their signs, such as colonial-style letters and lanterns, meant to attract customers who were, as a *Signs of the Times* article proclaimed in 1963, "looking for a place where they and their children could rest among people of their own class." (It went without saying that these people would also be of their own race.) As symbols of America's mythic past, colonial embellishments reinforced a business's stature and assured customers that they would be with the "right" sort of people.

Concept

As professional designers made inroads into the industry, the creative role of the signmaker shrank. In many cases, his tasks were reduced to the implementation of others' designs and the assembly and installation of prefabricated components. More often than not, design conceptualization was simply a process of choosing plastic components from a catalog. For sign shops still trying to provide design services, the challenge shifted from finding creative ideas to finding creative talent. They began searching for professionally trained art directors for newly created in-house design departments, which were isolated from the sales and production staff. Formally, signs reflected that they had been conceived as a kit of parts—signmakers composed with the parts rather than the whole in mind.

4.1 > INFLUENCES/SOURCES

The increased specialization and division of labor among signmakers and designers and their new production methods determined, in large part, how signs were conceived. Standardized components, which were cheap and easy to manufacture, limited design options, making necessary a new definition of originality. These regular and symmetrical components also reflected the needs of motel chains. The chains required signs that were easy to recognize and read at high speeds, would fit in anywhere, were inexpensive, and were easily transported. Architects, too, preferred more restrained designs that would not compete formally with their buildings. And simple, regular forms were coming into vogue as designers began to address the needs of a mass society and rejected the expressionistic originality of the 1950s. Design concepts were informed not so much by the designer's own experience or ideas as by knowledge gleaned from the extensive consumer interviews that industrial designers, hired by many motel chains, used to validate their decisions.

Although ornamentation became less effusive, off-the-shelf, prefabricated symbols were often added to a sign to make it appear more conservative. Colonial elements, especially those that symbolized wealth—such as Chippendale forms and lanterns—were especially popular. As the country fought over civil rights, these symbols were used to reinforce longstanding divisions of class and race.

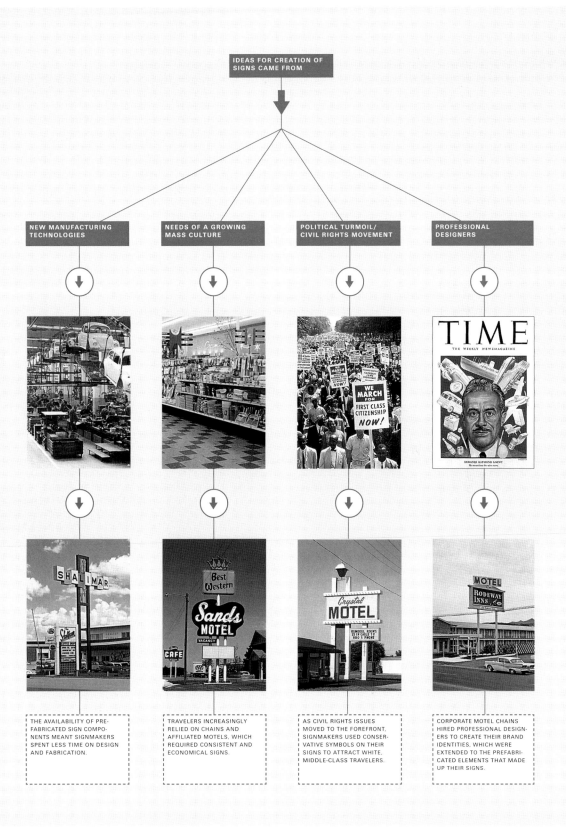

IDEAS FOR CREATION OF
SIGNS CAME FROM

NEW MANUFACTURING
TECHNOLOGIES

NEEDS OF A GROWING
MASS CULTURE

POLITICAL TURMOIL/
CIVIL RIGHTS MOVEMENT

PROFESSIONAL
DESIGNERS

THE AVAILABILITY OF PRE-
FABRICATED SIGN COMPO-
NENTS MEANT SIGNMAKERS
SPENT LESS TIME ON DESIGN
AND FABRICATION.

TRAVELERS INCREASINGLY
RELIED ON CHAINS AND
AFFILIATED MOTELS, WHICH
REQUIRED CONSISTENT AND
ECONOMICAL SIGNS.

AS CIVIL RIGHTS ISSUES
MOVED TO THE FOREFRONT,
SIGNMAKERS USED CONSER-
VATIVE SYMBOLS ON THEIR
SIGNS TO ATTRACT WHITE,
MIDDLE-CLASS TRAVELERS.

CORPORATE MOTEL CHAINS
HIRED PROFESSIONAL DESIGN-
ERS TO CREATE THEIR BRAND
IDENTITIES, WHICH WERE
EXTENDED TO THE PREFABRI-
CATED ELEMENTS THAT MADE
UP THEIR SIGNS.

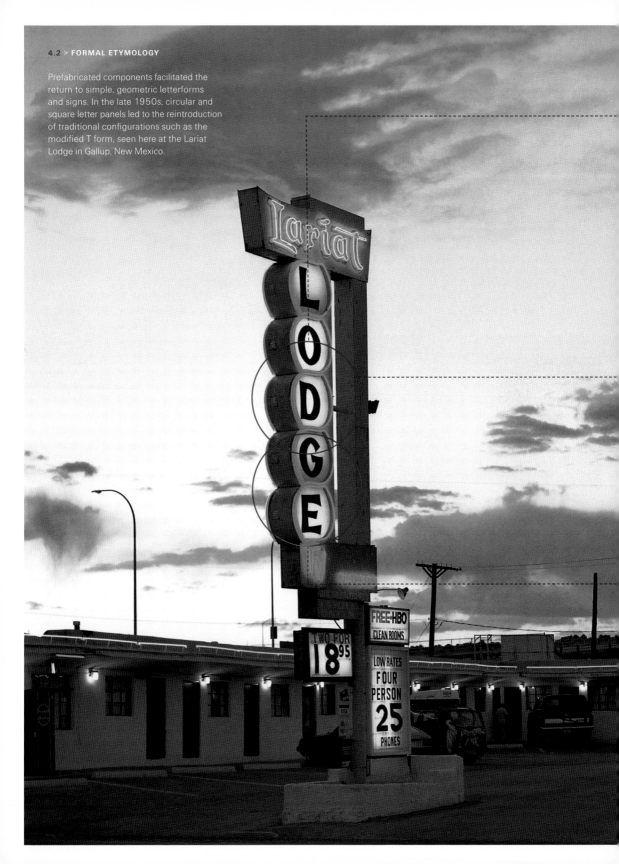

Prefabricated components facilitated the return to simple, geometric letterforms and signs. In the late 1950s, circular and square letter panels led to the reintroduction of traditional configurations such as the modified T form, seen here at the Lariat Lodge in Gallup, New Mexico.

The Lariat's original sign, built in the 1940s, was a traditional T form, quite similar to the later version. "Lariat" appears horizontally at the top of both signs, and the function ("motel" on the old and "lodge" on the new) appears vertically in square, capital letters. Colors are simple (blue and white on the old and black and white on the new) and have no conceptual relationship to the name of the motel.

The early 1950s version of the sign emphasized the Western theme through illustrations of a cowboy, lariat, and saguaro cactus and the phrase "Howdy Pardner." The word "motel" was abandoned for "lodge," which strengthened the sign's thematic content.

The typestyle used on the modular panels is proportionally square and all capital letters, as was the type used on the 1940s and 1950s iterations of the sign. This facilitated both vertical and horizontal arrangement of the letters and was in keeping with traditional patterns.

Modular, prefabricated sign components had parallels in many consumer products, such as this shelving designed in 1959. Individual components could be combined in various ways and were guaranteed to fit together because of their standardized dimensions. Creativity was expressed by the combination of elements rather than by the elements themselves.

Geometric patterns could be found on a variety of household products. Pure forms—such as the circle and the square—were often reproduced in multiples, as in this early 1960s fabric designed by Brita Ahlgren. Repetition and precision were modern traits that were thought to enhance the object's visual appeal.

Components

By the early 1960s, the transition from custom-shaped metal sign boxes to prefabricated plastic elements was nearly complete. The formal vocabulary of these new modular components was usually geometric and abstract. With the exception of a small revival of colonial symbols, signs contained few referents; illustrations were avoided, as were names that referred to nature or particular places.

METAL: SIGN SHOP

FABRICATION

4.3 > MATERIALS

Hand-painted metal signs remained popular until the late 1950s, when plastic became more affordable and its stripped-down simplicity became culturally acceptable. Although metal signs were rapidly becoming obsolete, sign shops continued to produce them because they could design, build, install, and service them without outside help. Professional designers preferred plastic because it was flexible, precise, and often allowed them to bypass the sign shop. Plastic manufacturers helped promote their material to art directors and industrial designers by producing standard panels in proportions that directly related to a format they were familiar with, the photograph.

Before 1960, there was little justification for paying a premium for a material that allowed for the identical reproduction of a sign. As year-round travel became the norm, however, the popularity of motel chains greatly increased. The chains' demand for identical signs, coupled with the new affordability of plastic, quickly made the material the new industry standard.

PLASTIC: OUTSOURCED

Although many metal signs of the late 1950s contained irregular shapes, the standard metal sheets they were made from maintained a traditional 1:2 proportion. As signs became larger in order to address increased travel speeds—and more crowded highway strips—the weight of metal signs became a limiting factor. By the early 1960s, most sign shops had switched to plastic.

TRADITIONAL DOUBLE-SQUARE PROPORTIONS

In the early 1960s, plastic was considered glamorous, beautiful, and extremely upscale. Many clients were willing to pay a premium for the image the material afforded. More important, plastic made it possible to reproduce trademarks exactly, reinforcing national advertising (a relatively new phenomenon) at the local level.

Most plastic panels were made with the same proportions as photographic film—appropriate to the new class of professional designers they were marketed to. Sign shops could purchase sheets to cut down and apply prefabricated letters, or buy complete, ready-to-install signs. The ease with which an entire sign could be duplicated accelerated the process of standardization and gave budding motel chains a significant cost advantage over independents.

PROPORTIONS OF 4" X 5" FILM

PROPORTIONS OF 35MM FILM

Plastic is an especially versatile m
1) Plastic is available for white ba
paper upon which most printed a
offers three-dimensional letters a
eye better than do flat signs. 3) P
translucent colors for good cont
and letters can be illuminated fo
a glamorous material, which ca
6) Plastic lends itself particularly
als and trademarks. 7) Plastic ha
in daylight. 8) Many prospects a
plastic at night and the beauty of
and up-to-date. 10) Plastic signs
not require periodic repainting.

LUCIAN HOWZE, "BETTER LOOK TO SIGN DESIGN FOR INCREASED SALES," *SIGNS OF THE TIMES*, OCTOBER 1958

erial for today's sign market:
grounds, which matches the white
and posters are seen. 2) Plastic
backgrounds, which attract the
tic is available in a variety of rich,
s. 4) The entire face of the sign
ghttime advertising. 5) Plastic is
res the imagination of viewers.
l to realistic and dramatic pictori-
ecidedly strong reading qualities
ascinated by the soft elegance of
erall illumination. 9) Plastic is new
tain their color brilliance, and do

While late-1950s signs continued to contain some irregular shapes, the trend was toward rectilinear forms and symmetrical configurations. "The use of rectangles in sign design," wrote signmaker Clint Hewlett in 1960, "does not necessarily mean monotony. Employing minor embellishments in structure and detail will deviate from the squareness without imposing on the simplicity and good taste in this most common of shapes." The evolution of the "bowtie" form illustrates the transition from expressive to more traditional, regular shapes. During its relatively short period of popularity, the bowtie progressed from very animated examples to ones that were boxy and rectilinear. Although the sign boxes were somewhat irregular, the overall form was based on the traditional geometric building block, the square.

METAL: THE BOWTIE FORM 1957–60

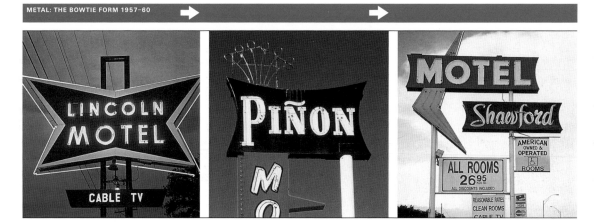

An early example of the bowtie form, the Lincoln Motel sign in Chandler, Oklahoma, is dynamic and exaggerated, although symmetrical in both directions.

On this sign for the Piñon Motel in Albuquerque, New Mexico, the bowtie is minimized by softer curves and a more subtle delineation of the form.

In later examples, such as this sign for the Shawford Motel in Santa Rosa, New Mexico, the angled or curved edges on the top and bottom are replaced with straight lines.

The idea behind modular sign components—that they would be interchangeable and easily assembled into a composition—dictated, to a great extent, their form. Shapes had to be simple and consistent, for ease of manufacture, but also adaptable to a wide variety of configurations. This also gave modular components many of the same attributes as traditional forms: they were geometric, symmetrical, and easily repeatable. Letter panels were often manufactured in photographic proportions—as sign panels were—but square and circular examples were not uncommon. Early signs made with modular elements tended to be bold, playful, and segmented, like metal signs of the same period. Later examples more closely resembled traditional 1940s signs, with symmetrical configurations.

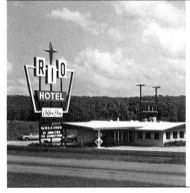 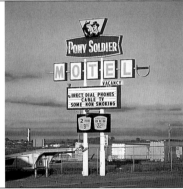 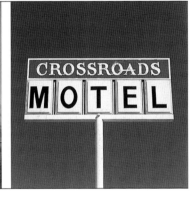

Early modular signs, like this early-1960s example in Tulsa, Oklahoma, gained their expressive quality primarily through the irregular placement of regular forms.

In this later sign in Tucumcari, New Mexico, letter components were placed along a uniform, horizontal baseline. The letters are still modular, but with a horizontal separation between them.

The modular nature of the letters on this motel sign in Albuquerque, New Mexico, is de-emphasized. Letters are butted up against each other, stressing the word "motel" rather than the individual letters.

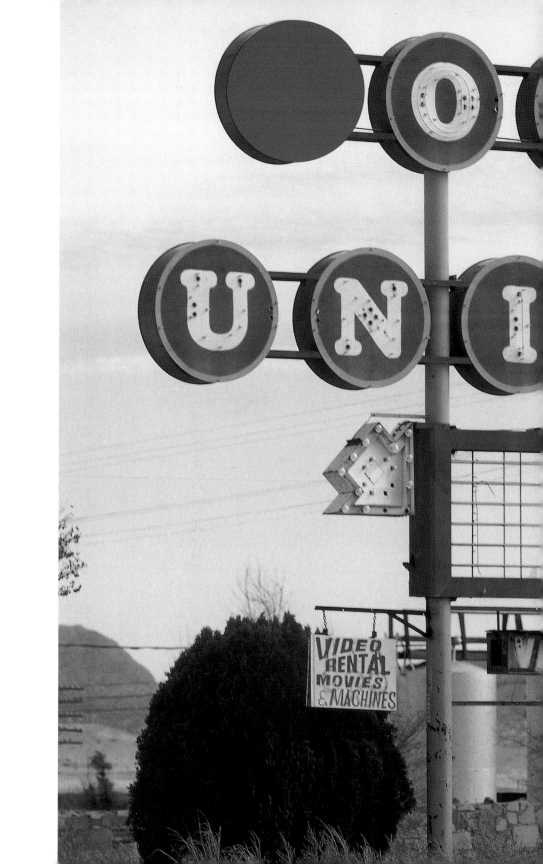

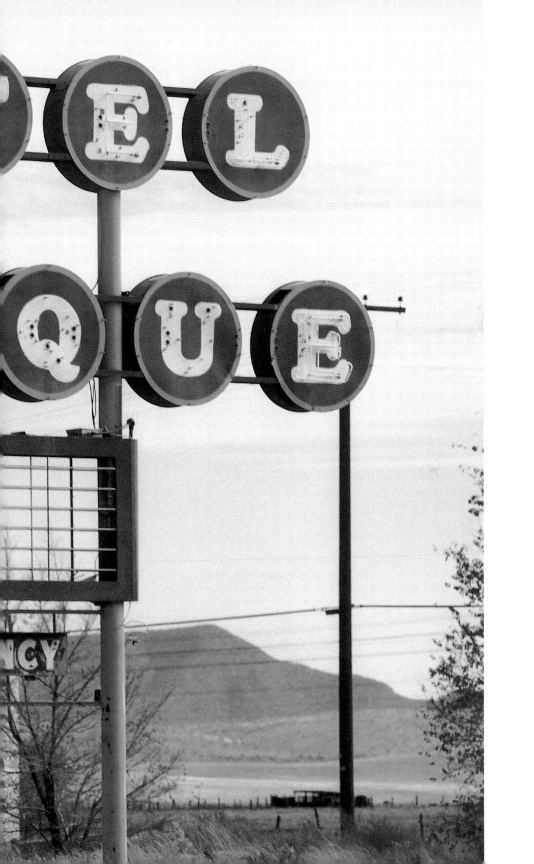

Structure continued to function as a compositional organizer for a sign's content, but less for aesthetic reasons than for functional ones. While structure was used in the mid-1950s to help make a sign appear more unique, by the end of the decade it was employed mainly to organize modular elements into a coherent arrangement. The sign-maker's primary creative contribution was limited to determining how the elements would be combined into a final composition.

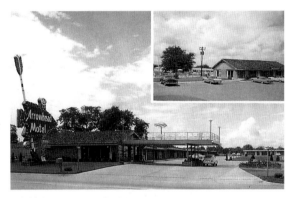

The mid-1950s sign at the Arrowhead Motel in Springfield, Missouri, is typical of the era: although the composition is dynamic and asymmetrical, the primary information—name and function—is centrally located on the main panel.

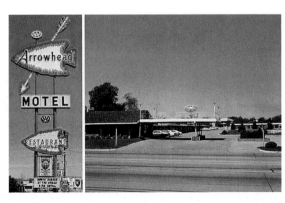

In this updated sign from the late 1950s, the introduction of modular components has allowed segmentation of the sign's form and spatial isolation of its content. The structure is symmetrical and organizes the many disparate forms to create a coherent and understandable message.

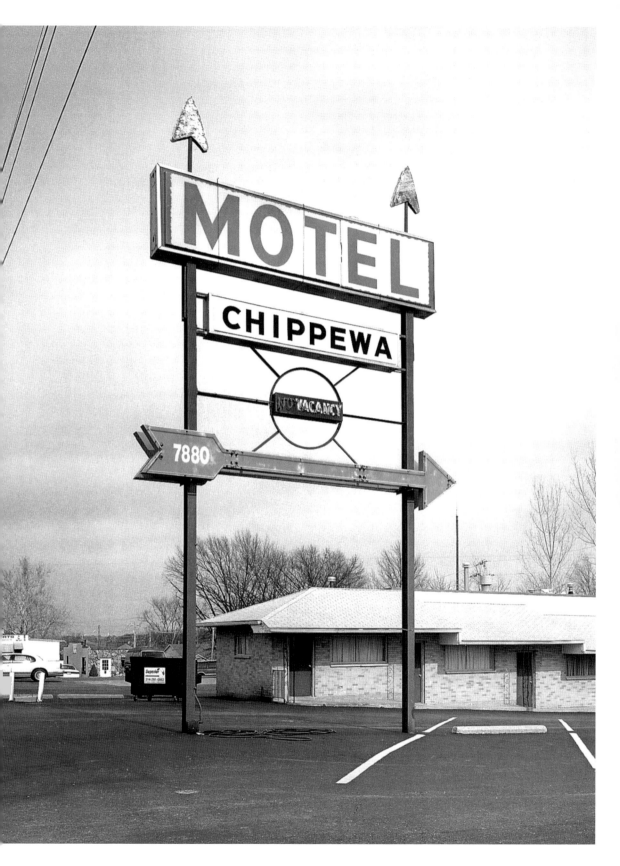

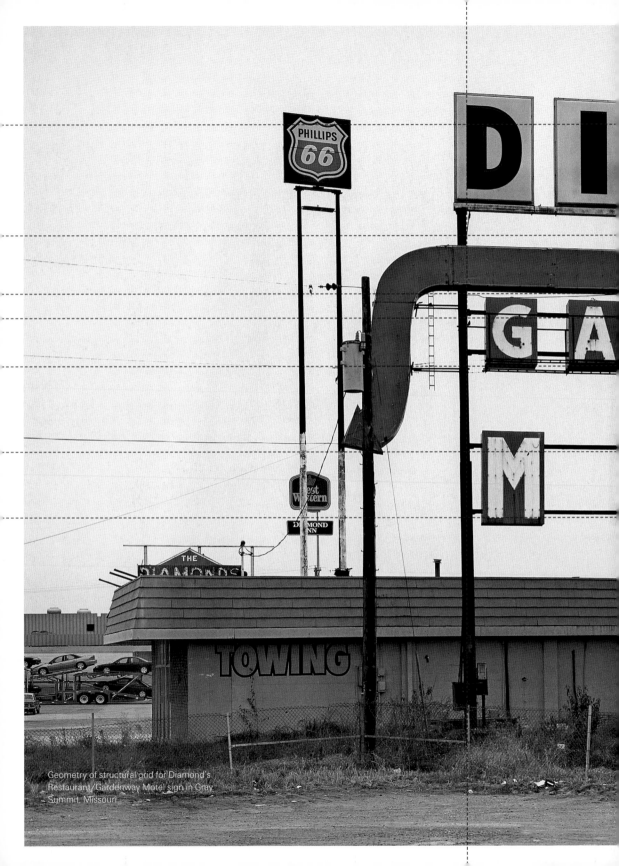

Geometry of structural grid for Diamond's Restaurant/Gardenway Motel sign in Gray Summit, Missouri.

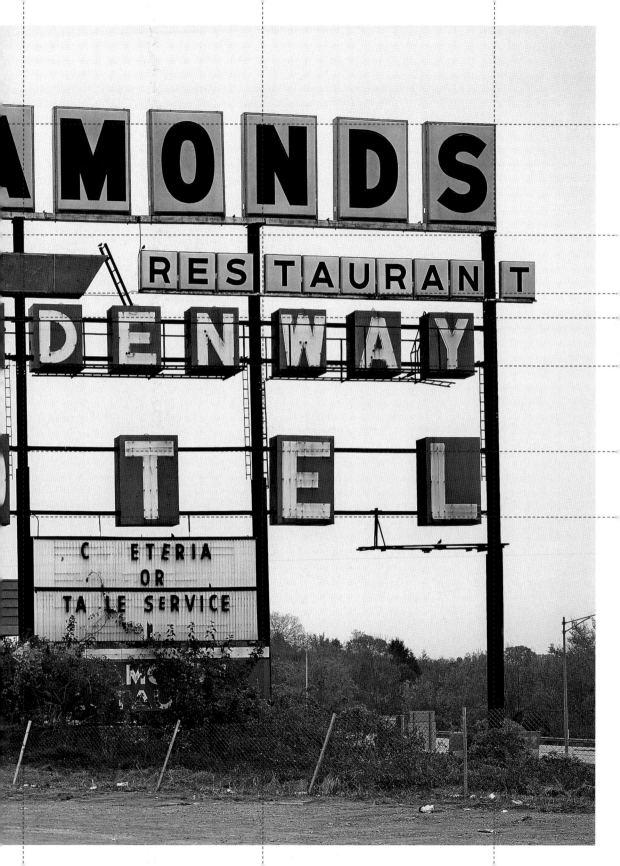

As prefabricated modular letters became more popular, typestyles were simplified. Script, common during the 1950s, fell out of favor because it was difficult to join individual letters and because its visual complexity made it inappropriate for a period enamored with simplicity. Script was used occasionally on hand-painted plastic panels, but most signs used generic or lightly stylized typefaces.

There were two distinct type trends during this period: conservative and modern. Colonial- and medieval-style type, which was used all over the country, was consistent with the rising conservatism of the era; motel owners chose the style to create an aura of "heritage" that would attract the "right" (white, married, upscale) people. Modern, generic fonts were particularly attractive to chains, since they imparted a sense of familiarity across regional boundaries. Both types of letters, however, utilized progressive materials such as backlit plastic and standardized alphabets. Because of this, colonial typestyles could be used to symbolize cultural conservatism without abandoning the motel's overall image of technological progressiveness.

Signs more than twenty years old were considered unattractive, and business owners were encouraged by local communities to remove them to improve the highway's appearance. "New" old-style signs, however, were extremely desirable. Because they were manufactured from plastic, colonial-style signs were considered progressive (although culturally conservative) and were therefore acceptable.

STYLIZED AND COLONIAL

TWO TRENDS FOR TYPE

GENERIC AND MODERN

Standardized plastic alphabets replaced traditional hand-painted letters because they were cheaper and more familiar. Simple, geometric type was accepted because its unornamented, square forms were consistent with the traditional lettering styles of the 1940s. But because the stripped-down letters were so different from the decorative typestyles of the early and mid-1950s, they were perceived as completely new and modern.

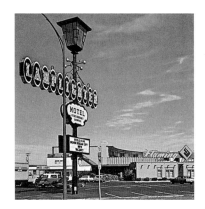

TRADITIONAL

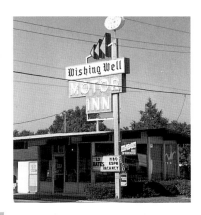

WOODCUT

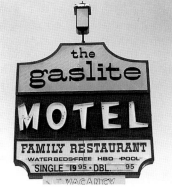

MEDIEVAL

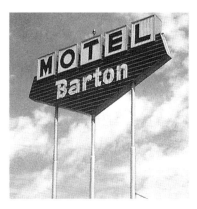

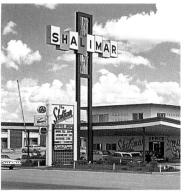

GENERIC

Colonial type was used to make a sign (and the motel it identified) more
upscale and conservative, unlike the stylized type of the 1950s, which was used to make
a sign appear more expressive and original.

Generic typestyles could appear both modern and traditional:
they were standardized and modular and therefore contemporary,
yet stylistically similar to pre–World War II styles.

Conservative (Colonial and Medieval) Names

COLONIAL MOTEL
GASLITE MOTEL
PUMP HANDLE INN
CANDLELIGHT INN
CARRIAGE HOUSE INN
BEN FRANKLIN MOTEL
COACH HOUSE INN
LEATHERWOOD MANOR
MT. VERNON MOTOR LODGE
ROYAL INN
KING'S INN

Progressive (Urban Renewal) Names

NEW MOTEL
DOWNTOWNER MOTEL
TOWN HOUSE MOTEL
CITY CENTER MOTEL

Upscale Names

AMBASSADOR MOTEL
HI-LINE MOTEL
BELAIRE MOTEL
PORTER HOUSE
VILLA INN

Motel names were influenced by the same trends that affected other elements of a sign. In general, names tried to convey wealth, prosperity, exclusivity, and "newness." Overtly upscale or colonial names seemed to do this best. The symbolism of colonial-themed motels of the 1960s, though, was different from their 1940s predecessors. Earlier colonial properties were often named after methods of travel (e.g., stagecoach), which served as symbols of independence and privacy. Second-generation colonial motel names, by contrast, were more indicative of social status and tended to convey a sense of permanence (Coach House), exclusivity (Mt. Vernon), and authority (Ben Franklin). Newer motels often used "inn" rather than "motel" to impart an aura of privilege.

Names that referred to urban revitalization and renewal were also common, reflecting the period's preoccupation with novelty. This interest related primarily to physical and technological modernity, not the cultural newness that was so influential during the early and mid-1950s.

Because metal signs were painted by hand, they had an unlimited palette of custom colors. The switch to prefabricated plastic signs greatly limited color choice. Typically, metal panels were painted dark colors with contrasting, light letters. Plastic panels, on the other hand, were generally translucent white to take advantage of fluorescent backlighting. Signmakers could paint letters onto the plastic, apply ready-made letters to the surface, or purchase preformed letter panels. Letters were usually a darker color, often black or red. Unlike neon, plastic signs appeared virtually the same both day and night, which was a great advantage for chains looking to present a consistent, familiar image.

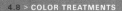

Color names of the late 1950s and early 1960s were influenced by the language used by the new professional design industry. Whether a designer worked with brick, paint, or printer's ink affected the colors he or she was accustomed to. Art directors often used artist's paint to illustrate their ideas, so colors like carmine and chrome yellow were a natural part of their vocabulary. Industrial designers relied primarily on "consumer interviews" to select colors for their corporate clients. This polling revealed that the most popular colors nationwide were red, white, and blue. Signmakers, anxious to please, integrated these names into their expanded vocabulary of color.

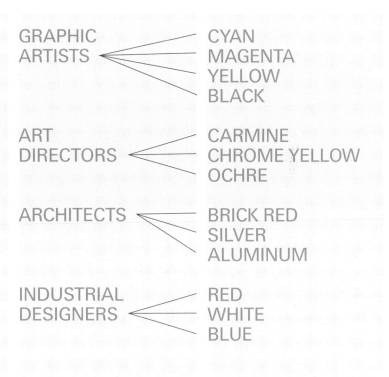

PROFESSIONAL
DESIGNERS

GRAPHIC
ARTISTS

CYAN
MAGENTA
YELLOW
BLACK

ART
DIRECTORS

CARMINE
CHROME YELLOW
OCHRE

ARCHITECTS

BRICK RED
SILVER
ALUMINUM

INDUSTRIAL
DESIGNERS

RED
WHITE
BLUE

The political conflicts of the 1960s, especially the civil rights movement, were reflected in the contradictory symbolism found on signs. Conservative and progressive symbols were often featured together. Even regressive symbols, such as "colonial" lanterns and "medieval" crowns and shields, were generally executed in plastic. The two trends—technological progress and ideological conservatism—sprang from a single impulse: to create an image of wealth and privilege.

The symbolism of progressiveness was abstract. It was generally conveyed through the use of modern materials, forms, names, and colors—almost never through figurative elements. The stripped-down, generic look that was becoming more prevalent also alluded to the new, sparse lines of corporate buildings, logos, and consumer products such as automobiles.

❶ Colonial-Modern

The Leatherwood Motor Inn sign in Gallup, New Mexico, contains colonial symbols—specifically the old style typeface—along with a modern, asymmetrical arrangement of the sign's elements. All of the sign's components are executed in contemporary materials.

❷ Colonial-Traditional

The Colonial Motel sign, the oldest of those shown here, is unusual in its lack of any truly modern elements. Most colonial signs from the period were constructed of plastic, not metal. The script type, Chippendale sign box, and antique blue paint all contribute to the sign's conservative image.

❸ Modern-Traditional

The Lariat Lodge sign in Gallup, New Mexico, illustrates how easy it was to arrange modern, modular elements into traditional compositional patterns. Although both traditional and modular elements shared several attributes—simple, geometric, easily repeatable—their cultural origins differed. Traditional forms emerged from a connection to community, while modern forms were a response to the needs of an increasingly generic mass society.

❹ Colonial-Modern-Traditional

The Park Hills Motel sign in Vinita, Oklahoma, has a combination of colonial, modern, and traditional elements. As with the colonial-modern Leatherwood Motor Inn sign, the seemingly contradictory symbols were all used to project an image of wealth and exclusivity.

COLONIAL **SYMBOLS**
MODERN **MATERIALS**
MODERN **FORM**

❶

COLONIAL ELEMENTS
SYMBOLIZED:
POLITICAL CONSERVATISM
WEALTH
EXCLUSIVITY

MODERN ELEMENTS
SYMBOLIZED:
PROGRESSIVENESS
WEALTH
MASS CULTURE

TRADITIONAL ELEMENTS
SYMBOLIZED:
UP-TO-DATENESS (BECAUSE
THEY WERE THE OPPOSITE OF
1950s ORIGINAL ELEMENTS)

COLONIAL **SYMBOLS**
TRADITIONAL **MATERIALS**
TRADITIONAL **FORM**

MODERN **SYMBOLS**
MODERN **MATERIALS**
TRADITIONAL **FORM**

COLONIAL **SYMBOLS**
MODERN **MATERIALS**
TRADITIONAL **FORM**

While colonial-themed motel signs of the 1940s usually included images of travel, later examples incorporated more overt symbols of power and subservience. Abstract colonial architectural details, such as Chippendale borders, were common, as were motels named after authority figures. Illustrations of colonial "servants" were particularly popular with chains; while ostensibly they symbolized service, the prevalence of the motif—and the classist intentions behind them, which were made clear in industry trade journals—made them emblems of subservience, too.

All of the major chains adapted their architecture, signs, or marketing materials to the colonial trend. Holiday Inn, which had the industry's most recognizable sign, added a colonial mascot to its promotional materials. Ramada Inn and Rodeway Inns used colonial images on all of their signs.

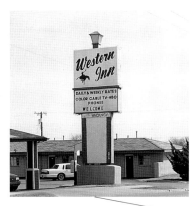

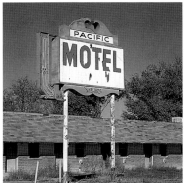

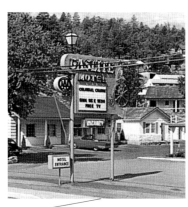

COLONIAL SYMBOLS
LANTERNS
CHIPPENDALE DETAILS
SCROLLS
SERVANTS/MASCOTS

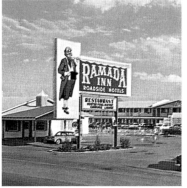

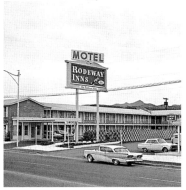

The types of traditional symbols used on signs mirrored the increasing racial conflict and resulting conservatism of the political climate. As racial tensions reached a feverish pitch with the 1965 Watts insurrection and the 1967 Newark rebellion, the symbols on signs became increasingly regressive, with medieval shields and crowns replacing colonial lanterns and Chippendale forms. While colonial symbols harked back to a period when slavery was the norm, medieval symbols were entirely autocratic without even the promise of democracy.

Colonial ➡ Medieval

TURRETS

Turrets were overt symbols of defensiveness and military strength, although signmakers did not consciously use them for this reason. Turrets also symbolized a willingness and ability to forcefully protect oneself from an enemy.

CROWNS

Crowns were the most popular medieval symbols used on signs during the mid-1960s; even Best Western updated their logo to include one. Crowns symbolized power, wealth, and class—further amplifying the discrepancy between the haves and the have-nots.

CRESTS

Crests, like crowns, symbolized the privilege granted to those born into "proper" circumstances, such as family, class, and race. The use of crests promoted the belief that an individual attained status not because of what he or she did but because of who he or she was.

SHIELDS

Like turrets, shields were forceful symbols of defense. Earlier shields were more clearly articulated than later ones, which tended to incorporate the form more abstractly.

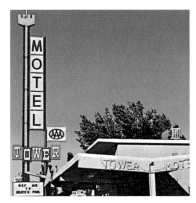

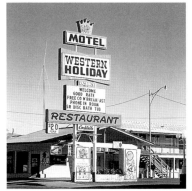

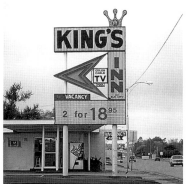

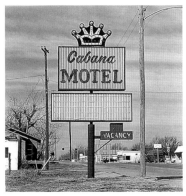

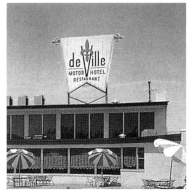

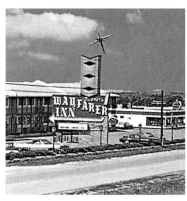

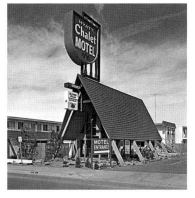

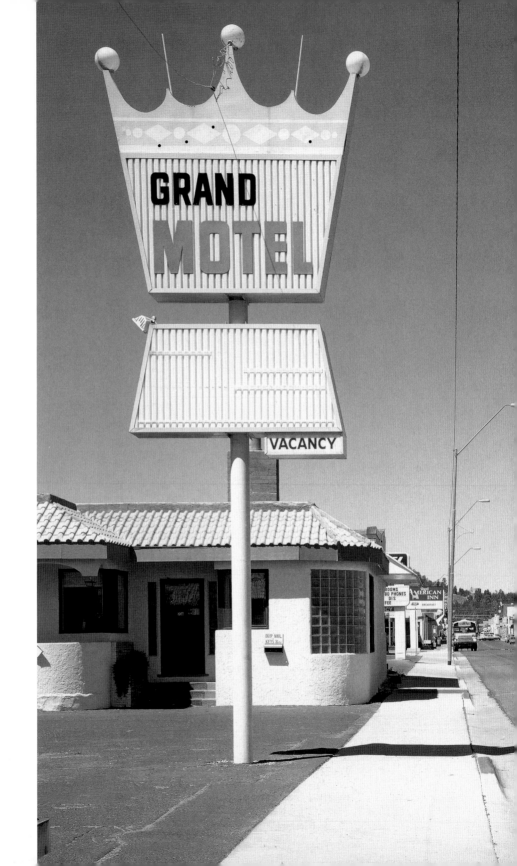

Composition

By the late 1950s, signs were becoming more orderly and structured, reflecting the increased availability of regularly shaped, modular elements. By the middle of the next decade, compositions were consistently symmetrical, often arranged in a manner very similar to traditional 1940s examples. The hierarchy of a sign's elements, however, changed dramatically. For chains, the brand image, be it a symbol or the company name, was the most important element. For independents, function took precedence over name.

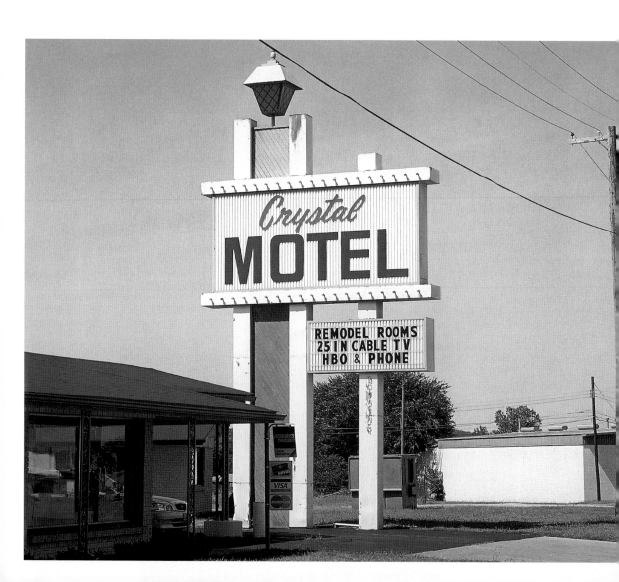

4.11 > SYMMETRY

The first modular signs, built in the late 1950s from prefabricated metal components in slightly irregular shapes, were arranged in a somewhat asymmetrical manner. Within a few years, most modular components were made of plastic and came in simple, geometric shapes that were both adaptable to a variety of sign designs and easy to produce and transport. The more regular the modular forms, the more likely they were to be arranged in a symmetrical manner.

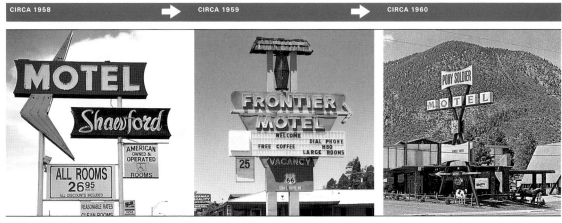

| CIRCA 1958 | CIRCA 1959 | CIRCA 1960 |

This late-1950s sign in Santa Rosa, New Mexico, combines prefabricated components and customized elements, such as the hand-painted lettering for the name of the motel. The composition is asymmetrical, but much less so than examples from the middle of the decade.

Although the forms on this Flagstaff, Arizona, sign are relatively dynamic, they are organized geometrically. Like the Crystal Motel in Tulsa, Oklahoma, it is almost symmetrical, except for a slight shift in the horizontal position of the main sign boxes.

The Pony Soldier Motel, also in Flagstaff, is a completely modular sign from the early 1960s. In keeping with the regularity of the prefabricated elements, the composition is entirely symmetrical.

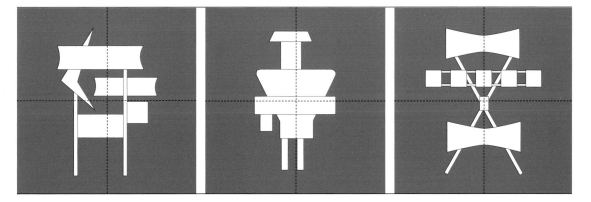

One of the sign industry's longest-standing traditions, placing the motel name above the function, was rejected in the late 1950s and early 1960s. "It hardly seems necessary," wrote sign designer Lucian Howze in 1958, "to put the name [of the motel] in letters large enough to be read at [a] distance. Just the word 'motel' seems important enough to be seen from afar, since this word describes the service being offered to the traveler."

For chains, the opposite was true. Because of their increased brand recognition, it was no longer necessary for chains to include any indication of their service on their signs, and many of them dropped it altogether.

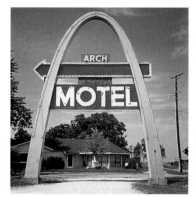 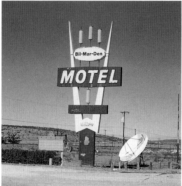 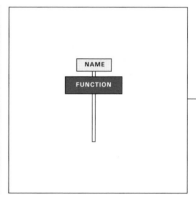

The movement of the word "motel" from bottom to top was gradual. Signmakers first made the business name much smaller than "motel."

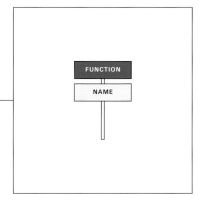

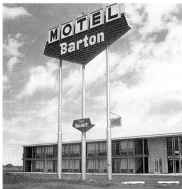

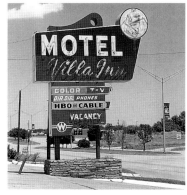

By the late 1950s, "motel" began appearing above the name, downplaying an individual motel's uniqueness yet making the type of business more distinct from other types of enterprises.

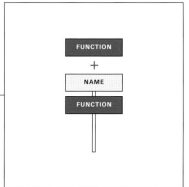

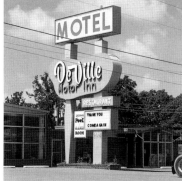

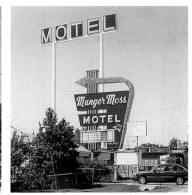

Older signs were updated to reflect the new hierarchy, either by placing a new sign on top of the older one or by building a higher sign, which could be seen from farther away.

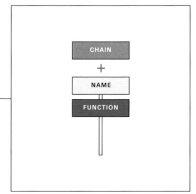

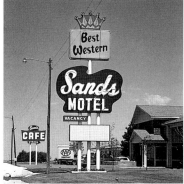

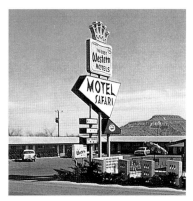

Many customers preferred motels that were part of referral chains such as Best Western because they guaranteed a certain level of quality. By the late 1950s, referral chain signs were being placed above those of the motel itself. As a writer for *Signs of the Times* pointed out in 1963, "Gone is the day when we will see signs which say 'Joe's Motel, a Quality Court.' We are now selling 'Quality Courts.' If Joe wants his name on the sign, it will be in small print."

Many motel owners could not afford to replace or alter their existing signs, but this did not mean that their signs did not emulate the new content hierarchy. Some owners replaced broken or spent neon tubing only if it was used for the words "motel" or "vacancy." During the day, the signs maintained their traditional content hierarchy, but at night they included only what had become the most important element—the function.

DAY
NAME AND FUNCTION

NIGHT
FUNCTION ONLY

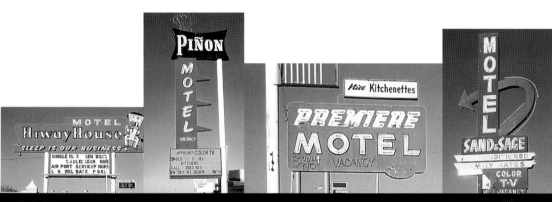

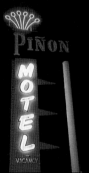

Context

As highway strips became more crowded and visually complex, the 1950s method for making signs stand apart from their competitors—by using dynamic, individualistic designs—became less effective. Instead, signmakers built simpler, more regular signs that would contrast with the surrounding visual cacophony. The motels themselves became more elaborate and self-sufficient with the addition of swimming pools and other amenities. This further eroded any connection with contexts outside the motel complex.

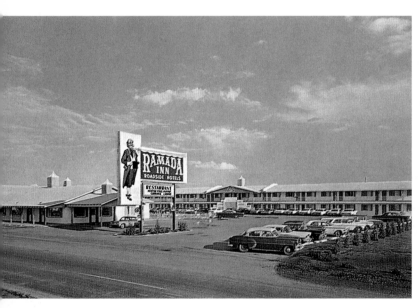

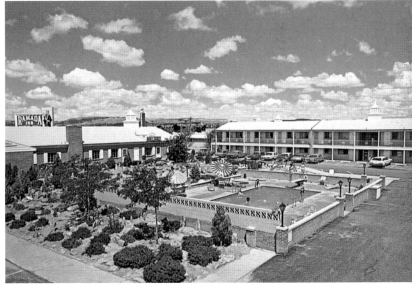

4.13 > NATURAL/ARCHITECTURAL CONTEXT

A shift in attitude toward motels' natural and man-made contexts can be seen in their postcards. Earlier postcards usually showed the sign and motel from the vantage point of a car passing by, a view that usually included some indication of the highway and surrounding context. Late-1950s postcards often showed two views: one of the exterior and one of the interior courtyard, which was often an enclosed pool area—a kind of constructed oasis. By the early 1960s, exterior views were usually avoided altogether; postcards tended to focus entirely on the private, internal areas of the motel complex, where the placement of natural elements such as plants and water was dictated by strict, controlling geometries.

The architecture of the motel complex was equally rigorous and, like its sign, constructed from clearly expressed modular components. All elements of the motel complex, including its sign, buildings, and grounds, were increasingly repetitive and geometric. This precise adherence to abstract geometric rules, along with the increased focus on the inner areas of the motel, resulted in an arrangement entirely disconnected from spatial and temporal contexts.

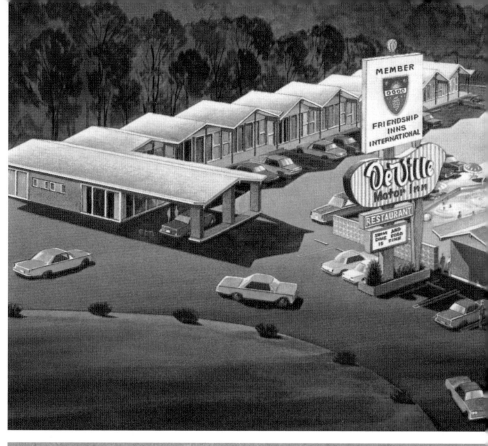

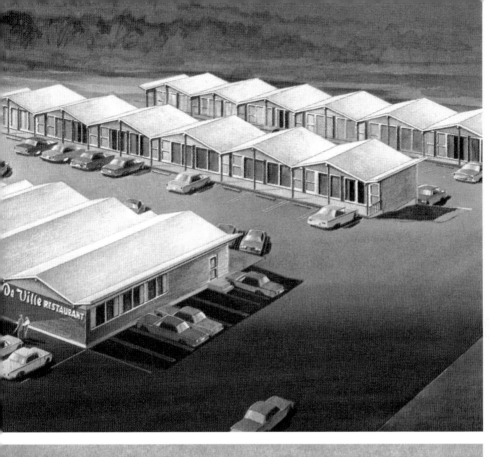

Signs changed in several ways to address the evolving highway strip. In addition to their increased formal simplicity, signs also became considerably taller, making them easier to recognize from farther away and at higher speeds. A motorist's field of vision was greatly affected by this increase in speed—peripheral vision decreased dramatically, as did the ability to absorb information.

40 MPH

EARLY 1960S

45° FIELD OF VIEW

This late-1950s sign for the Royal Holliday Motel reflects traditional content hierarchy and also contains a detailed illustration.

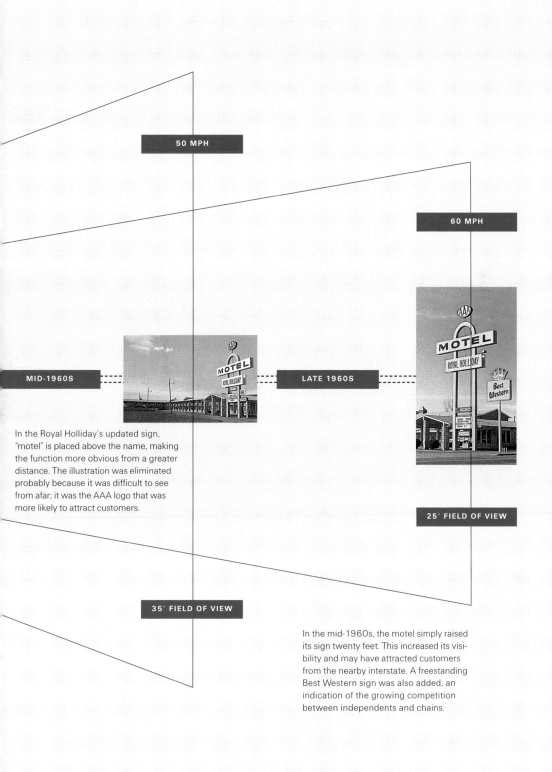

50 MPH

60 MPH

MID-1960S

LATE 1960S

In the Royal Holliday's updated sign, "motel" is placed above the name, making the function more obvious from a greater distance. The illustration was eliminated probably because it was difficult to see from afar; it was the AAA logo that was more likely to attract customers.

25° FIELD OF VIEW

35° FIELD OF VIEW

In the mid-1960s, the motel simply raised its sign twenty feet. This increased its visibility and may have attracted customers from the nearby interstate. A freestanding Best Western sign was also added, an indication of the growing competition between independents and chains.

Independent motel signs were increasingly being constructed from prefabricated elements purchased from national manufacturers. Those elements needed to be generic in order to function in a variety of contexts. Signmakers tended to choose names, materials, type-styles, and colors that would be familiar to customers regardless of the motel's location. As modular components became more readily available, the possibility of creating multiple identical signs became an affordable reality. And when the number of chain motels surged, it became more and more difficult for independent motels to compete.

MODULAR PLASTIC PANELS

This sign in Williams, Arizona, is composed entirely of modular components. When using such elements, a signmaker could either combine them into a unique, one-of-a-kind arrangement or repeat the design at different locations.

STANDARD TYPE

Signs that incorporated standard type, such as this one in Gallup, New Mexico, were easier to read since motorists were already familiar with the simple lettering style.

PREFABRICATED SIGN PACKAGES

Complete, prefabricated sign packages could be purchased and customized with a motel's name. Large panels with change-able letters provided an area for temporary messages.

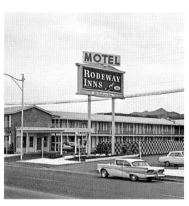
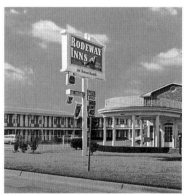

These technological developments—modular plastic panels, standard type, and prefabricated sign packages—in combination with a period that favored corporate expansion, led to an explosion in the construction of new chain motels along Route 66. Mass-produced elements ensured visual continuity between signs in different locations and virtually eliminated the aesthetic idiosyncrasies that resulted when individual signs were fabricated by different signmakers and shops.

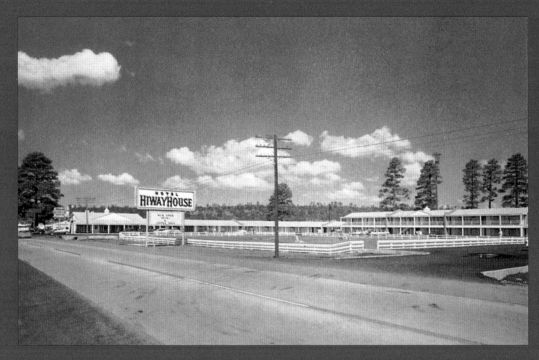

4.15 > NATIONAL CONTEXT

Early motel chains struggled to develop brand identities that would identify their businesses
in a familiar and consistent manner. The Hiway House chain, for example, used similar typestyles and
forms, but signs were never entirely consistent.

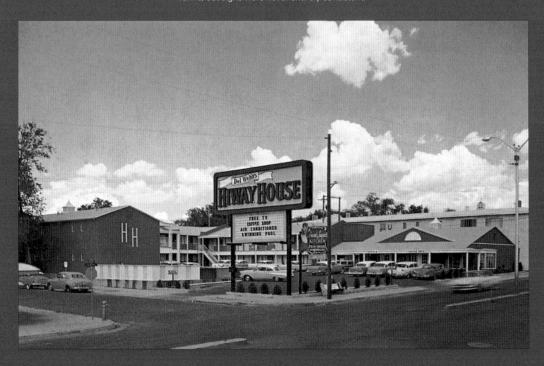

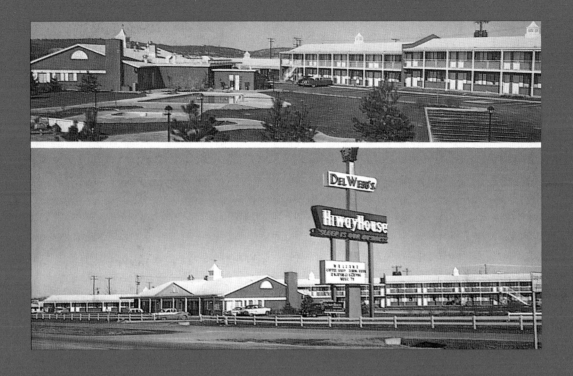

The business name and content hierarchy varied, as did colors, shapes, and illustrations. It was not until the mid- to late 1960s, when motel owners began to purchase complete prefabricated signs rather than modular elements to be assembled on site, that signs began to appear more consistent.

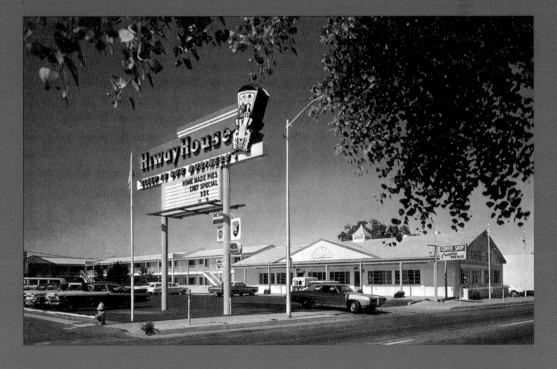

Conclusion

The new trend toward simpler, more generic forms was a boon for signmakers, since they could finally begin to free themselves from the demanding pressure for constant innovation. The fanciful compositions of the 1950s had required significant investments of time on the part of the designer, making it more difficult for shops to remain profitable. By contrast, the plastic components used on early-1960s signs were already designed and manufactured, which saved the signmaker considerable time and money. Designing a sign was as easy as perusing a catalog for components, having them shipped to the shop, and arranging them into a satisfactory composition. Signs were created from a kit of parts rather than bought as completely finished products, so signmakers still had a significant role in determining the final appearance, even if it was limited to deciding the arrangement of prefabricated elements.

More than anything else, the era was defined by the penchant for juxtaposing technologically progressive materials with conceptually regressive content. Trade journals abounded with articles such as "A Modern Approach in Colonial Design Techniques," "The Colonial Motif...Rendered in Plastic," and "Expressing Antiquity in a Plastic Sign." The combination of colonial themes and plastic components seemed perfectly appropriate at the time, mainly because plastic was still considered glamorous and sophisticated. Symbols of "antiquity," such as lanterns, crowns, and shields, conveyed the same thing as plastic—exclusivity and wealth.

Yet developments that led to the success of the sign industry during the early 1960s—the introduction of prefabricated elements, the rapid construction of new highways, general economic prosperity—had by the middle of the decade begun to foreshadow its decline. These developments stimulated corporate expansion, but at the expense of independents, which traditional sign shops relied on for business. Motel chains had little need for signmakers—they hired their own professional designers and contracted production services to plastic manufacturers directly. By the end of the decade, the signmaker's role in the process had been irrevocably compromised.

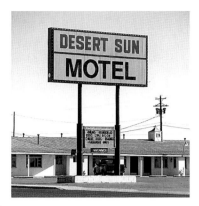

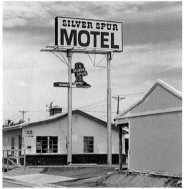

5

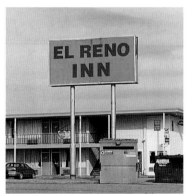

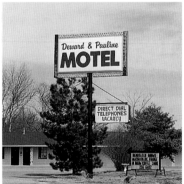

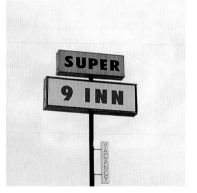

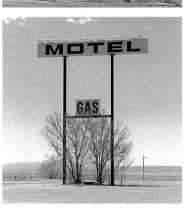

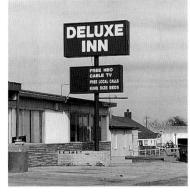

Intensive Simplicity: 1961–1970s

The signs that appeared along Route 66 during the mid- and late 1960s were extremely simple in terms of content and execution. Much like the signs of the early 1940s, they contained only the most basic elements—sign box, type, and pole—arranged in traditional, symmetrical configurations. The 1:2 sign box was once again common, as were plain type treatments. But while there was little formal variation between the signs from these two periods, there were distinct conceptual differences. Signmakers were now addressing the needs of a mass society. Signs of the 1960s were produced with almost no consideration for the specific contexts where they would appear. They were thought of abstractly and arithmetically—as lines on paper—rather than materially.

Signmakers became increasingly anonymous, making signs for towns they would never visit. This lack of contact sheltered the signmaker from the direct, personal criticism pre–World War II designers had been subject to if they failed to fulfill a community's expectations and also freed him from a sense of personal obligation to these towns. Without this personal interaction and commitment, signmakers began to lose interest not only in the local effects of their signs but in their craft itself. Signs from this era were often made of unsubstantial materials and constructed poorly.

Although most individual signmakers escaped public criticism, the industry did not. By the mid-1960s, Americans began to question the rampant destruction of the natural vistas along their highways. In October 1965, the Highway Beautification Act was passed, signaling a distinct shift in public opinion. "This bill does more than control advertising and junkyards along the billions of dollars of highways," remarked President Lyndon B. Johnson at its signing. "This bill will bring the wonders of nature back into our daily lives." It is arguable whether the bill achieved its goal; it did, however, encourage signmakers to keep their signs simple, discreet, and tasteful. Signmakers paid homage to nature not by imitating it but by interfering with it less. Still, the signmaker found other ways to overpower nature, now by making his signs appear the same both day and night.

The signmaking patterns established in the late 1960s—simple forms, basic typestyles, backlighted plastic panels, and inexpensive construction—continued to dictate the design of many signs through the 1970s and beyond. Even at the turn of the twenty-first century, generic, rectangular sign boxes are ubiquitous at independent motels, reflecting the importance of frugality in a business dominated by national chains.

Concept

Although several different external forces affected how signs were conceived during the 1960s—government regulation, the construction of interstate highways, and the growth of corporate motel chains—all of them pushed signs in the same direction, toward simplicity. The result was a proliferation of similar compositions based on basic geometric forms that were devoid of decoration and trendy details. There "is the danger," warned *Signs of the Times* in 1966, "of deadening the creative process through increased emphasis on extraneous influences. Restraint and discipline fortified with [our] professional knowledge are the best aesthetic tools." This restraint signaled a return, in form at least, to the traditional sign designs of the late 1930s and 1940s. But while signmakers acknowledged their traditions, the simple, geometric signs of the 1960s were meant to symbolize a new culture of mechanized and standardized progress, not a retro vision of the past.

5.1 > INFLUENCES/SOURCES

National motel chains bypassed sign shops and instead hired industrial or graphic designers to create logos that could be used in a variety of contexts and configurations. These logos became the core of the chains' brand identities: the physical sign was usually a less important consideration.

Independent motels maintained the traditional process of conceptualization. Owners were still involved, working with signmakers to select the prefabricated components that would make up a sign. These choices were greatly influenced by corporate branding trends. "Recognizing the accomplishments of giant corporations," reported *Signs of the Times*, "smaller advertisers can be counted on to venture more and more into standard graphics of their own." Signs were pieced together from prefabricated components, so rarely were two exactly alike; nevertheless, the use of standardized elements resulted in signs that were culturally inert. Generic elements worked equally well for motel signs or supermarket signs for Arizona, Illinois, or anywhere in between.

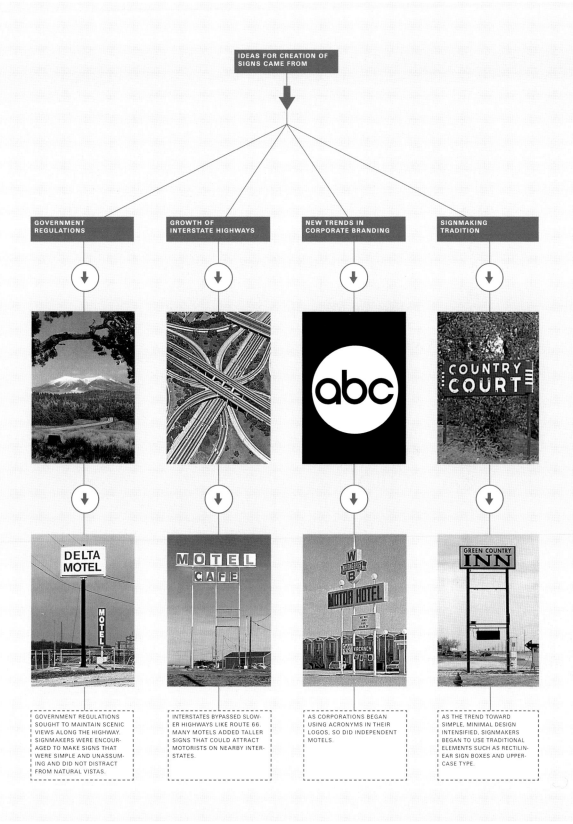

IDEAS FOR CREATION OF SIGNS CAME FROM

GOVERNMENT REGULATIONS

GROWTH OF INTERSTATE HIGHWAYS

NEW TRENDS IN CORPORATE BRANDING

SIGNMAKING TRADITION

GOVERNMENT REGULATIONS SOUGHT TO MAINTAIN SCENIC VIEWS ALONG THE HIGHWAY. SIGNMAKERS WERE ENCOURAGED TO MAKE SIGNS THAT WERE SIMPLE AND UNASSUMING AND DID NOT DISTRACT FROM NATURAL VISTAS.

INTERSTATES BYPASSED SLOWER HIGHWAYS LIKE ROUTE 66. MANY MOTELS ADDED TALLER SIGNS THAT COULD ATTRACT MOTORISTS ON NEARBY INTERSTATES.

AS CORPORATIONS BEGAN USING ACRONYMS IN THEIR LOGOS, SO DID INDEPENDENT MOTELS.

AS THE TREND TOWARD SIMPLE, MINIMAL DESIGN INTENSIFIED, SIGNMAKERS BEGAN TO USE TRADITIONAL ELEMENTS SUCH AS RECTILINEAR SIGN BOXES AND UPPERCASE TYPE.

The Desert Sun Motel sign in Grants, New Mexico, has many of the same design elements as early-1940s signs: a symmetrical, rectangular sign box of roughly 1:2 proportion; sans serif, all capital letters; and two simple supporting poles. Yet signs of the 1960s were determinedly contemporary. Their simple form represented a rejection of the personal and expressive signs of the previous decade in favor of clean, universal designs.

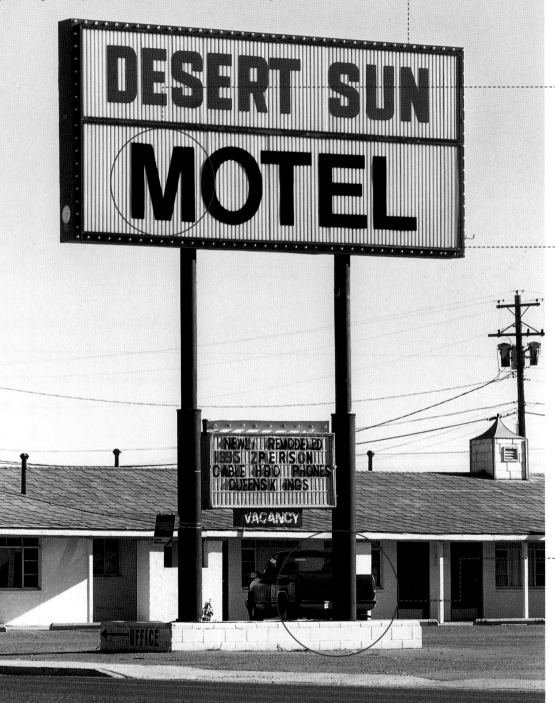

The 1:2 proportion of the Desert Sun sign box is identical to this early-1940s "suitcase" sign. Both signs also contain a horizontal division that differentiates name from function.

Although the Desert Sun sign used new, prefabricated letters, the typestyle closely replicates the hand-painted, sans serif letters on this 1940s sign at the Western Motel in Santa Rosa, New Mexico.

The return to simple geometry was not limited to signs—the design of many consumer goods was generated from the proportions of the square, as this shelving system was.

The furniture, decorative objects, and art of the era conveyed an obsession with geometry and mathematical precision. This fabric design from the early 1960s incorporates both actual numbers and the pure geometry of the circle. Like the signs of the period, this design was created with a featureless, abstract context in mind.

The symmetrical, two-pole structure was another element popular during the 1940s and before; it provided additional support for supplemental advertising messages.

Components

To make signs adaptable to a wide range of businesses and locations, prefabricated components were as generic as possible. Sign boxes and letters were executed in simple, geometric shapes; even motel names became more abstract. In keeping with designers' pursuit of a universal, generic effect, signs did not reflect features of the surrounding context.

5.3 > MATERIALS

By the early 1960s, signmakers considered neon visually distracting. They believed that the material interfered with the geometric simplicity of the letters, and that it caused an unwanted shift in a sign's appearance from day to night. During the day, all of a sign's elements were clearly visible; at night, only those elements highlighted in neon were. To be considered modern and well designed, a sign had to appear to be machine-made. Any overt indication of a signmaker's hand, such as hand-painted letters or bent neon tubing, was rejected.

Plastic allowed signmakers to create signs that looked almost identical day and night. "Zigzaggy neon jumping all over the place," wrote art director Fil Sessions, should be "replaced with clean plastic areas quietly lit from behind and accented with brilliant, colored panels." By illuminating plastic panels from behind, signmakers could create signs that were evenly lit across their entire surface. Plastic had several other advantages: by the early 1960s, it became cheaper than metal and neon (important when used in large quantities), it weighed less (making it easier to pack and transport to distant locations), and it was the only material that could precisely replicate corporate trademarks. Plastic's neat, flat surface also appealed to signmakers looking to duplicate the modern, stripped-down look of many new corporate identities.

DAY

NIGHT

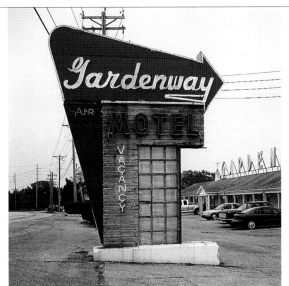

"Suitcase" sign boxes with 1:2 proportions were extremely popular in the late 1960s, just as they had been before World War II. Design trends, and signmakers' heightened awareness of them, encouraged rectangular signs. "The customer that yesterday called for round ends and sweeping curves," wrote signmaker William Haire in 1966, "now prefers squares and rectangles." Not only could they be produced easily, but signmakers also felt that the solid, rectangular panels provided a visual respite from the distracting highway views. Signs with a combination of small, irregular forms, like those common during the early 1950s, were difficult to read against the cacophony of the highway strip. Simple, white backdrops created a visual boundary and made signs easier to read.

Other traditional and highly geometric forms such as the T and the circle also experienced a resurgence in popularity. Like other signs of the period, these were executed in plastic, giving them an entirely modern appearance.

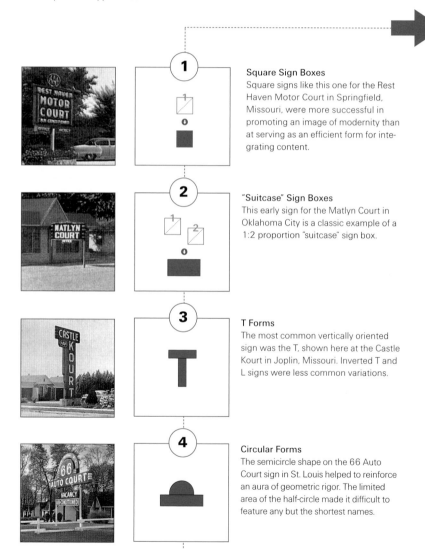

1940s

1 Square Sign Boxes
Square signs like this one for the Rest Haven Motor Court in Springfield, Missouri, were more successful in promoting an image of modernity than at serving as an efficient form for integrating content.

2 "Suitcase" Sign Boxes
This early sign for the Matlyn Court in Oklahoma City is a classic example of a 1:2 proportion "suitcase" sign box.

3 T Forms
The most common vertically oriented sign was the T, shown here at the Castle Kourt in Joplin, Missouri. Inverted T and L signs were less common variations.

4 Circular Forms
The semicircle shape on the 66 Auto Court sign in St. Louis helped to reinforce an aura of geometric rigor. The limited area of the half-circle made it difficult to feature any but the shortest names.

Square Sign Boxes

Square sign boxes worked best for motels with short names such as this early 1960s sign for the Bronco Motel in Amarillo, Texas. All other information was listed on a separate part of the sign so that it would not compete with the simplicity of the square.

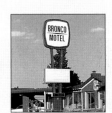

"Suitcase" Sign Boxes

Pure rectilinear shapes like those found on the Deluxe Inn sign in El Reno, Oklahoma, were the formal basis for most signs during the period. Squares and rectangles were universal and could be executed precisely with the new manufacturing technologies.

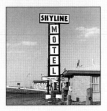

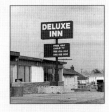

T Forms

The classic T sign was easy to reproduce in plastic. Steel poles such as those used at the Skyline Motel in Amarillo, Texas, supported the sign and provided a structural framework for the modular components.

Circular Forms

Circles, such as this one on the South West Motel sign in Grants, New Mexico, were used in much the same manner as they had been before World War II— placed on top of signs to add visual interest and provide a location for the motel name.

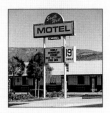

1960s

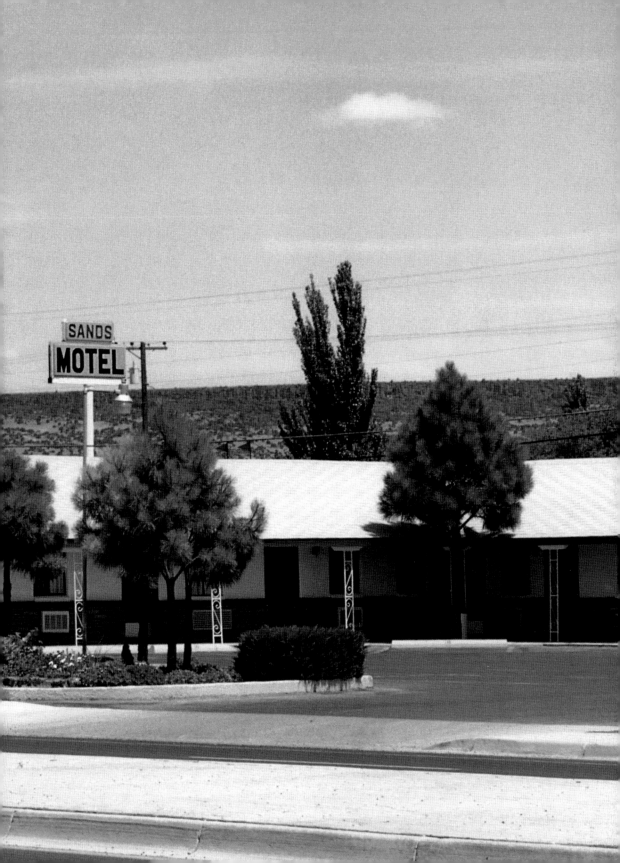

One of the most debated subjects among signmakers of the 1960s was the choice of type-face. In the absence of any other decorative elements, type determined the aesthetic direction. When selecting type, signmakers looked for a universal familiarity. "What we need," wrote a reporter for *Signs of the Times*, "are letters to fit the mental image of the public, as a light bulb will fit any socket, whether it be in Winnemucca, Nevada, or Woonsocket, Rhode Island." Signmakers achieved this primarily by using typestyles similar to those seen in newspapers, magazines, and books. These styles were also remarkably similar to earlier sign lettering. The most popular hand-painted typefaces among signmakers were sans serif and had square proportions, but such choices frustrated professional designers who preferred similar, but standardized typefaces such as Helvetica or Futura.

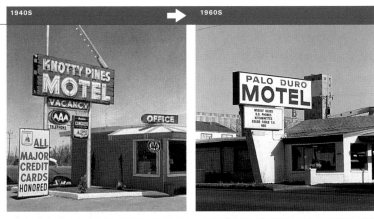

1940S → 1960S

Helvetica was designed in 1951 by the Swiss designers Edouard Hoffman and Max Miedinger, but much hand-drawn lettering, even decades earlier, was remarkably similar. Because of the likeness between Helvetica and earlier, sans serif vernacular lettering styles, Helvetica was accepted into the signmaking tradition during the late 1950s and early 1960s. It continues to be the most popular choice for all types of prefabricated signs.

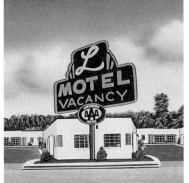

Futura, introduced in Germany in 1928, appealed to signmakers because it was rigidly geometric, symmetrical, and lacked superfluous embellishment. The Futura M has splayed sides, which help to reinforce its square proportion. It was commonly used on early hand-painted signs and contin-ued to be popular throughout the 1960s and 1970s.

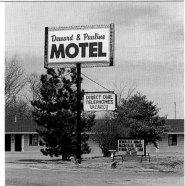

Although signmakers generally preferred sans serif typefaces, they occasionally used slab serif alphabets, especially if the sign was themed. Slab serif letters are different from serif ones: the serifs of the former are more geometric.

SUPER
9 INN

VACANCY

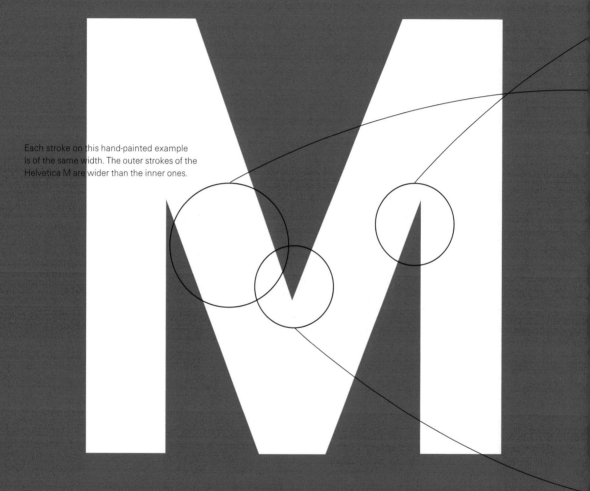

Each stroke on this hand-painted example
is of the same width. The outer strokes of the
Helvetica M are wider than the inner ones.

5.5 > TYPE TREATMENTS

There were very few aesthetic or structural differences between the hand-painted sans serif
typefaces of the 1940s and the standardized ones of the 1960s. Handcrafted letters
tended to be more perfectly square than those in Helvetica and other modern typefaces.

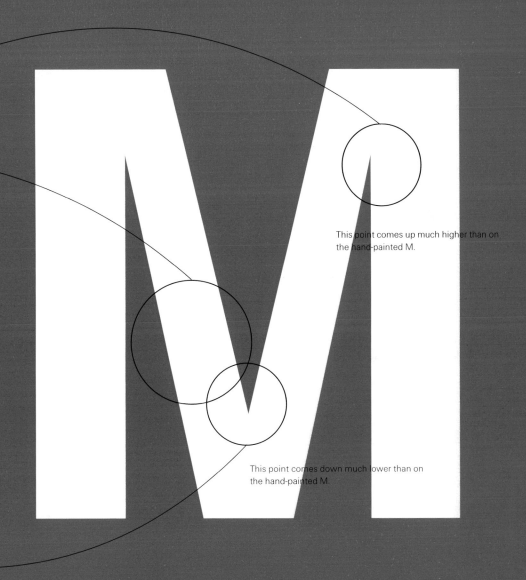

This point comes up much higher than on the hand-painted M.

This point comes down much lower than on the hand-painted M.

New fonts were designed to make maximum use of the limited space available in periodicals and books, which meant they were often taller than they were wide. The different stroke widths on the Helvetica M also make it appear less geometric than the hand-drawn M.

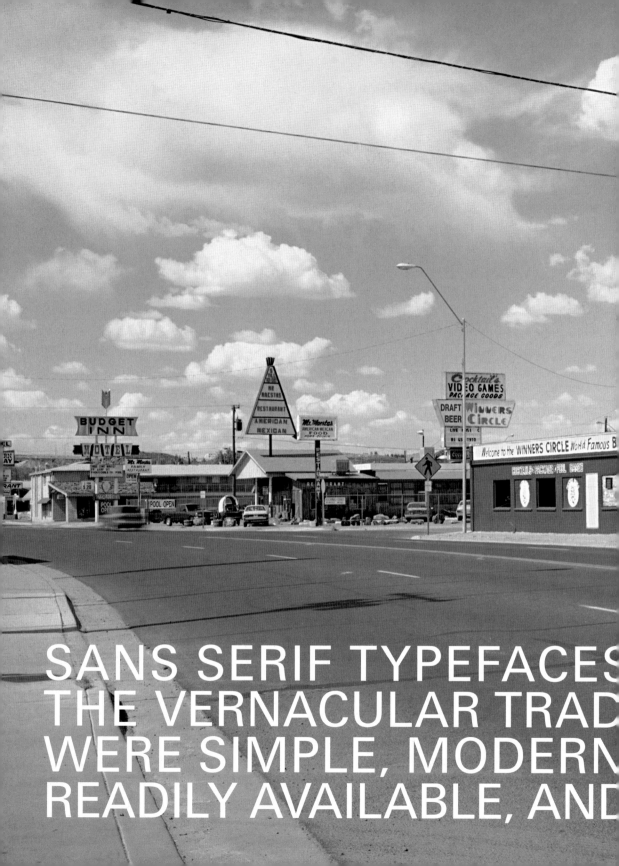

SANS SERIF TYPEFACES
THE VERNACULAR TRAD
WERE SIMPLE, MODERN
READILY AVAILABLE, AND

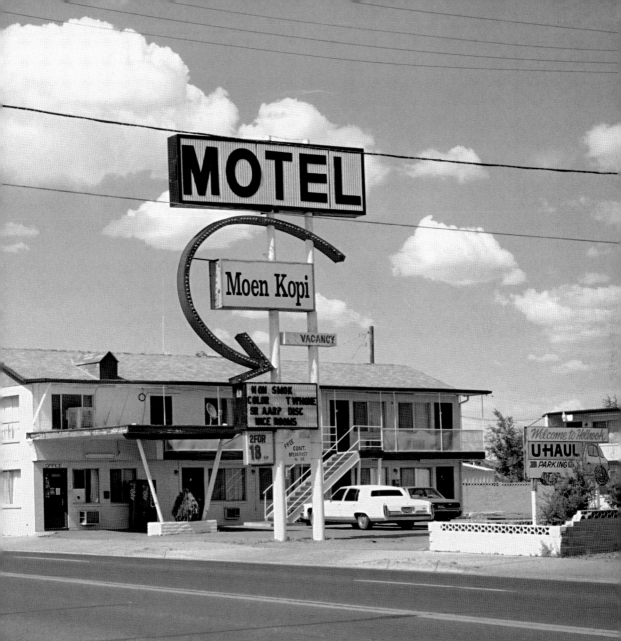

WERE ACCEPTED INTO
TION BECAUSE THEY
LOOKING, GEOMETRIC,
REPEATABLE.

Type on signs had generally been all uppercase until the mid-1960s, when a small fad for upper- and lowercase letters emerged. Graphic designers believed that the combination of letters was easier to read because it was more familiar (this was how newspapers and books were laid out) and because the different heights of the letters helped differentiate them from a distance. Signmakers, however, preferred all uppercase letters because they were traditional (and therefore "proven") and easier to construct (if not prefabricated). In fact, most sign painters had little, if any, experience painting lowercase letters.

All capital letters were preferred by sign-makers; graphic designers favored upper- and lowercase. Ultimately, the signmaker prevailed—by the 1970s, most signs contained letters that were all uppercase.

MOTEL **Motel**

MOTEL **Motel**

MOTEL **Motel**

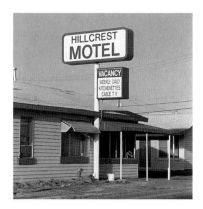

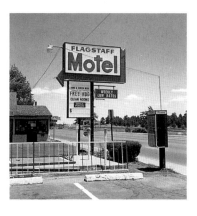

Many of the new, standardized fonts had elongated vertical proportions that conserved space on the printed page, but they were not meant to be read from a distance. When signmakers did choose such letters, it was usually for economic reasons. Many sign companies priced signs by square footage of background plus an additional amount per letter based on vertical height. "By raising the height of letters two or three inches," wrote art director Lucian Howze, "a commission salesman could get $10 or $15 more commission on the sign." Unfortunately, signs with tall, thin letters were more difficult to read, especially when viewed obliquely, from a motorist's perspective.

Generic Natural Names

SANDS MOTEL
SUN N' SAND MOTEL
SUNNY MOTEL
SUNSET MOTEL
SUNDOWN INN
DESERT SUN MOTEL

Leisure Names

WONDERLAND MOTEL
SUNTAN MOTEL
LEISURE LODGE MOTEL
PARADISE MOTEL

Contextless Names

TIME MOTEL
DELTA MOTEL
CLOCK MOTEL

Quality Names

BEST INN
DELUXE INN

Price-Driven Names

BUDGET INN
SUPER 9 INN

Although business names were still chosen to attract tourists, they were increasingly generic, with little or no reference to a motel's geographic or cultural context. When names did allude to nature, they were not specific. Names like "Sunny Motel" and "Sands Motel" were sufficiently nondescript to fit in in any warm climate, while others, such as "Time Motel," would function anywhere.

Many motels catered directly to tourists, and names such as "Leisure Lodge Motel" reflected this. Price and quality were also deciding factors for many customers, so owners frequently referred to these attributes when choosing a name for their motels.

By the late 1960s, many motels were dispensing with the name on the sign altogether. Independents needed the word "motel" to be as prominent as possible so that customers could quickly distinguish them from other types of businesses. By this time independents had little hope of competing with the national chains except through price, so any personal touches, other than indications of economy, were futile. In this regard, simple, generic signs conveyed an image of frugality that appealed to budget-minded customers.

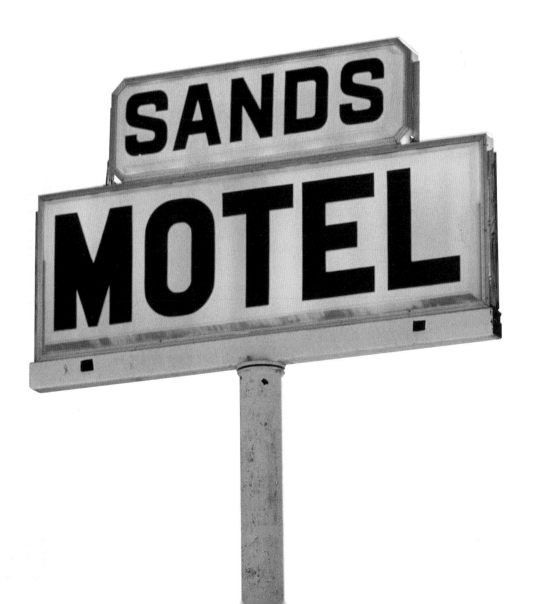

MOT
MOTE
MOTEL

5.7 > COLOR TREATMENT/COLOR NAMES

The language used to describe color in industry journals such as *Signs of the Times* shifted dramatically in the early 1960s. Until then, evocative color names had been the rule—sapphire, ochre, chocolate, etc. In the 1960s, however, new materials, especially prefabricated plastic, sharply limited the signmaker's palette. The most widely available colors were white, red, black, blue, and yellow—primary colors devoid of regional or cultural ties or connotations. Trade journals advised signmakers to chose colors based on their visual clarity and suggested appropriate colors for particular letter heights (those shown here represent recommendations for signs fifty feet high). Color selection became a scientific process. For example, yellow letters could be smaller than red ones since they were considered to be more legible. Some design purists found color unnecessary. "Clean design," wrote signmaker Charles Meyers, "defies the need for color…black and white [will suffice]."

BLACK—15 INCHES

RED—12 INCHES

YELLOW—9 INCHES

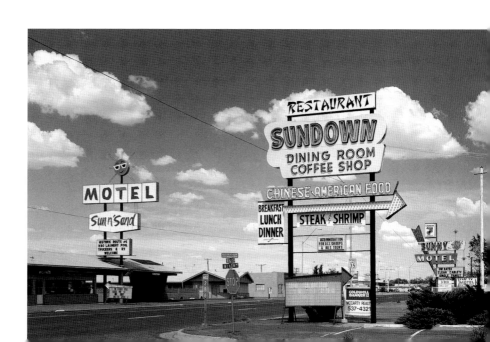

With simplicity dictating the overall appearance of 1960s signs, overt symbols were rare. The ornamental flourishes, decorative type, and playful shapes of the 1950s were replaced with standard typefaces, rectilinear forms, and symmetrical arrangements. All elements of a sign, including type and form, were expected to contribute to the functional obligation of identifying and promoting the business.

Yet the new stripped-down signs did more than just fulfill their functional requirements: they also symbolized a new contemporary aesthetic. Their very stripped-down quality identified them as up-to-date. Unornamented, rectilinear forms comprised the new vocabulary of International Style architecture and design, from the glass-and-steel towers going up in cities to the tail fin–less Lincolns and Cadillacs in car showrooms. The prominent use of plastic—for letters and as background—also announced modernity; plastic was at that time seen as luxurious and progressive, a material proof of better living through technology. Additionally, the simplicity of form and type constituted a symbolic rejection of the excesses of the 1950s.

Signmakers and professional designers did not acknowledge the similarities between 1940s and 1960s signs—they seem not to have noticed. Signmakers were chastened by professional designers when they used "outdated" hand-painted American fonts instead of more "modern," European fonts like Helvetica, but there was no acknowledgment that many of these late-1950s European typefaces were based on earlier American designs.

Ultimately, the contemporary aesthetic and the forms that symbolized it were readily accepted by the signmaking industry because they were already familiar both to the industry and to the public. Simple, geometric, and symmetrical forms were at the foundation of traditional signmaking methods because they were efficient, orderly, and easy to repeat. The new materials and styles introduced during the 1960s did not replace these vernacular goals; they merely provided a more efficient and economic way to achieve them.

SYMMETRY
SYMMETRICAL SIGNS WERE ECONOMICAL AND EFFICIENT. THEY WERE ALSO FORMALLY CONSISTENT WITH OTHER VERNACULAR STRUCTURES OF THE PERIOD.

RECTILINEAR FORMS
RECTILINEAR SHAPES WERE EASY TO CONSTRUCT BY HAND WITH SIMPLE TOOLS. THEY ALSO PROVIDED A FLEXIBLE AREA FOR ORGANIZING AND ARRANGING TYPE.

SANS SERIF TYPEFACES
SANS SERIF LETTERS WERE GEOMETRIC AND MODERN. SIGNMAKERS OFTEN RELIED ON MECHANICAL AIDS TO ENSURE THAT HAND-PAINTED LETTERS APPEARED PRECISE.

1940s

1950s

1960s

SYMMETRY
SYMMETRICAL SIGNS WERE CONSIDERED MORE ELEGANT AND SOPHISTICATED THAN ASYMMETRICAL COMPOSITIONS, WHICH WERE OFTEN REFERRED TO AS GARISH.

RECTILINEAR FORMS
RECTILINEAR SHAPES ALLOWED SIGNMAKERS TO DISPLAY THE MOTEL NAME AND FUNCTION ON A CONTROLLED, NEUTRAL BACKGROUND.

SANS SERIF TYPEFACES
SANS SERIF LETTERS, BECAUSE OF THEIR WIDESPREAD USE IN OTHER MEDIA, WERE INSTANTLY FAMILIAR, WHICH MADE THEM EASIER TO READ.

Composition

Sign components were arranged in a simple and symmetrical manner. Type was centered on rectilinear sign panels mounted on generic metal poles. The hierarchy of sign elements often depended on whether the motel was a chain or an independent. The former emphasized the name; the latter, the function.

5.9 > SYMMETRY

To augment a sign's orderly appearance, all of its elements were arranged symmetrically. "A sign should be as simple as possible," wrote signmaker Harry Miller in an unintentional evocation of 1940s compositions, "and [without] distracting and pointless gingerbread." Symmetrical signs also conveyed modernity and newness since they were the formal opposite of mid-1950s signs. And through their visual repose, these signs addressed some of the public's concern about the effect of signage on the landscape. Blank, ornament-free compositions fit into the highway vista simply by not being distracting.

FUNCTION LARGE

NAME SMALL

5.10 > CONTENT HIERARCHY: EARLY 1960s

The popularity of chain motels made it difficult for independents to attract customers by name alone. The signmakers' solution was to greatly emphasize the function, "motel," often using backlit letters that could be seen from great distances. The physical hierarchy of name and function varied—some motels still placed name over function, but many reversed the order. Either way, the visual emphasis was almost always on the function.

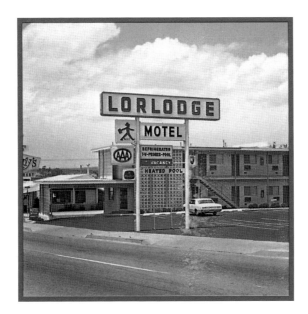

NAME LARGE

FUNCTION SMALL

Chain motels, which often incorporated their function into their brand name (Lorlodge, Travelodge, Holiday Inn), were insulated from the independents' name-versus-function dilemma because their business was generated primarily through brand recognition. To be safe, however, early-1960s chains often included some indication of function in addition to, or as part of, their corporate logo.

FUNCTION ONLY

5.10 > CONTENT HIERARCHY: LATE 1960s

By the late 1960s, many independent motels dispensed with the business
name altogether. By simplifying the sign's content to one word, "motel," it was possible
to use very large letters that could be read at greater distances. This increase
in scale allowed independents to compete visually with other signs.

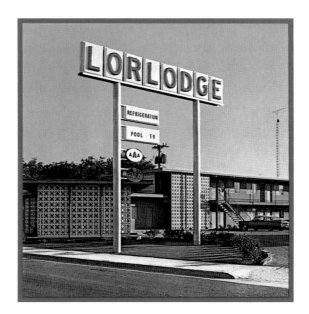

NAME ONLY

As chains expanded during the late 1960s, they increased their brand recognition and familiarity to consumers, both through extensive advertising and promotional campaigns and by increasing the number of locations. As this occurred, less information was needed on the signs that identified them. "Their names and trademarks have become so familiar," noted an editor for *Signs of the Times* in August 1962, "that no additional words are necessary to list and describe products and services."

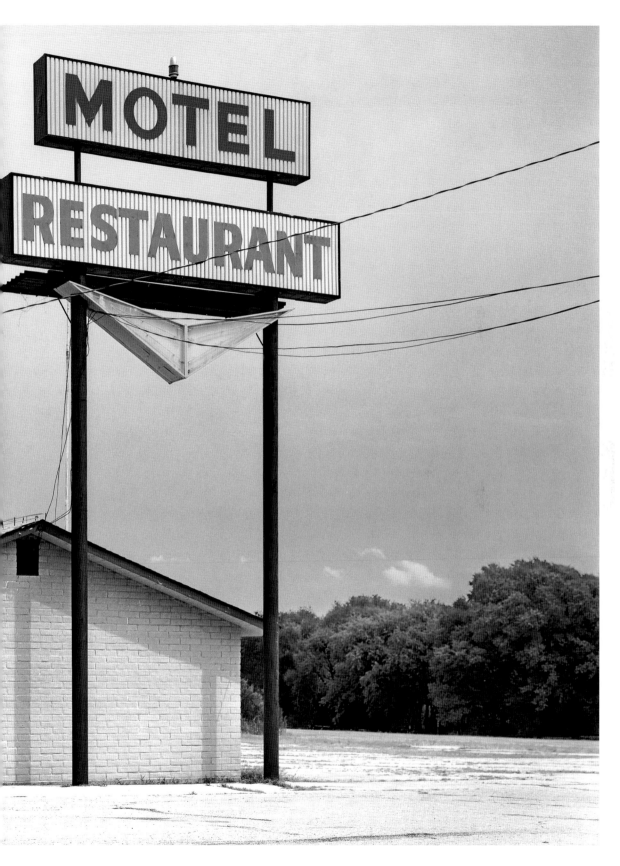

Context

New government regulations—most notably the Highway Beautification Act of 1965—were meant to preserve the natural beauty of American highways. Signs and billboards were banned on all rural and suburban interstates, and it became illegal to erect or paint signs on trees, rocks, or other natural features. Signmakers responded by designing plain, non-distracting signs that did not so much blend in with the surrounding landscape as quietly stand apart from it. Motel buildings followed suit: together with their signs they created highly controlled, internally focused, artificial oases that coexisted with their natural context without relating directly to it.

5.11 > NATURAL CONTEXT

Many motels and chains produced advertising postcards that highlighted the natural beauty of their particular region. Generally, these views were not of the immediate area around the motel but of grander or more idyllic locations nearby. Motels could use these postcards to convey an appreciation of natural beauty without making any direct reference to it in their signs or buildings.

When signmakers did refer to nature, it was in a more abstract way. For example, the Alpine Motel and the Paradise Motel are both located in Flagstaff, Arizona, in a scenic area. The older motel uses a more specific reference, "alpine," to relate itself to the mountains. The newer motel uses a name far more generic: "paradise" could work anywhere, in almost any town or region.

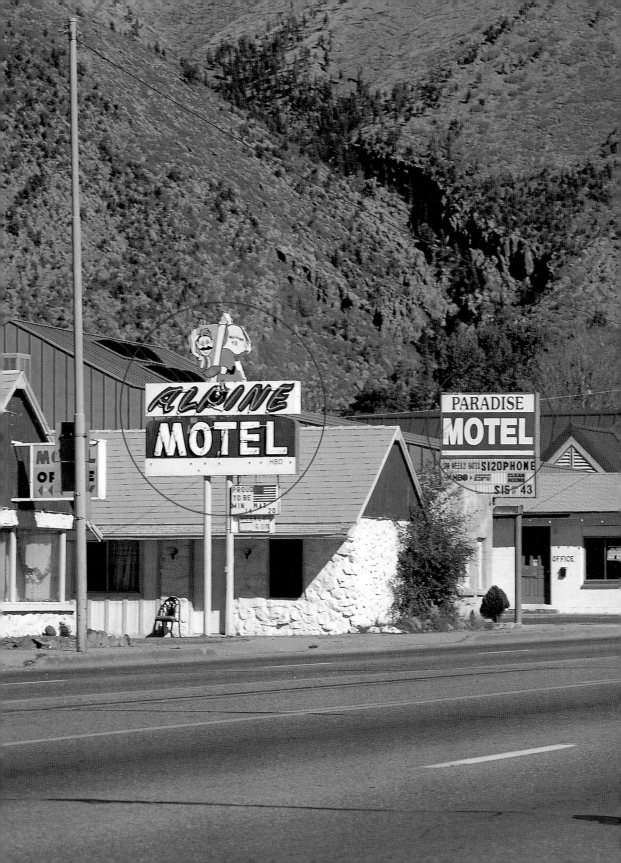

Although it was not until 1983 that Route 66 was fully bypassed by
modern four-lane highways, the transition was well under way by
1970. Motel owners along the older road experienced a sharp drop
in business. To make matters worse, the Highway Beautification Act
of 1965 prohibited them from advertising on nearby interstates.
Many independent motels went out of business. Those close to the
new highways, such as the Silver Spur Motel in Amarillo, Texas, and
the Rio Motel in Tulsa, Oklahoma, installed larger and taller signs—
often alongside their original ones—that could be read by motorists
traveling on the interstates.

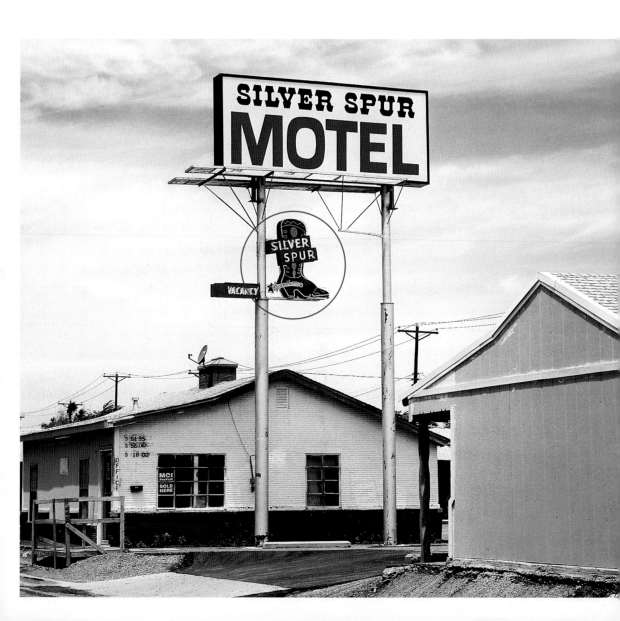

The height of signs changed dramatically between the late 1940s and 1970s, from an average of ten feet during the late 1930s to over eighty feet during the 1970s. Faster cars, the introduction of lighter materials for sign construction, and the growth of the interstate system were all responsible for these increased sign heights.

80 FT
70 FT
60 FT
50 FT
40 FT
30 FT
20 FT
10 FT

1935 1945 1955 1965 1975

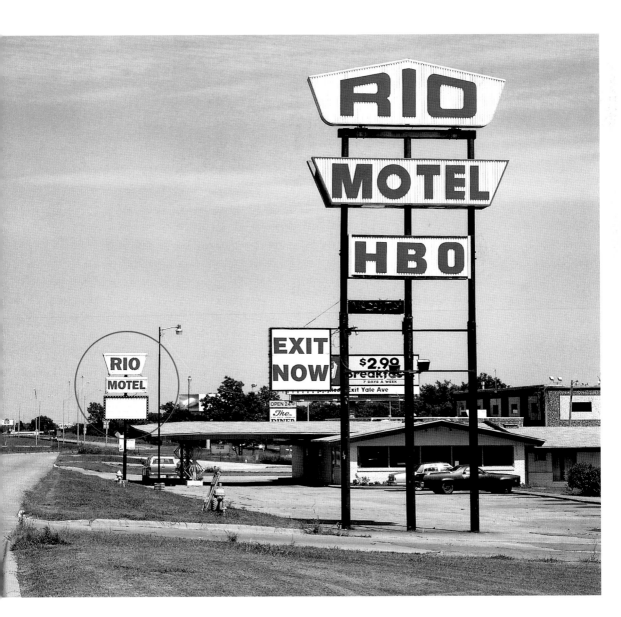

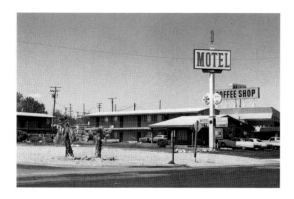

5.13 > NATIONAL CONTEXT

By the early 1960s, signmakers focused most of their attention on creating designs that functioned in a national, rather than a regional or local, context. New manufacturing technologies made it possible for chains to produce identical signs (and buildings) in large quantities. Because they were installed in a wide range of locations, chain motel signs needed to be simple and easy to understand, and devoid of any potentially confusing local symbols. Although independents were still producing unique signs, they had to compete with the chains for their customers, so they also adopted a neutral, stripped-down aesthetic.

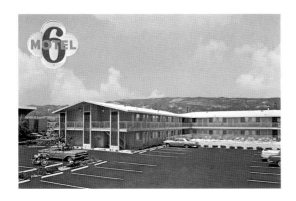
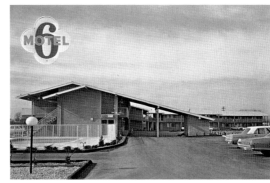
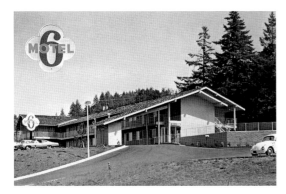
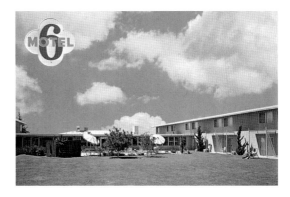
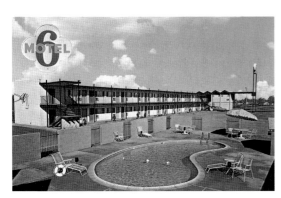
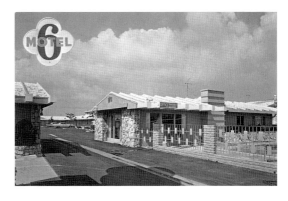
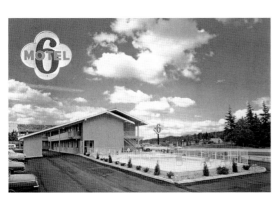
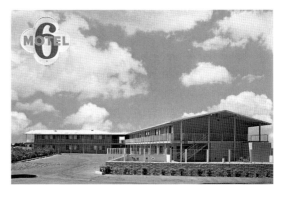

Conclusion

During the 1960s, the U.S. government, under mounting pressure from a public upset with the proliferation of roadside "visual pollution," began to exert its influence on the signmaking industry. "The nation's visual image," wrote graphic designer Joseph Selame in 1966, "can deteriorate only so far before the law-makers of the land will be called to action." The Highway Beautification Act of 1965 was intended to keep new billboards out of rural and scenic areas, elimi-nate those already in place, and encourage roadside beautification. Although the signs that identified motels on their own premises were not controlled under the new law, simplicity and restraint were encouraged. "The more primitive a people," observed Selame, "the more they are attracted by bright, big, shiny objects. Too many signs of the past indicate the primitiveness of the American people."

The new, more minimal signs that resulted from this political and cultural pressure were surprisingly similar to older examples in their simplicity and geo-metric rigor. In fact, the era's new manufacturing technologies encouraged the production of traditional sign elements. For example, consistent, square, evenly spaced letters were very desirable before World War II, but difficult to execute by hand. By the 1960s, though, these types of letters were easily and inexpensively produced in plastic.

While they shared many characteristics with their predecessors, signs of the 1960s were not meant to imitate 1940s examples. The new signs were the products of a new, mass society. They were not just simple; they were generic. They had few if any ties to their physical contexts, and their plastic backgrounds and letters provided a stark visual contrast to earlier metal sign boxes and neon lettering. During the 1940s, signmakers had felt it important to make signs that lasted, so they built with longevity in mind. Durable materials and thoughtful craftsmanship gave those signs a visual presence that 1960s signs lacked. By the early 1970s, most motel owners did not expect their signs to last more than a few years because of the period's rapidly changing business conditions. Plastic panels were quick to install, change, and replace when damaged.

The simple shapes that defined the signs of the 1960s continued to deter-mine the appearance of signs for the next thirty years. Generic, rectangular sign boxes are still common on American highway strips. Although much maligned, these signs meet all of the requirements of the early American vernacular builder: they are geometric, distinct from their natural surroundings, technologi-cally sophisticated (incorporating the most modern materials and construction methods), easy to understand, free of ornament, functional, and economical.

Conclusion

It is fairly easy to identify five clear formal and stylistic eras in the design of motel signs between 1940 and the 1970s; indeed, it is those distinct periods of development that form the basis for the chapters of this book. Yet it is important to remember that larger patterns, which extend well beyond the few decades in question, are at work.

While the focus of much of this study has been the actions and attitudes of individual signmakers, one useful way to visualize and understand the long-term patterns of change and stability in motel signs is to compare them to the processes of biological evolution. Although there are significant differences between the way that natural things and those created by man evolve—especially in terms of intent—there are remarkable similarities between the two processes. For both, change is continual and directional in nature. For both, periods of formal stability are punctuated by periods of rapid change. And for both, vestiges of past forms and structures often survive in later examples, providing clues to their origins.

Seeing the history of a design discipline in terms of biological processes has wider implications, especially for the analysis of vernacular design. Studying vernacular design is not like studying architecture, or art history, or any other discipline on the "high" side of culture. For one, there is often very little written documentation of such designs; physical artifacts are key. More important, the forces that inform and guide vernacular designers are, at least in a metaphorical way, "natural." While any given motel sign was the creation of a single craftsperson, collective design choices were guided more by outside forces—the economy, the community, the competition, and the signmaking tradition—than by personal expression, thus emphasizing the analogy between formal evolution and evolution in the natural world.

"Evolution is change in the properties of populations of organisms over time," evolutionist Ernst Mayr points out in his book *What Evolution Is*. "Genes,

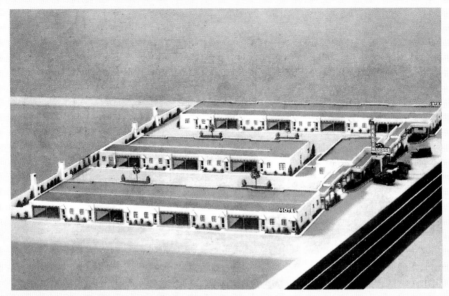

CIRCA 1940

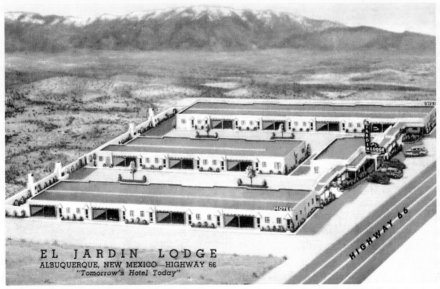

EL JARDIN LODGE
ALBUQUERQUE, NEW MEXICO—HIGHWAY 66
"Tomorrow's Hotel Today"

CIRCA 1945

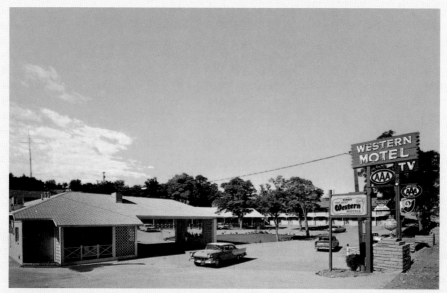

CIRCA 1947

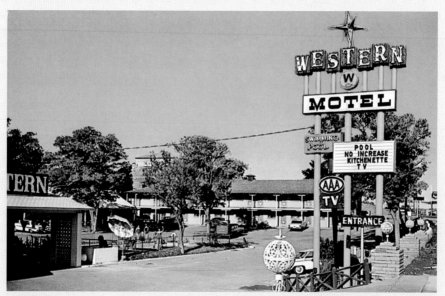

CIRCA 1959

individuals, and species play a role, but it is the change in populations that characterizes organic evolution." The same follows for vernacular design: a formal aberration that affects one vernacular object reveals something about its maker, but a widespread change across an entire group of objects generally indicates larger cultural pressures. The opposite is true for objects of high culture: it is individual uniqueness, not similarity to others, that makes an object significant.

Evolutionary biology offers many insights into the changes that occurred in signs. As with plants and animals, motel signs had to be well-adapted to their environment, to be "fit." And as travel and commerce on Route 66 boomed, that environment changed quickly and radically. Signmakers had to create new signs that would succeed—that would be noticeable and memorable, would appeal to customers and draw them in, and would be economical for the motel owner. If a sign was not perfectly suited to its specific time and environment, the business it advertised would not prosper. In this sense—an evolutionary rather than an aesthetic one—the generic plastic signs of the late 1960s can be considered just as successful as the earlier, hand-crafted neon signs that connote a "golden age" of American road travel. Signs from both eras fulfilled the needs of their specific time.

One key aspect of biological evolution is the tendency to acquire and maintain "adaptedness," those qualities that contribute to an object's or organism's fitness or health. Shade plants, for example, adapt to reduced amounts of light by growing larger leaves to provide more area for photosynthesis to occur. A similar process is evident in signs: as traffic speeds increased on highways, sign boxes were made larger and larger to better attract motorists' attention.

Stability—the retention of the qualities most "fit" for a specific organism—is also important to adaptedness. Just as some biological characteristics reach evolutionary maturity (four limbs for mammals, for instance), so too did some design elements remain static over decades. Indeed, the evolution of signs extends back much further than 1940. Many of the elements of modern motel signs evolved from the inn signs of the nineteenth century. Square proportions, block lettering, and the use of all uppercase letters, for example, were common by the 1820s. The same forces that encouraged their use in the modern era were present then, too. "Long before the emergence of modernism as an artistic movement, the forms and imagery of inn signs made a virtue of simplicity and standardization," writes Catherine Gudis in *Lions & Eagles & Bulls*, a catalog for an exhibition of early inn signs from Connecticut. "They employed structures and an iconography that were easily repeated [which made them more familiar] to many different types of audiences."

Another evolutionary characteristic is the tendency toward diversity. Different environments and micro-environments give rise to different species:

consider the variety of finches on the different islands of the Galápagos, or the language differences in human populations separated by water or mountains or other barriers. Diversity among motel signs along Route 66 occurred for one of four primary reasons: geographic separation, competition, technical innovation (neon, plastic, etc.), and the introduction of "foreign" ideas (those culled from other disciplines or cultures, such as Art Deco or Streamline).

The diversity exhibited among geographically separated signs is limited when compared to what came about through the other catalysts. During the 1940s, for example, it was the fairly subtle variations in symbols, style, and craftsmanship of illustrations, color combinations, and lettering techniques that made individual signs appear unique, rather than any fundamental difference in form or function. These subtle variations often reflected the local concerns and personal tastes of signmakers, who were at the time very interested in making signs appropriate to a small region.

Changes brought about by increased competition among motels were more dramatic. Extreme measures were often taken to differentiate one sign from another, especially during the 1950s. Signmakers introduced irregular forms, bright colors, and super-stylized type; the era's emphasis on uniqueness and creativity demanded that no two signs be alike.

The "foreign" ideas that fueled sign diversity include styles and techniques that came from outside existing signmaking traditions, whether from different regions or countries or from different disciplines. Abstract Expressionism, for example, provided a convenient aesthetic for signmakers struggling to create original signs during the 1950s. Later, graphic designers directed signmakers to abandon hand-drawn type for standardized typefaces. Such standardization was rapidly accepted into the signmaking tradition (and remains an integral part of it) because it provided a solution to two longstanding problems: that of making a sign appear as familiar as possible, and that of facilitating geometric precision and repeatability.

The forces encouraging change in sign design were many and often subtle, with a variety of results. When communication between different parts of the country expanded through improved highways, automobiles, and television, traditions limited to a particular region faded, since they were less popular with the new, more diverse audience. The disappearance of owners' names from signs is one example of this; outside of a limited, local audience, the owner of a motel was unimportant. Features that were easier for out-of-towners to comprehend, such as the Western themes that began in the Southwest, became popular. This expansion of once-local symbols was double-edged—it also necessitated their watering down, to increase their readability for out-of-towners. References to local Indian tribes and obscure native flora, for example, were

CIRCA 1951

CIRCA 1963

CIRCA 1963

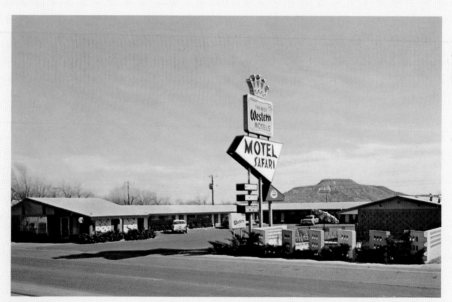

CIRCA 1966

exchanged for more generic, iconic symbols such as tepees and cacti.

During the 1960s, new travel and transportation patterns made it necessary for signmakers to introduce signs better adapted to the new interstate highways and competition from chain motels. Some signmakers responded by placing the business name below the function ("motel") rather than above it. Although this required only a simple rearrangement of the two words, it created a fundamentally different sign: one that prioritized the generic over the unique. This differentiated independent motels from chains, which continued to promote brand names.

In addition to looking at how and why signs changed, it is also important to consider the temporal aspects of change. While transformation in biological processes can take millions of years, the presence of a human hand and mind in the signmaking process engenders much more rapid change. Some innovations lasted only a short time—for example, the highly stylized type used during the mid-1950s—indicating that the change was merely a fad. The brief life of most stylistic trends means that signs evolve much faster than most biological organisms. This rapid change also allows for easily recognition of which adaptations might qualify as real additions to the signmaking tradition. Here again the parallels with biological evolution are valid: most adaptations are of limited use. Those that become accepted as tradition, such as the use of simple, all capital letters for the word "motel," are less common than those that do not. Occasionally signs contained vestigial structures, elements that had at one time been fully functional, such as the rounded, circular tops that adorned many vertically oriented signs during the 1940s. Turn-of-the-century signs often included stars within this shape, while later versions were either blank or included type. Such vestigial elements offer a better understanding of a particular sign's origin and also attest to the persistence of traditional forms.

The study of vernacular design requires a dedication to understanding the complex processes that influence and guide the development of form. Indeed, it is this understanding of how things evolve that give them their most profound meaning and significance. Every new object represents a fresh attempt to address the constantly changing needs of a complex environment; many are successful and multiply, while others fail and are doomed to extinction.

Evolutionary biology offers methodologies for studying all types of vernacular objects. It suggests that every object contains within it the physical clues to its origins, so it is prudent to carefully evaluate all of the object's components and the relationships between them. It implies that it is more important to identify longstanding traditions than short-lived innovations, and changes in populations rather than individual aberrations. But most important, biological evolution suggests that vernacular objects might be best evaluated in the

manner that organisms are—in terms of how they perform in their specific circumstances, not how they conform to individual ideas about what constitutes beauty. In this way of looking at the landscape of Route 66, its motel signs are not singular objects or nostalgic reminders of the past but rather elements of a continuous, and continuing, history of vernacular design.

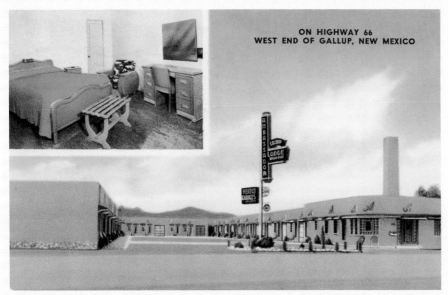

CIRCA 1940

CIRCA 1965

Motel Locations

Notes

Page 11
John Brinckerhoff Jackson, *Discovering the Vernacular Landscape* (New Haven: Yale University Press, 1984), xii.
Page 12
John R. Stilgoe, *Common Landscape of America, 1580 to 1845* (New Haven: Yale University Press, 1982), 133.
Page 13
Henry Glassie, "Folk Art," in *Folklore and Folklife: An Introduction*, ed. Richard M. Dorson (Chicago: University of Chicago Press, 1972), 269, 272-79, as cited in Glassie, *Folk Housing in Middle Virginia: A Structural Analysis of Historic Artifacts* (Knoxville: University of Tennessee, 1975), 170.
Pages 16–17
James Warren Belasco, *Americans on the Road: From Autocamp to Motel, 1910–1945* (Cambridge, Mass.: MIT Press, 1979), 19–39.
Page 20
Thomas C. Hubka, "Just Folks Designing," in *Common Places: Readings in American Vernacular Architecture*, ed. Dell Upton and John Michael Vlach (Athens: University of Georgia Press, 1986), 427.
Page 24
Edward Shils, *Tradition* (Chicago: University of Chicago Press), 236.
Lucian H. Howze, "Designing Electric Signs: Designer Must Be an Idea Producer," *Signs of the Times* 168, no. 2 (October 1964): 68.
Shils, *Tradition*, 326.
Page 33
Phil Hammond, "Personality in Your Signs," *Signs of the Times* 126, no. 2 (October 1950): 106, 86.
Page 46
Susan P. Schoelwer, "Rediscovering the Public Art of Early American Inn Signs," *Lions & Eagles & Bulls: Early American Tavern & Inn Signs From the Connecticut Historical Society* (Hartford: Connecticut Historical Society/Princeton University Press, 2000), 11.
"Commercial and Electric Sign Design: What the Past Has Contributed," *Signs of the Times* 173, no. 1 (May 1966): 50.
Page 51
Paul R. Fritsch, "The Electric Sign Has Three Missions," *Signs of the Times* 122, no. 4 (August 1949): 38.
"Advertising and Selling the Tourist Court," *Tourist Court Journal*, April 1945, 8.
Page 54
Belasco, *Americans on the Road*, 19–39.
Page 60—61
A. H. Gurtin, "Judging Outdoor Advertising Sketches for Effectiveness by Percentage," *Signs of the Times* 52, no. 1 (January 1926): 12.
Page 64
E. Emmerson, "Signs: Their Part in Modern Advertising," *Signs of the Times* 66, no. 1 (September 1930): 24.
"Advertising and Selling the Tourist Court," 9.
Page 77
Mark Gottdiener, *The Theming of America: Dreams, Visions, and Commercial Spaces* (Boulder, Colo.: Westview Press, 1997), 70–71.
"Advertising and Selling the Tourist Court," 18.
Page 85
Paul R. Fritsch, "The Sign Pole: An Adventure in Design," *Signs of the Times* 125, no. 1 (May 1950): 22.

Page 90
C. E. Meyer, "New Concepts and Ideas in Porcelain Enamel Signs," *Signs of the Times* 149, no. 1 (May 1958): 48.
Page 94
"Young Man Hitches Wagon to Pictorial Artist Star," *Signs of the Times* 140, no. 4 (August 1955): 54.
Page 103
Douglas Towne, "The Mysteries of the Wandering Cactus Unearthed: A Monograph on the Commercial Use of the Saguaro Emblem," *Society for Commercial Archaeology Journal* 14, no. 2 (spring/summer 1995): 13–19.
Page 104
Towne, "Mysteries of the Wandering Cactus," 14.
Page 115
Peter B. Horsley, "Designing the Neon Display Box," *Signs of the Times* 127, no. 2 (February 1951): 98.
Page 131
Bob Fitzgerald, "The Values of Script in Sign Applications," *Signs of the Times* 170, no. 3 (July 1965): 60.
Page 136
"Best of the Month Contest," *Signs of the Times* 146, no. 4 (August 1957): 62.
Page 138
Lucian H. Howze, " Designing Electric Signs: Arrows, Lamps and Ovals," *Signs of the Times* 167, no. 4 (August 1964): 74.
Page 144
Horsley, "Designing the Neon Display Box," 55.
Page 152
Paul R. Fritsch, "Use the Design to Sell the Sign," *Signs of the Times* 131, no. 2 (June 1952): 23.
Page 156
Lucian H. Howze, "Better Look to Sign Design for Increased Sales," *Signs of the Times* 150, no. 2 (October 1958): 43.
Page 161
Lucian H. Howze, "Designing Electric Signs," *Signs of the Times* 165, no. 3 (November 1963): 53.
Pages 168–69
Howze, "Better Look to Sign Design for Increased Sales," 103.
Page 170
Clint Hewlett, "Small Plant...So What?," *Signs of the Times* 155, no. 4 (August 1960): 108.
Page 196
Lucian H. Howze, "Designing Signs and Outdoor to Meet Advertiser Problems," *Signs of the Times* 149, no. 1 (May 1958): 37.
Page 197
H. H. Mobley, "The Motels of Today Need Impressive Electric Signs," *Signs of the Times* 164, no. 1 (May 1963): 45.
Page 210
"A Modern Approach in Colonial Design Techniques," *Signs of the Times* 164, no. 1 (May 1963): 70.
"The Colonial Motif...Rendered in Plastic," *Signs of the Times* 156, no. 4 (December 1960): 76.
Bob Fitzgerald, "Expressing Antiquity in a Plastic Sign," *Signs of the Times* 167, no. 2 (June 1964): 50.
Page 213
"President Lyndon B. Johnson's Remarks at the Signing of the Highway Beautification Act of 1965, October 22, 1965," from http://www.lbjlib.utexas.edu/johnson/archives.hom/speeches.hom/651022.asp

Page 214
Fil Sessions, "The Electric Sign Legacy: Sign Design—Review and Criticism," *Signs of the Times* 173, no. 1 (May 1966): 60.
"The Trend in Sign Graphics," *Signs of the Times* 179, no. 2 (June 1968): 130.
Page 218
Sessions, "Electric Sign Legacy," 60.
Page 220
William Henry Haire, "Evaluate the Trends: Management Considerations in Design," *Signs of the Times* 173, no. 1 (May 1966): 67.
Page 224
Lucian H. Howze, "Electric Signs: Letters—A Necessary Evil," *Signs of the Times* 174, no. 2 (October 1966): 50.
Page 232
Howze, "Electric Signs: Letters," 50.
Page 236
Bob Fitzgerald, "Designing With Reflectives," *Signs of the Times* 155, no. 1 (May 1960): 68.
Charles D. Meyers, "Selling Through Design: The Persuasive Design Sales Tool," *Signs of the Times* 173, no. 1 (May 1966): 71.
Page 240
Harry J. Miller, "Keep the Sign Simple," *Signs of the Times* 166, no. 4 (April 1964): 44.
Page 245
"Gasoline Oil Signs Showing Way," *Signs of the Times* 161, no. 4 (August 1962): 22.
Page 254
Joseph Selame, "Emphasis on Sign Readability: Designing for a Sophisticated Public," *Signs of the Times* 173, no. 1 (May 1966): 59, 58.
Page 257
Ernst Mayr, *What Evolution Is* (New York: Basic Books, 2001), 8.
Page 261
Catherine Gudis, "From Tavern Signs to Golden Arches: A Landscape of Signs," in *Lions & Eagles & Bulls*, 91.

Selected Bibliography

This bibliography is an edited selection of the books and articles I found to be the most useful in preparing this book. The list includes books from a variety of different disciplines, including folklore, sociology, art, architecture, anthropology, graphic design, biology, and literary criticism.

Motels, Route 66, and Roadside Culture
Except for *Learning from Las Vegas*, all of these books address roadside culture from a historical perspective. Warren Belasco's study is notable for his astute observations on the cultural shift that occurred when travelers switched from trains to automobiles, while *The Motel in America* contains a thorough analysis of the motels along Route 66 in Albuquerque, New Mexico.

Belasco, Warren James. *Americans on the Road: From Autocamp to Motel, 1910–1945*. Cambridge, Mass.: MIT Press, 1979.

Jakle, John A., Keith A. Sculle, and Jefferson S. Rogers. *The Motel in America*. Baltimore: Johns Hopkins University Press, 1996.

Kelly, Susan Croce. *Route 66*. Norman: University of Oklahoma Press, 1988.

Liebs, Chester H. *Main Street to Miracle Mile*. Boston: Little, Brown, 1985.

Venturi, Robert, Denise Scott Brown, and Steven Izenour. *Learning from Las Vegas: The Forgotten Symbolism of Architectural Form*. Cambridge, Mass.: MIT Press, 1977.

Tradition and Innovation
The authors in this section seek to understand the complex processes that encourage stasis or change in things and organisms. Most of the work focuses on man-made artifacts and addresses either tradition or innovation. *What Evolution Is* is unique in that Mayr presents a balanced approach to both using nature as his subject.

Barnett, H. G. *Innovation: The Basis of Cultural Change*. New York: McGraw-Hill, 1953.

Eliot, T. S. "Tradition and the Individual Talent." In *Selected Prose of T. S. Eliot*. San Diego: Harcourt Brace & Company, 1975.

Hubka, Thomas C. "Just Folks Designing." In *Common Places: Readings in American Vernacular Architecture*. Ed. Dell Upton and John Michael Vlach. Athens: University of Georgia Press, 1986.

Mayr, Ernst. *What Evolution Is*. New York: Basic Books, 2001.

Shils, Edward. *Tradition*. Chicago: University of Chicago Press, 1981.

Vernacular Material Culture
It was only in the 1960s, when the breakthrough work of Fred Kniffen and Henry Glassie first appeared, that analytical books on vernacular culture became common. The most notable of these studies focus on the subject of folk architecture; Glassie's *Folk Housing in Middle Virginia* is still one of the most influential—and thorough—works in the field. The introductory essay in *Material Culture Studies in America, 1876–1976* provides a comprehensive overview of the discipline, outlining its shifting paradigms from collecting to description and analysis.

Glassie, Henry. *Folk Housing in Middle Virginia: A Structural Analysis of Historic Artifacts*. Knoxville: University of Tennessee Press, 1975.

———. *Pattern in the Material Folk Culture of the Eastern United States*. Philadelphia: University of Pennsylvania Press, 1968.

Jackson, John Brinckerhoff. *Discovering the Vernacular Landscape*. New Haven: Yale University Press, 1984.

Schlereth, Thomas J., ed. *Material Culture Studies in America, 1876–1976*. Nashville: American Association for State and Local History Press, 1982.

Stilgoe, John R. *Common Landscape of America, 1580 to 1845*. New Haven: Yale University Press, 1982.

Upton, Dell, and John Michael Vlach, eds. *Common Places: Readings in American Vernacular Architecture*. Athens: University of Georgia Press, 1986.

American/Regional Culture
These books on American culture have less to do with the interpretation of things and more to do with defining particularly American ways of thinking, including addressing the relationship between culture, economics, and social change. *Cycles of Conquest* is the exception—it examines the interrelationship between Spanish, Mexican, and American cultures, and their influence on the Indians of the Southwest.

Bell, Daniel. *The Cultural Contradictions of Capitalism*. New York: Basic Books, 1976.

Commager, Henry Steele. *The American Mind: An Interpretation of American Thought and Character Since the 1880s*. New Haven: Yale University Press, 1990.

Spicer, Edward H. *Cycles of Conquest: The Impact of Spain, Mexico, and the United States on the Indians of the Southwest, 1533–1960*. Tucson: University of Arizona Press, 1962.

Methods of Inquiry and Analysis
This is the most diverse (and subjective) list and includes work from folklorists, graphic designers, historians, artists, and psychologists. *Envisioning Information* and *Pedagogical Sketchbook* are particularly useful for those interested in visual approaches to analysis.

Downing, Frances, and Thomas C. Hubka. "Diagramming: A Visual Language." In *Perspectives in Vernacular Architecture, II*. Ed. Camille Wells. Columbia: University of Missouri Press, 1986.

Klee, Paul. *Pedagogical Sketchbook*. London: Faber and Faber, 1953.

Kubler, George. *The Shape of Time: Remarks on the History of Things*. New Haven: Yale University Press, 1962.

Photography Credits

Lévi-Strauss, Claude. *Structural Anthropology*. Trans. Claire Jacobson and Brooke Grundfest Schoepf. Garden City, N.Y.: Doubleday, 1967.

Piaget, Jean. *Structuralism*. Trans. Chaninah Maschler. New York: Basic Books, 1970.

Tufte, Edward R. *Envisioning Information*. Cheshire, Conn.: Graphics Press, 1990.

Page 35
"Candy Kitchen," Young Electric Sign Company, Historical Archive

Wright Morris, "Farmhouse near McCook, Nebraska," 1940

Page 46
"Orpheum," Young Electric Sign Company, Historical Archive

"Lux," Young Electric Sign Company, Historical Archive

Page 57
Ben Shahn, "Central Ohio," 1938. Library of Congress, Prints & Photographs Division, FSA-OWI Collection

Page 63 (from top)
Walker Evans, "Frame Building with Jigsaw Ornament, Southeastern U.S.," 1936. Library of Congress, Prints & Photographs Division, FSA-OWI Collection. LC-USF342-8269A

Wright Morris, "Gano Grain Elevator, Western Kansas," 1940

Wright Morris, "Meeting House, Southbury, Connecticut," 1940

Walker Evans, "Negro Church, South Carolina," 1936. Library of Congress, Prints & Photographs Division, FSA-OWI Collection. LC-USF342-8055A

Walker Evans, "Roadside Store, Vicinity Greensboro, Alabama, Summer," 1936. Library of Congress, Prints & Photographs Division, FSA-OWI Collection. LC-USF342-8282A

Page 102
Jeffry Meyers, "Prickly Pear Cacti," Index Stock

Page 103
John Warden, "Saguaro Cacti," Index Stock

Page 110
John Collier, "Albuquerque, New Mexico," 1943, Library of Congress, Prints & Photographs Division

Page 166
"Motel," Young Electric Sign Company, Historical Archive

"Gulf," Young Electric Sign Company, Historical Archive

About the Author

Lisa Mahar is cofounder and partner in the New York architecture and design firm MAP. Her first book, *Grain Elevators*, won the AIA International Book Award. Mahar is the recipient of a Design Arts Award from both the National Endowment for the Arts and the New York State Council on the Arts. She was also a winner of an ID Magazine Graphic Design Honor Award for *Aldo Rossi: Architecture 1981–1991*.